Soul of Yosemite

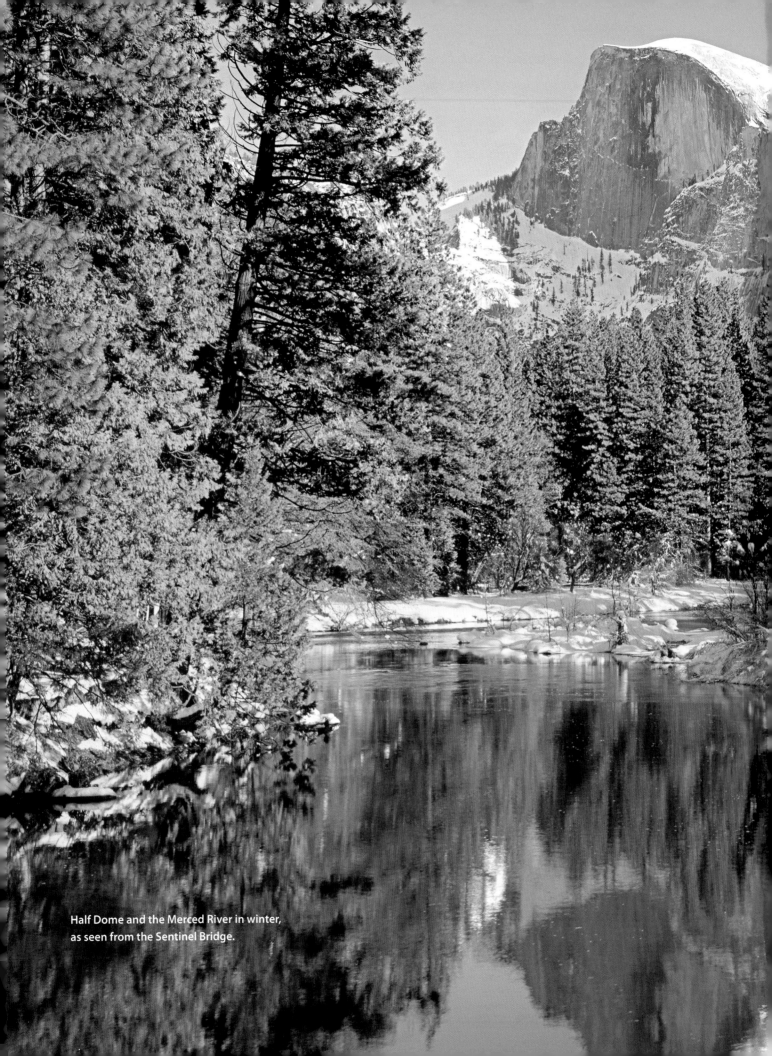

Half Dome and the Merced River in winter,
as seen from the Sentinel Bridge.

Soul *of* Yosemite

PORTRAITS OF LIGHT AND STONE

Ed Cooper

FALCONGUIDES ®

GUILFORD, CONNECTICUT
HELENA, MONTANA

AN IMPRINT OF GLOBE PEQUOT PRESS

FALCONGUIDES®

Copyright © 2011 by Ed Cooper

FalconGuides is an imprint of Globe Pequot Press.
Falcon, FalconGuides, and Outfit Your Mind are registered trademarks of Morris Book Publishing, LLC.

All interior photos by Ed Cooper except that of the author on page 108 taken by park visitor.

Text design: Claire Zoghb
Project editor: Julie Marsh
Layout artist: Melissa Evarts
Map by Daniel Lloyd © Morris Book Publishing, LLC

Library of Congress Cataloging-in-Publication Data

Cooper, Ed, 1937-
 Soul of Yosemite : portraits of light and stone / Ed Cooper.
 p. cm. -- (FalconGuides)
 ISBN 978-0-7627-6995-7
 1. Yosemite National Park (Calif.)—Pictorial works. 2. Yosemite National Park (Calif.)—Description and travel. 3. Yosemite Valley (Calif.)—Pictorial works. 4. Yosemite Valley (Calif.)—Description and travel. I. Title.
 F868.Y6C665 2011
 979.4'47—dc22

 2010040569

Printed in the United States of America

10 9 8 7 6 5 4 3 2 1

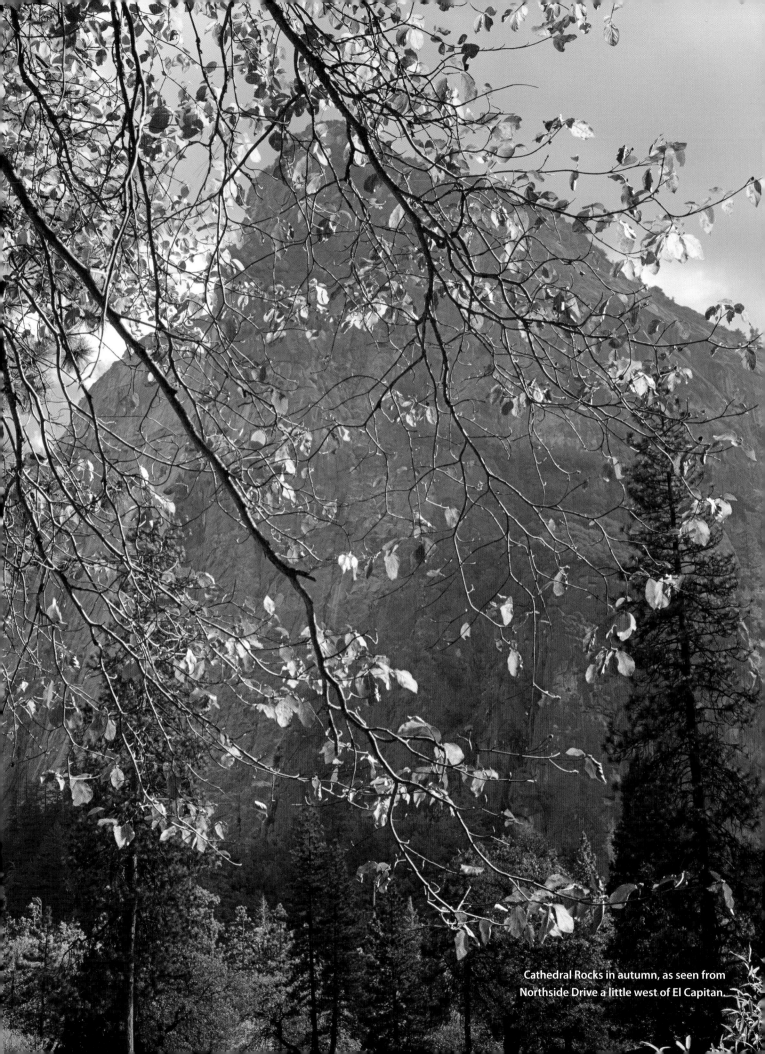

Cathedral Rocks in autumn, as seen from
Northside Drive a little west of El Capitan.

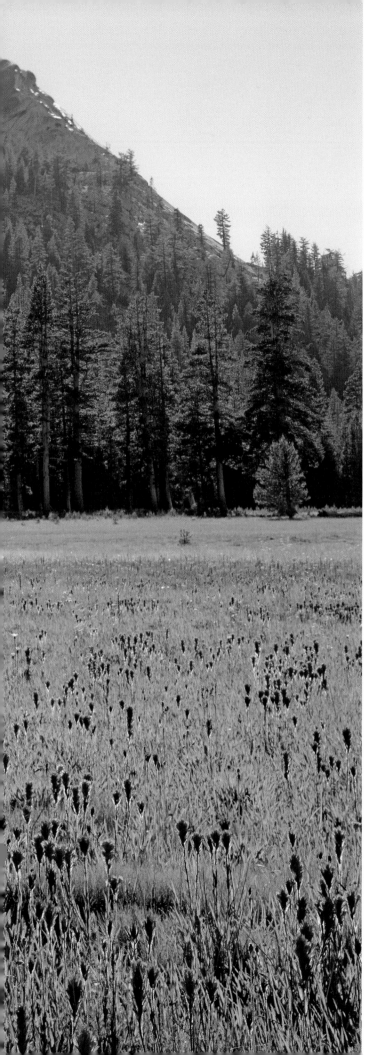

C O N T E N T S

Owl's clover and Granite Domes near the west
end of Tuolumne Meadows.

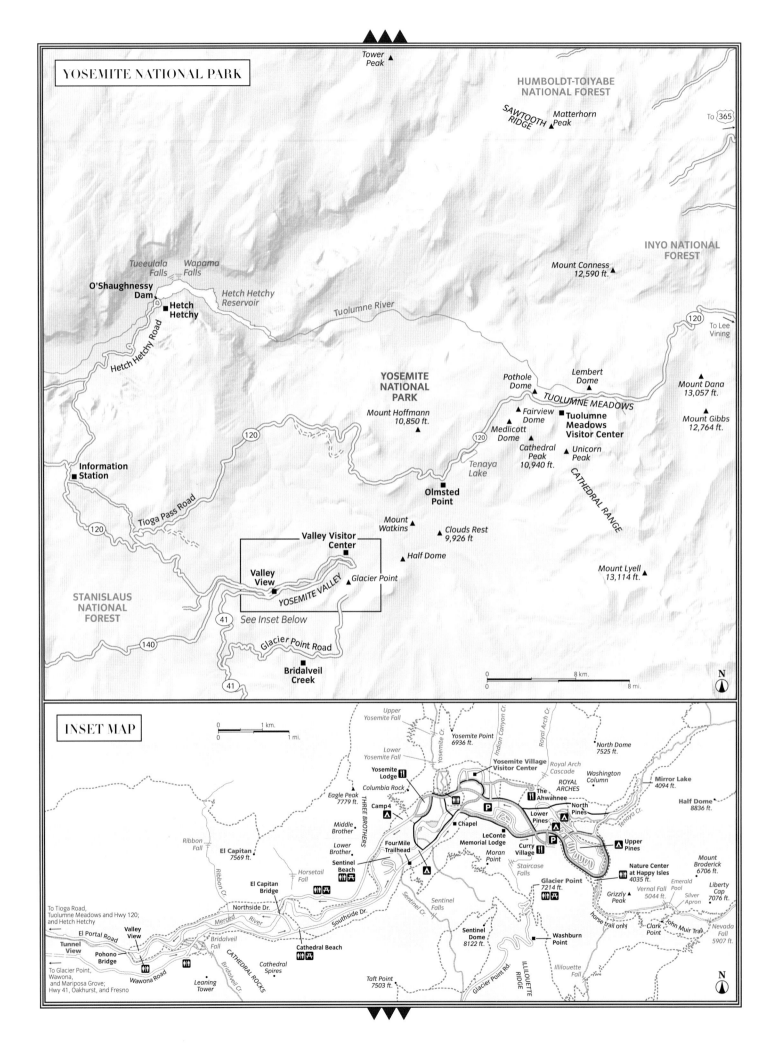

INTRODUCTION

My first view of Yosemite Valley was short, taking perhaps two hours. I arrived in the valley in one of the many clunker cars I owned then, during a spring break from college. The time was March, it was raining lightly, and only the lower parts of the great rock formations were visible. I had heard of climber Warren Harding's attempt to ascend the Nose of El Capitan, but he was not on the rock as far as I could see. I had not even heard of Camp 4, the camp where rock climbers hung out. The year was 1958.

I am reminded of Howard Carter's comment to his patron Lord Carnarvon on November 22, 1922, when Carnarvon asked Carter if he saw anything upon first peering into the entrance to the burial chamber of King Tutankhamen: "Yes, I see wonderful things." That was my feeling during the short time I spent in Yosemite Valley back then.

Harding finished his climb of the Nose, along with Wayne Merry and George Whitmore, in November 1958. It was not until four years later that I returned to Yosemite Valley, first to climb, then to enter into a romance with recording images of one of the most fantastic places on this planet.

The working title of this book was *Soul of Rock*, which might have led readers to imagine it had something to do with music. That's not really far off the mark, because Yosemite is, I believe, a symphony in stone. The theme of this book is the rock of Yosemite in its many shapes and forms, whether alone or in combination with other elements. Yosemite Valley is only about 7 miles long (about 11km) and averages about 0.7 mile in width (1.1km). It is a very small geographic area to include so much beauty.

I would like to take this opportunity to thank my wife, Debby, for her support in this project, and for her extensive knowledge of correct grammar.

ORGANIZATION OF THIS BOOK

As I pondered how to organize the photographs for this book, I considered several scenarios. One was to organize the images by subject, such as "rock and water," "rock and people," "rock and valley," "just plain rock," and so forth. Another option was to organize all the photos according to rock formations, grouping all El

Capitan photos together, all Half Dome photos together, etc.

My final decision was to organize the photographs more or less in the order that a visitor arriving for the first time in Yosemite Valley would see the formations. In this sense, this book is a picture guide to the great rock formations in Yosemite Valley. The same principle has been applied to Yosemite National Park roads outside the valley, as well as to trails. Each section of the book contains some introductory information, and in addition, all photos are accompanied by information specific to those particular images.

El Capitan from the Diving Board, a rock formation at the base of the southwest face of Half Dome.

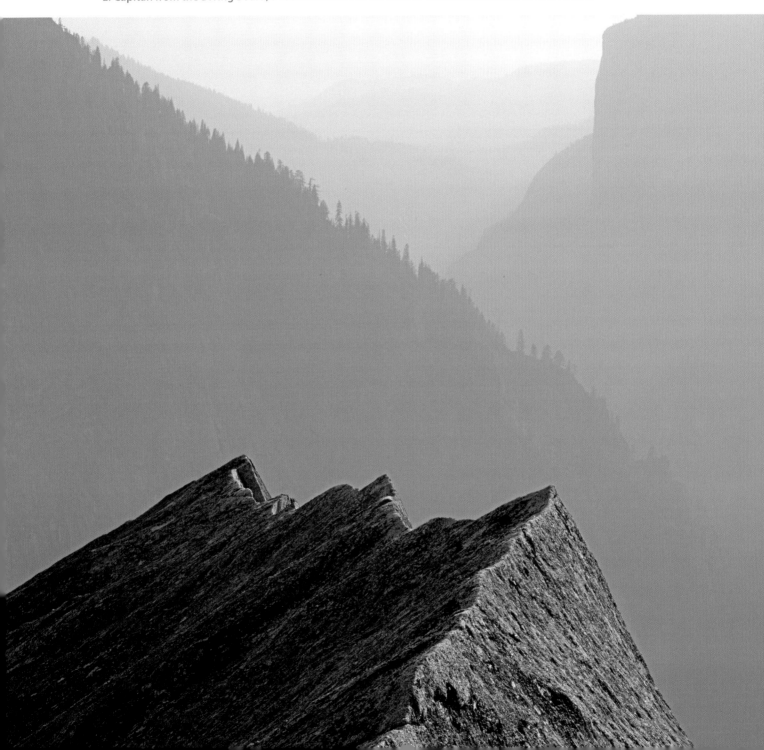

S O U T H S I D E D R I V E

There are three major routes into Yosemite Valley from the west, which are used by most people visiting the valley. The other approach, from the east, goes over 9,945-foot (3,031m) Tioga Pass and is closed from about November to May, depending on the snowpack. All three western approaches (and the western end of the eastern approach) converge within a few miles of each other, at the western end of Yosemite Valley.

The majority of the drivable mileage within the valley is on one-way roads. All the approaches funnel vehicles onto Southside Drive on the south side of the Merced River, which is one way all the way to Curry Village at the east end of the developed valley floor. At this point the road crosses the Merced River on Stoneman Bridge and becomes the one-way Northside Drive heading west (with the exception of roads around Yosemite Village).

There are two exits from Southside Drive, one of which is a two-way road that crosses the Merced River on the Sentinel Bridge and leads to Yosemite Village, Yosemite Lodge, and the historic Ahwahnee Hotel. The other exit is at El Capitan Bridge, which leads to Northside Drive heading west out of the valley or loops back to Southside Drive at the Pohono Bridge.

This section includes images taken along or close to Southside Drive as far as the Sentinel Bridge; they appear in the order that the viewer sees formations when driving along the road. Among the significant landforms showcased in this chapter are El Capitan, Bridalveil Fall, and Cathedral Rocks.

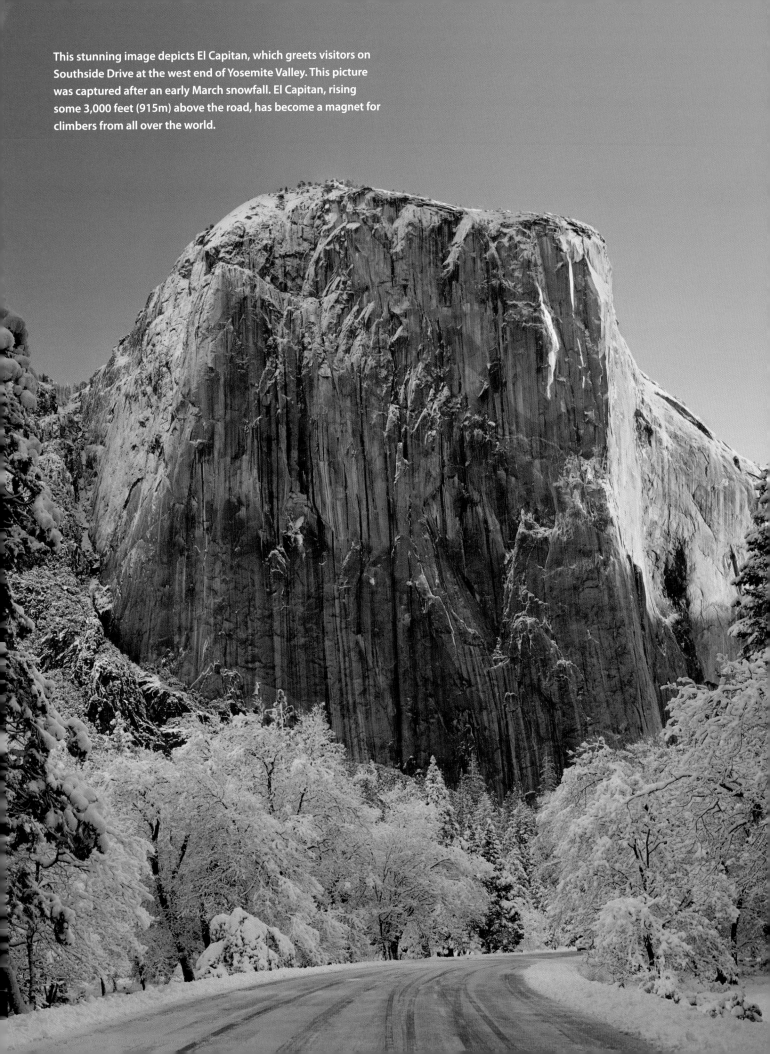

This stunning image depicts El Capitan, which greets visitors on Southside Drive at the west end of Yosemite Valley. This picture was captured after an early March snowfall. El Capitan, rising some 3,000 feet (915m) above the road, has become a magnet for climbers from all over the world.

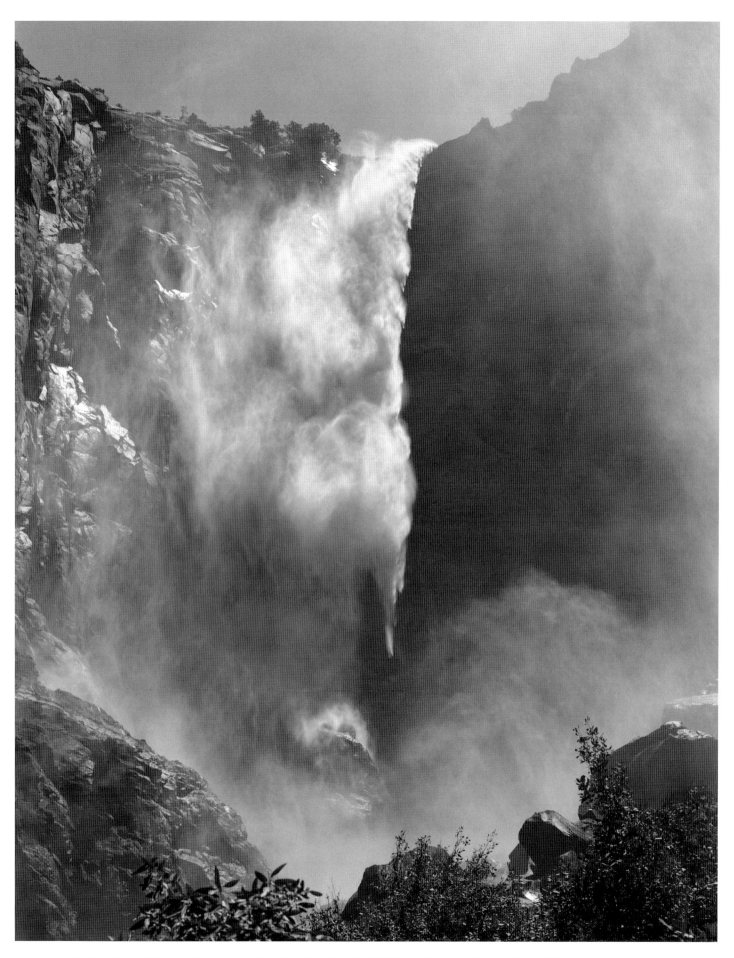

Rock and water! It doesn't get any better than this. Bridalveil Fall is located near the junction of Wawona Road and Southside Drive. This image is an outstanding portrait of the fall.

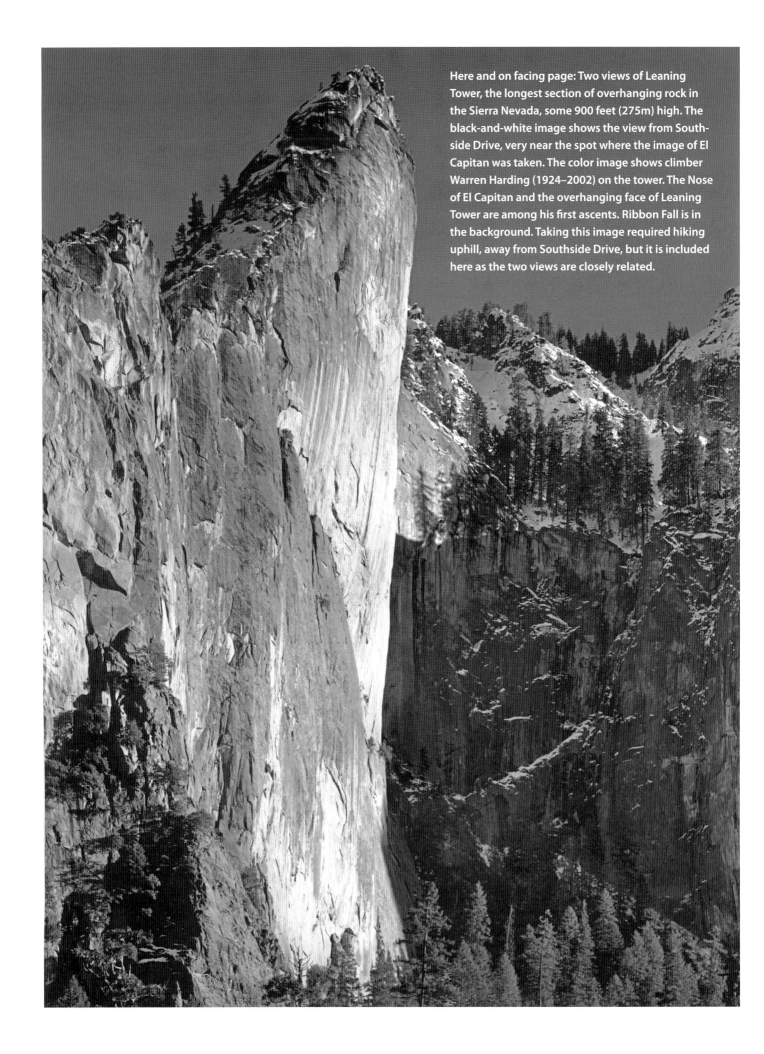

Here and on facing page: Two views of Leaning Tower, the longest section of overhanging rock in the Sierra Nevada, some 900 feet (275m) high. The black-and-white image shows the view from Southside Drive, very near the spot where the image of El Capitan was taken. The color image shows climber Warren Harding (1924–2002) on the tower. The Nose of El Capitan and the overhanging face of Leaning Tower are among his first ascents. Ribbon Fall is in the background. Taking this image required hiking uphill, away from Southside Drive, but it is included here as the two views are closely related.

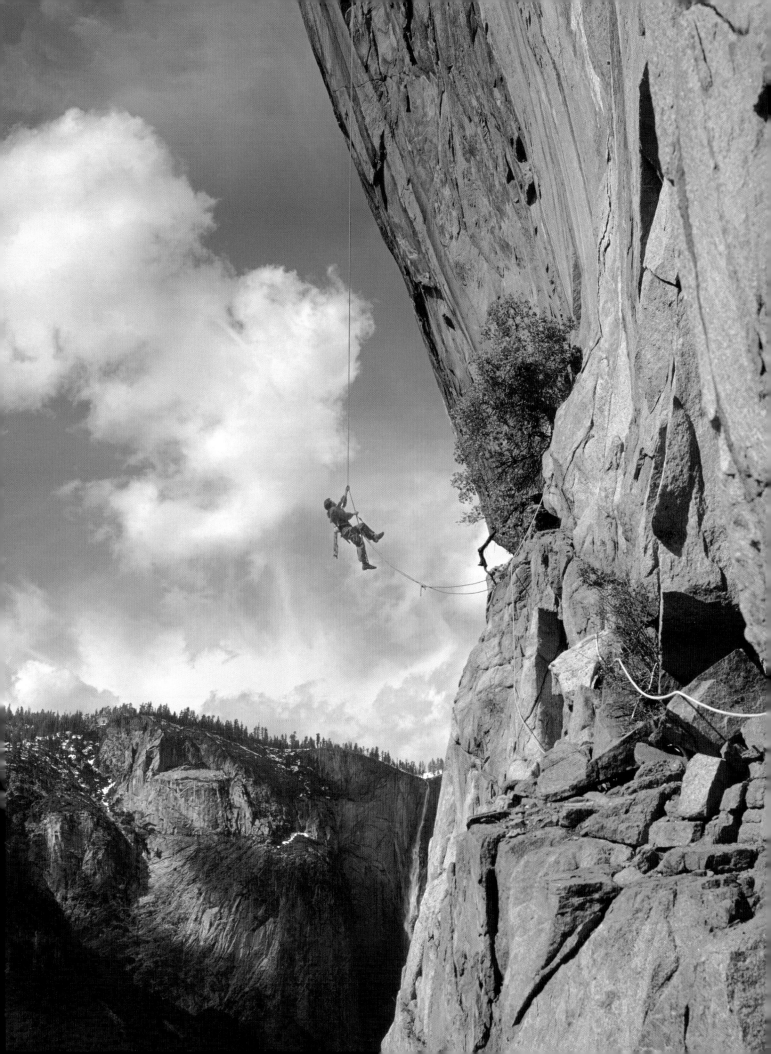

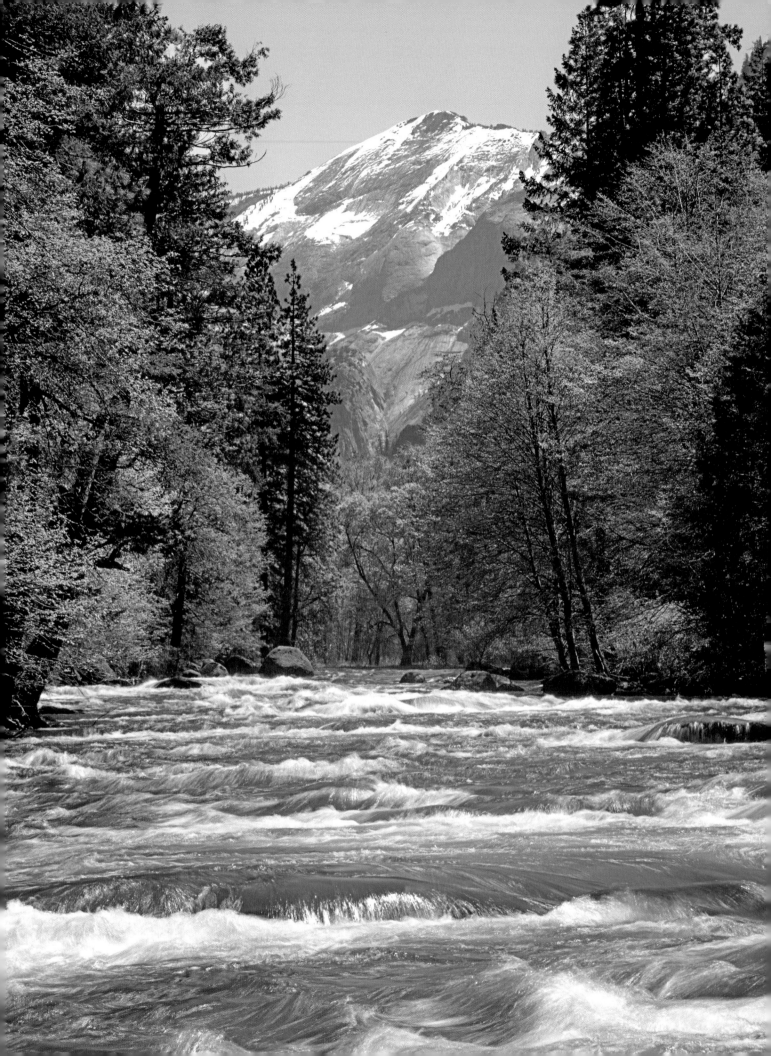

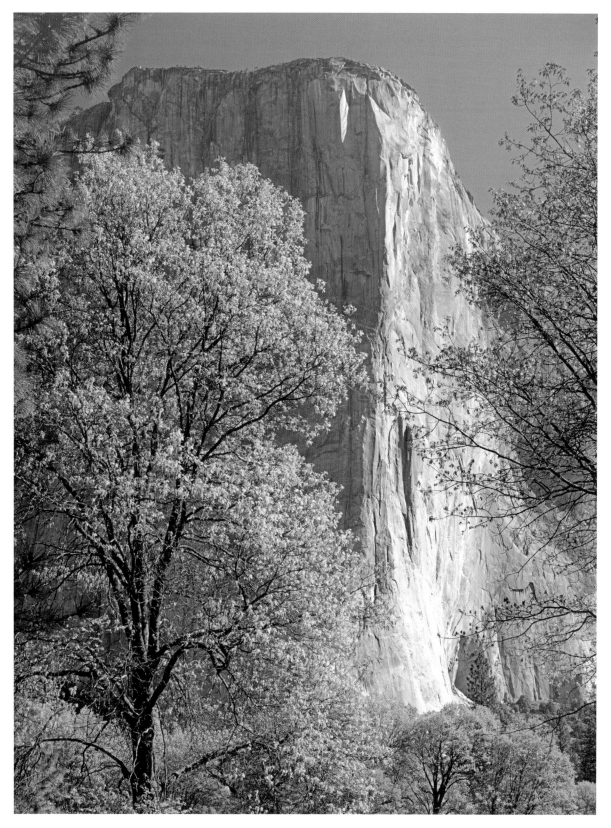

Above: When you are underneath the Cathedral Rocks, you can see El Capitan and the Merced River through the trees. This area affords fine views. In this image, oak trees in spring are highlighted against El Capitan. The Nose divides the sunlit southwest face from the shaded southeast face.

Facing page: You will see this view, captured in springtime, just as you start to pass underneath the Cathedral Rocks, if you keep a sharp outlook on the Merced River to your left. Clouds Rest, 9,926 feet (3,025m), rises in the distance almost 5,000 feet above this point.

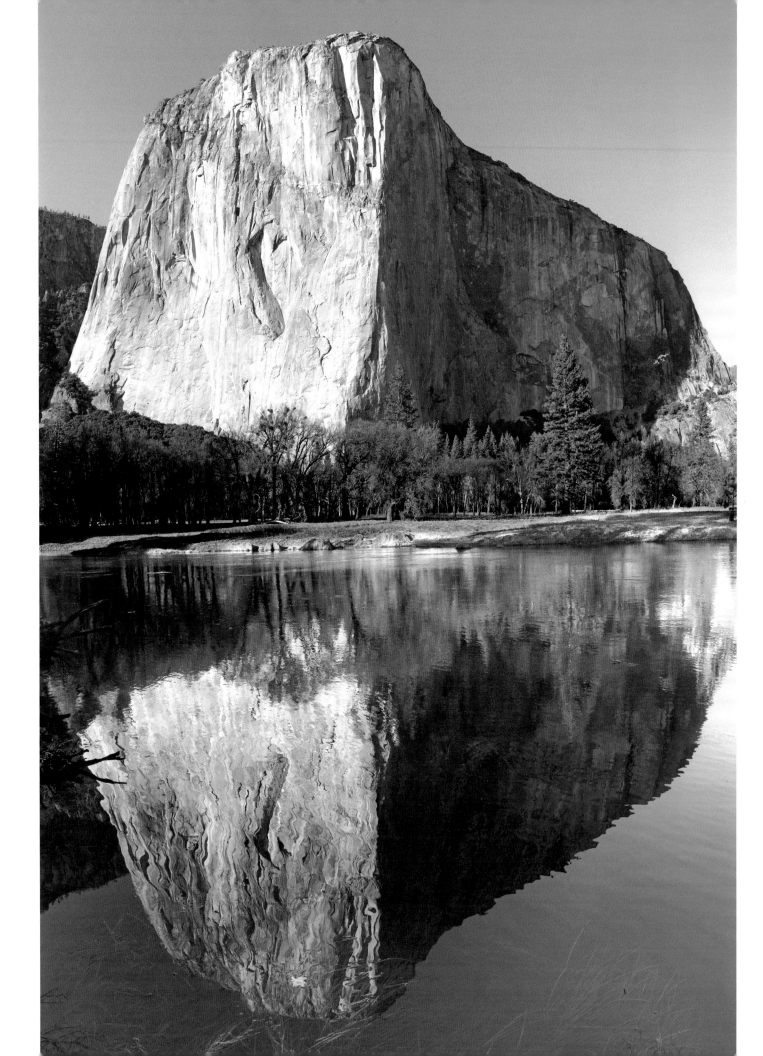

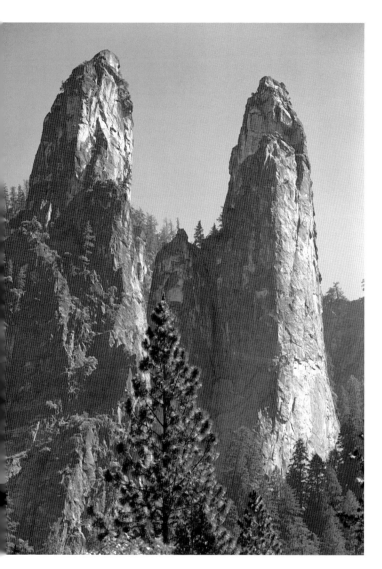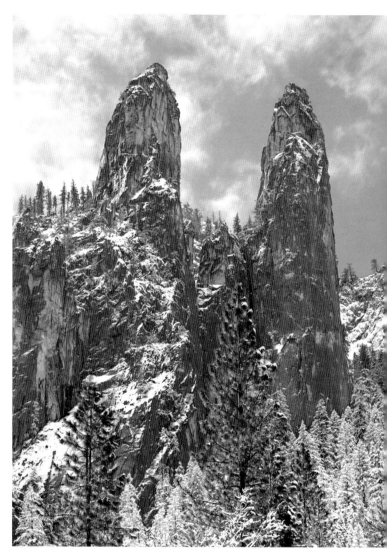

Above: These two views of the Cathedral Spires were taken from a pullout near the junction of Southside Drive and the road over the Merced River at El Capitan Bridge. The summer view highlights the very steep northwest face of the Higher Cathedral Spire, on the right. The other view shows the spires in winter dress.

Facing page: This early spring reflection view, taken on the Merced River near Cathedral Rocks, is possible only when water flow in the river is very low. This super wide-angle shot was created by stitching together six separate digital images.

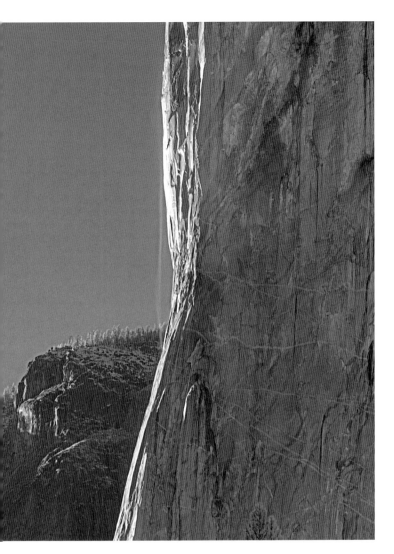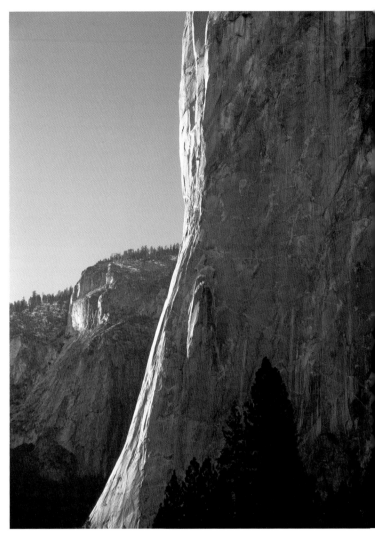

Above: These two views, taken from El Capitan viewpoint on Southside Drive, show different aspects of the Nose of El Capitan. The black-and-white image shows the thin ribbon of the rare El Capitan Nose Waterfall, only active in spring in years of very heavy winter snowfall. The color image shows a sunset on the Nose, obtainable only in the fall and winter months when days are short. At that time of year, the sun sets much farther to the south so it doesn't go behind a hill at sunset but shines on the Nose until the very last light.

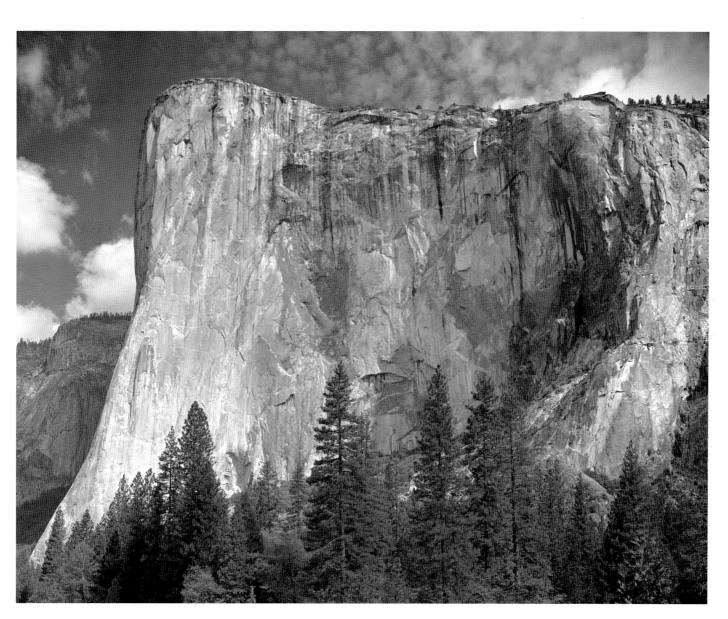

Above: This view of the southeast face of El Capitan was captured at El Capitan viewpoint.

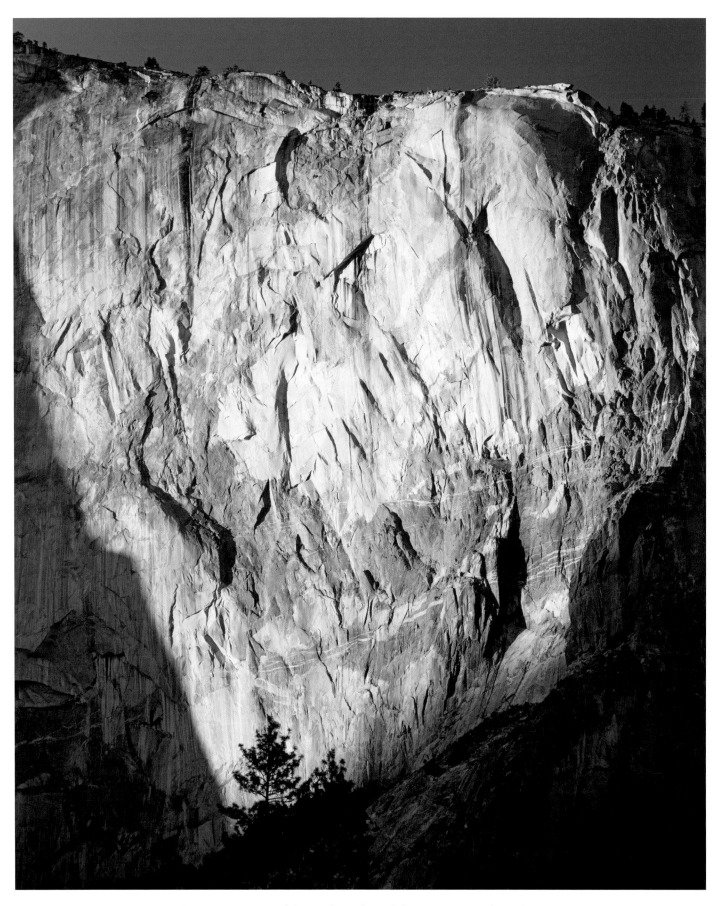

Above: A setting sun illuminates the eastern portion of the southeast face of El Capitan, as seen from El Capitan viewpoint. The east buttress is on the right.

Facing page: A very wide-angle view shows a winter reflection of El Capitan in the Merced River, as seen below El Capitan viewpoint.

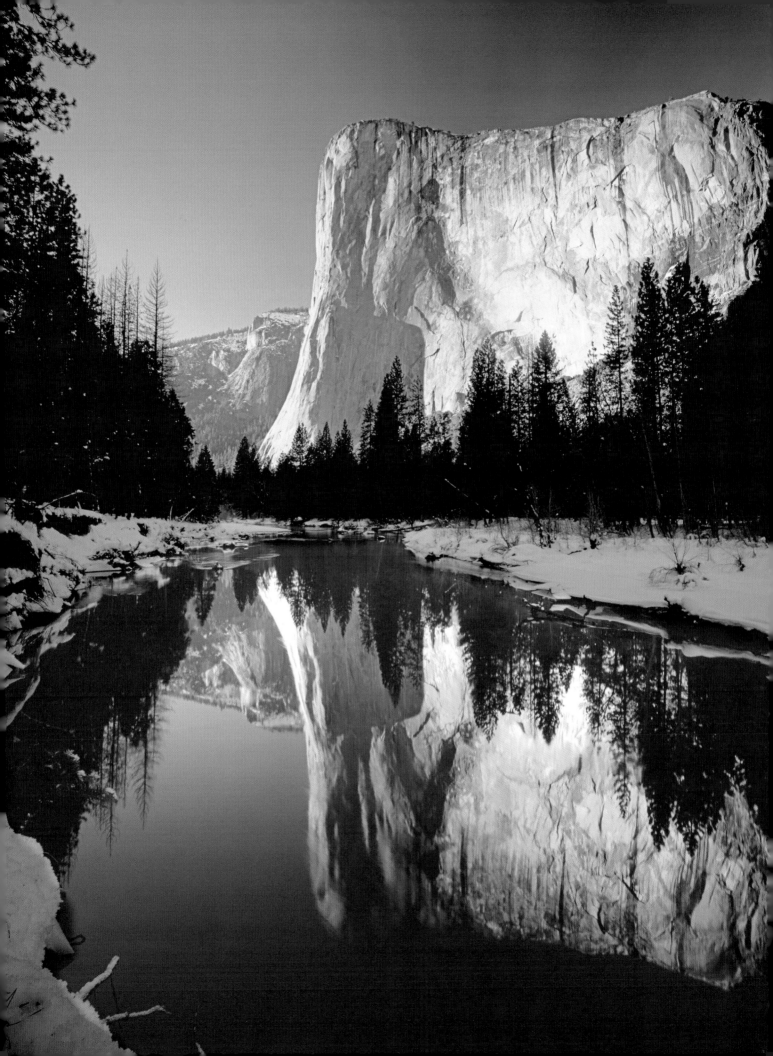

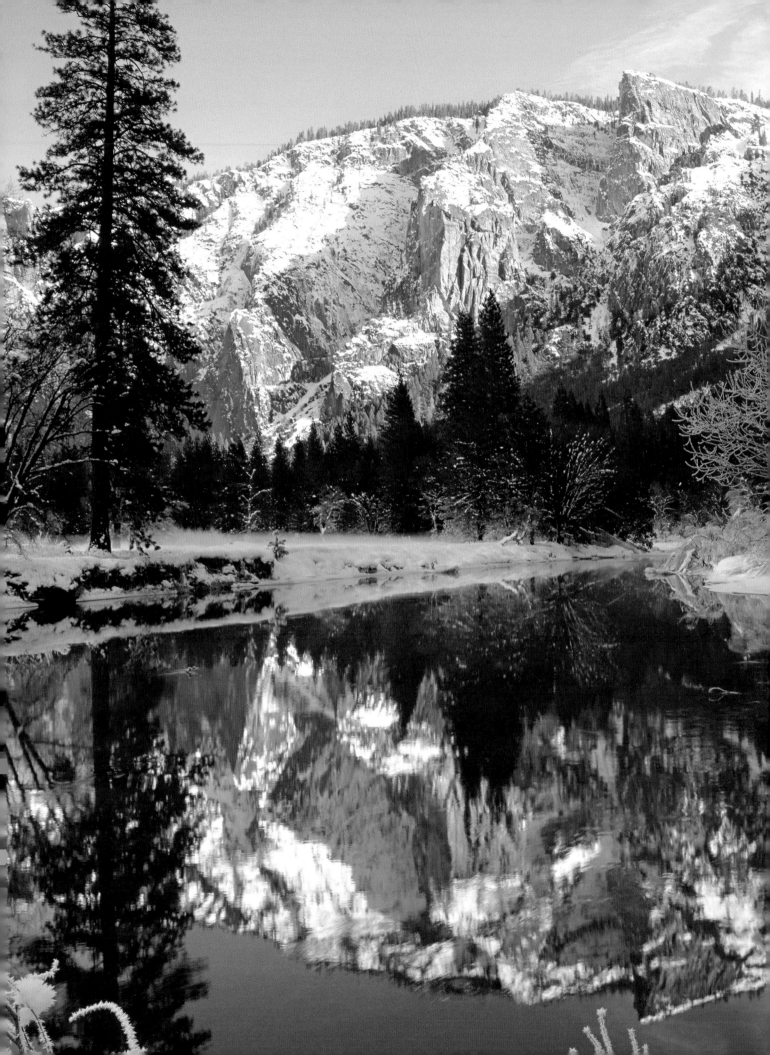

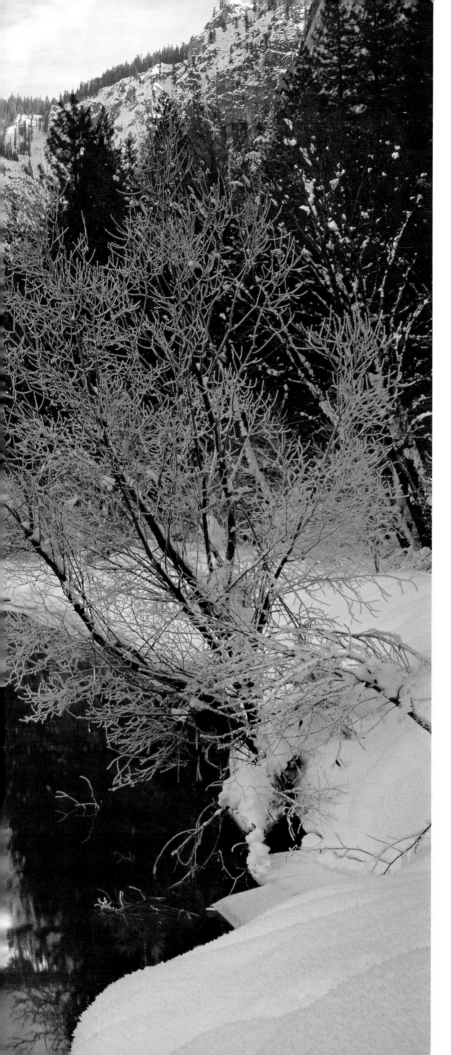

Another winter view, looking in the opposite direction (west) from El Capitan viewpoint, shows Taft Point, the pointy peak on the south rim of the valley, reflected on the Merced River.

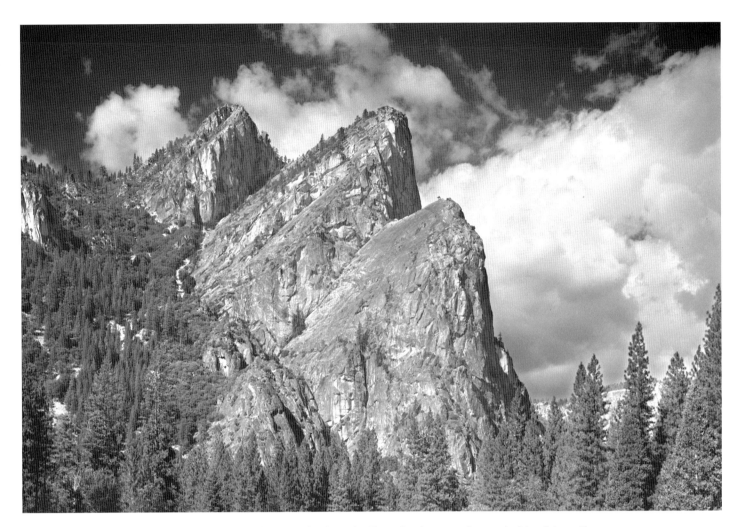

Above and facing page: These two photographs show the Three Brothers, on the north side of the valley, as seen from near Cathedral Beach. The highest brother is Eagle Peak, at 7,779 feet (2,371m). The southeastern faces of these peaks (the right-hand profiles) contain some very unstable rock. In 1987 a large rockfall off Middle Brother crashed across Northside Drive and closed it for several months, until the road could be cleared and was determined safe for travel again. The black-and-white image shows clouds over the peaks; the color image shows their reflections in the Merced River, with ice in the foreground.

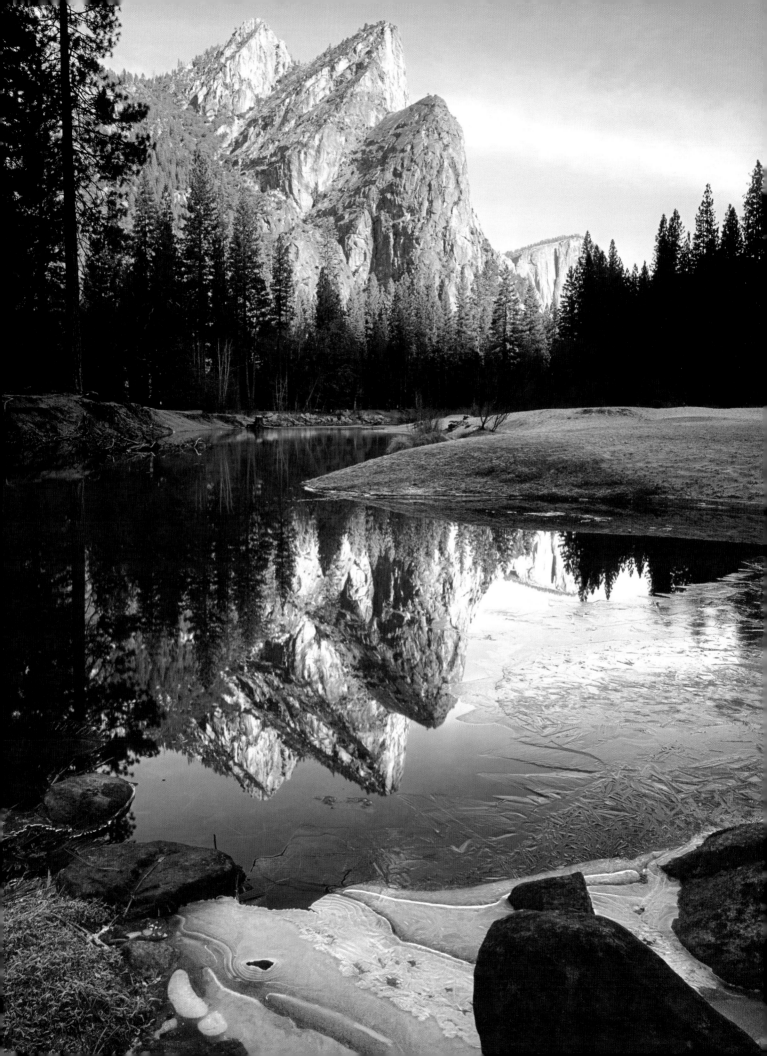

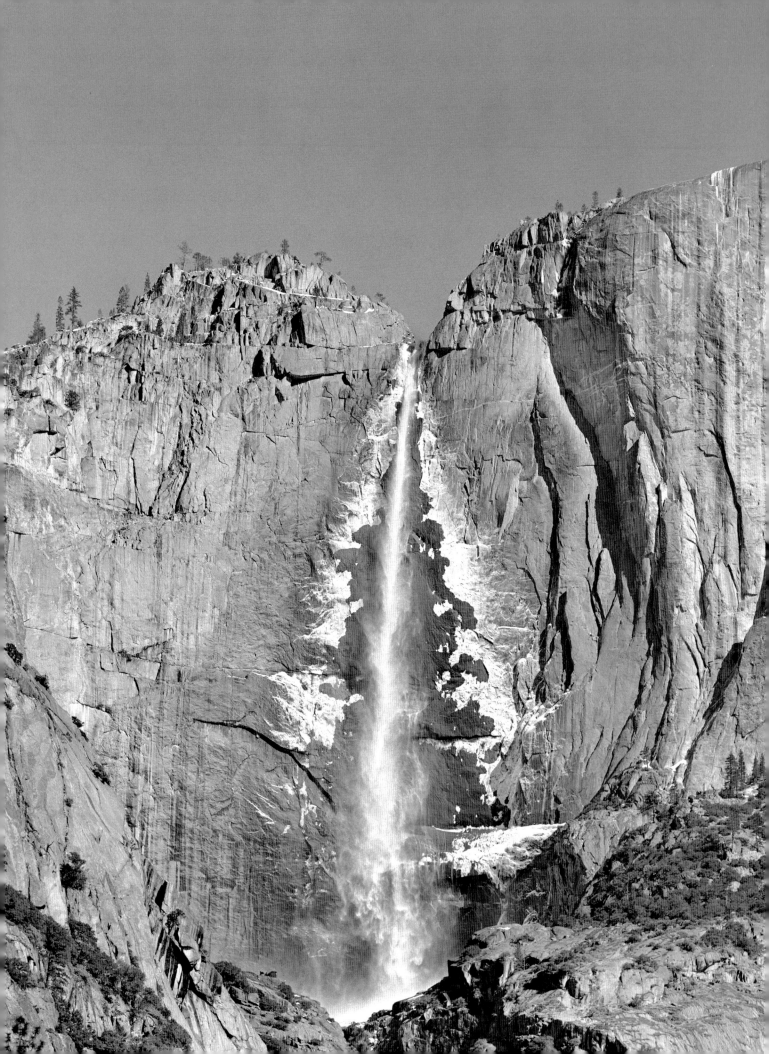

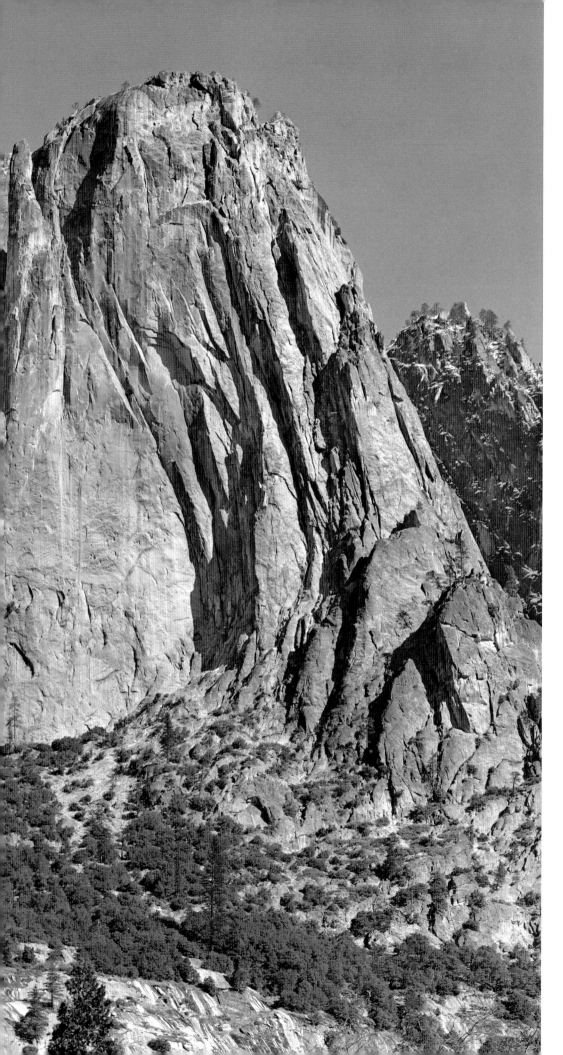

This early March view, taken somewhat west of the Sentinel Bridge, shows frost forming on the granite walls on both sides of Upper Yosemite Fall. The Lost Arrow and its shadow are at the upper right center of the frame, and Yosemite Point Buttress is on the right. At 2,425 feet (739m), Yosemite Falls (including Upper Yosemite Fall, Middle Yosemite Fall, and Lower Yosemite Fall) constitutes the highest free-leaping waterfall in North America.

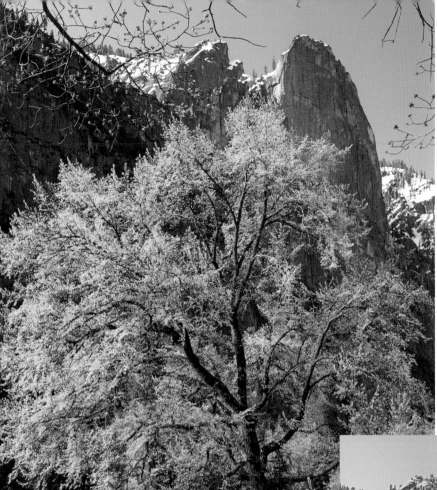

Above and right: These two views of Sentinel Rock, taken near the Yosemite Chapel along Southside Drive, show two different seasons on the rock: first, with the delicate green of oak leaves in spring, and second, with brilliant autumn colors.

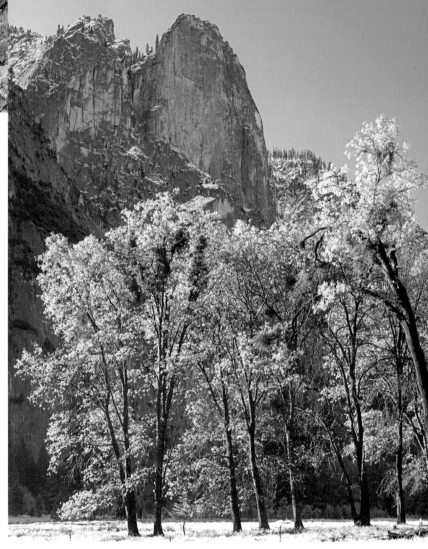

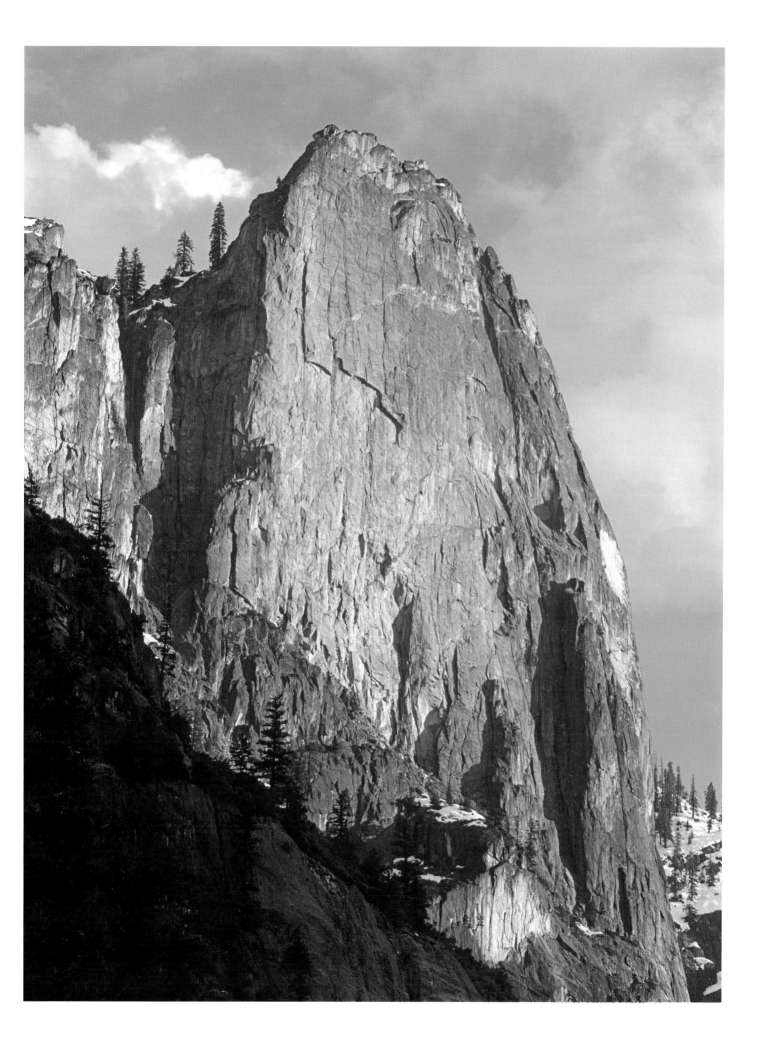

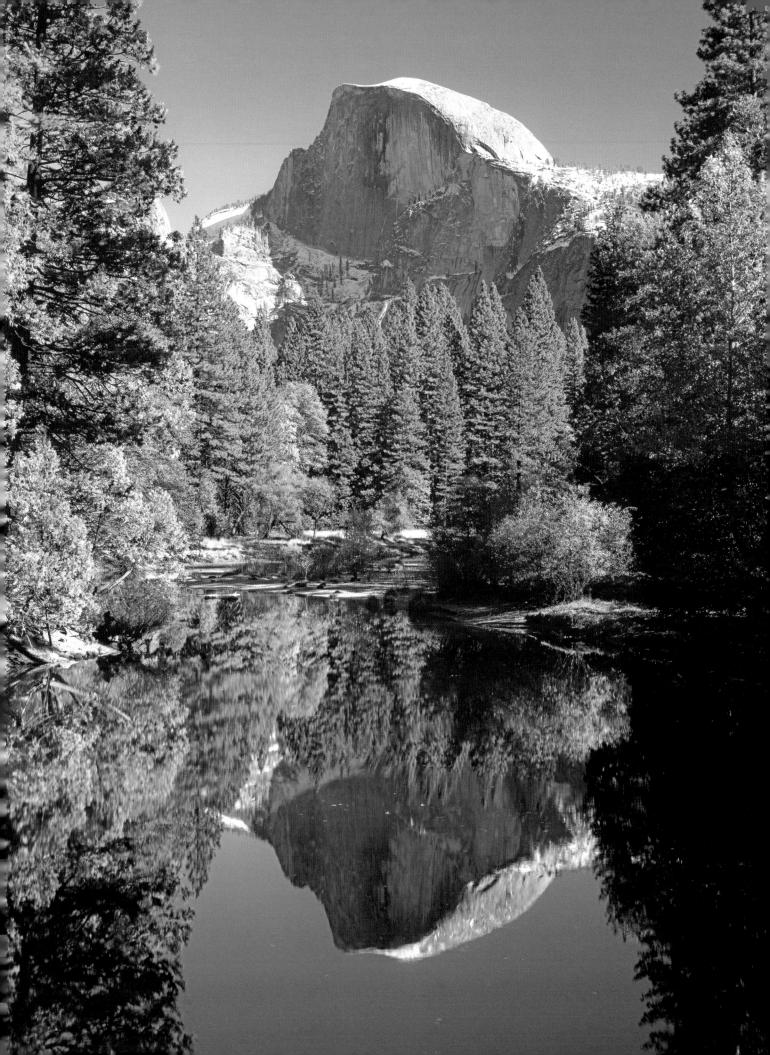

2

△△△

EAST OF
YOSEMITE VILLAGE

This section contains images taken close to the roads east of Yosemite Village. This includes Southside Drive from Sentinel Bridge to Curry Village, Northside Drive from Curry Village back to Yosemite Lodge, the side road to the Ahwahnee Hotel, and the road to Mirror Lake, which once was open to vehicle traffic and is now open only to shuttle busses, vehicles displaying disabled placards, bicyclists, and pedestrians. Iconic Yosemite formations, including Half Dome, Glacier Point, and the historic Ahwahnee Hotel, are focused on in this chapter.

Facing page: This view of Half Dome reflected into the Merced River, as seen from the Sentinel Bridge, was taken from one of the three most popular photo spots in Yosemite Valley. (The other two are Tunnel View and Valley View.) The still waters of autumn allow an almost perfect reflection. Although technically this viewpoint is not east of Yosemite Village, Half Dome most certainly is.

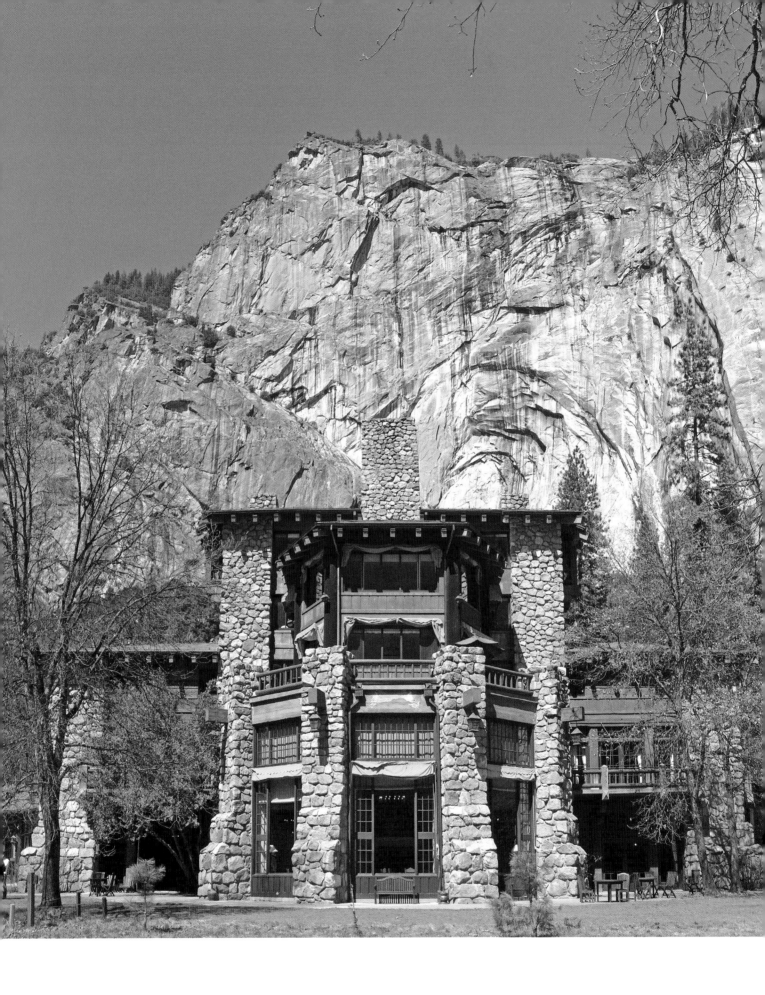

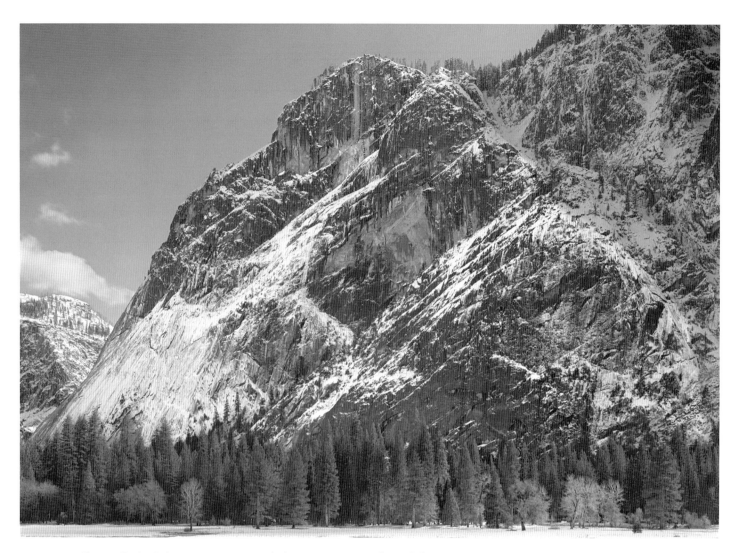

Above: Glacier Point, upper center, and Glacier Point Apron, lower left, as seen after a snowstorm. This view is from the large meadow east of Yosemite Village and west of the Ahwahnee Hotel. Glacier Point used to be famous for the summer evening firefalls, which were halted by the National Park Service in 1968 due to environmental concerns. Firefalls are described in more detail in the introduction to the Glacier Point Road chapter.

Facing page: The Ahwahnee Hotel, a National Historical Landmark, is shown in its setting below the granite formation known as the Rhombus. The rock is somewhat unstable here. A rockfall in 2009 spilled large boulders close to the parking lot, and a rock chip actually damaged the windshield of a car in the lot. The Ahwahnee opened in 1927; during World War II it was temporarily converted into a U.S. Navy Convalescent Hospital. These days it offers park visitors an option for fine dining and lodging in the valley.

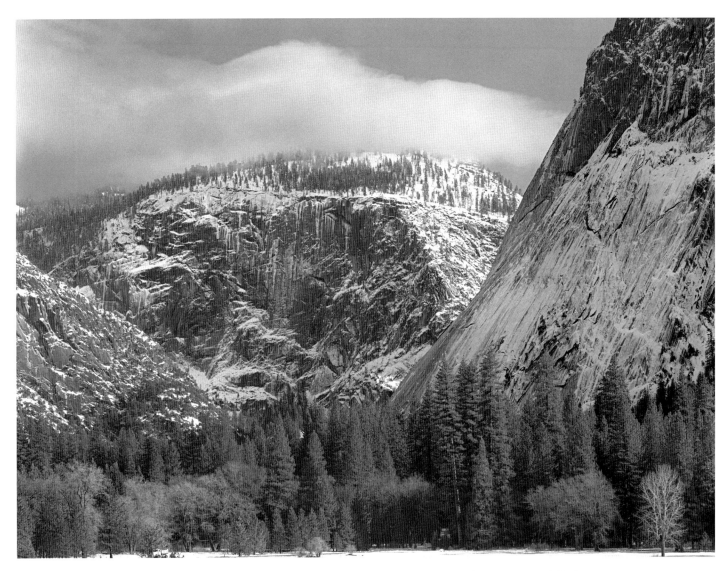

Above: The John Muir Trail, which starts at Happy Isles, passes directly beneath the Panorama Cliff. Glacier Point Apron is on the right. This photo was taken from the large meadow east of Yosemite Village and west of the Ahwahnee Hotel.

Facing page: Glacier Point Apron and Yosemite Falls as seen from Sierra Point. The trail to Sierra Point was closed in the 1970s due to rockfall, but Sierra Point can still be reached if you know where to go. Rockfall danger continues to loom below Glacier Point. Separate incidents in 1996 and 1999 killed two people and injured many more, destroyed portions of the forest below Glacier Point, and damaged structures at Curry Village.

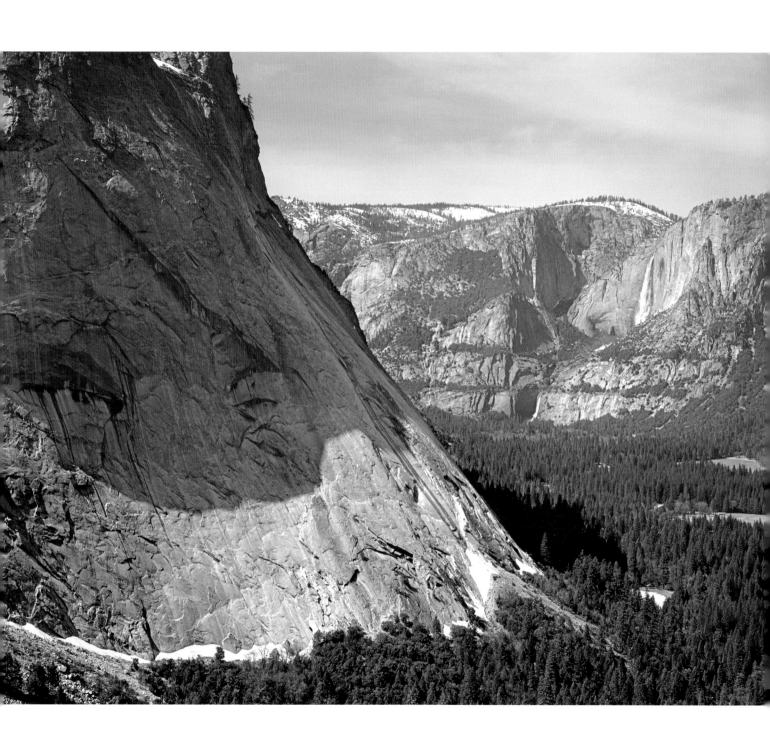

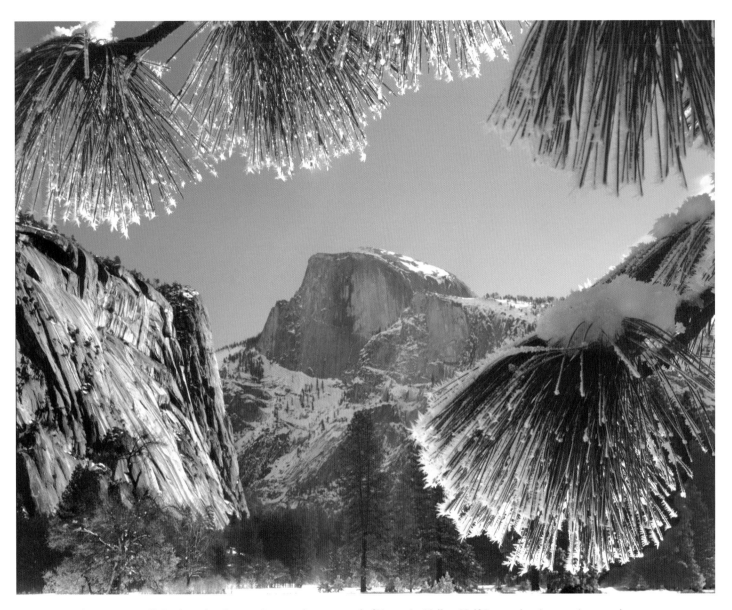

Above: Just as El Capitan dominates views at the west end of Yosemite Valley, Half Dome dominates views at the east end. This January view was taken from the large meadow east of Yosemite Village and west of the Ahwahnee Hotel. The Royal Arches and Washington Column are on the left.

Facing page: This late autumn view of Half Dome after a light snowfall was taken just west of the very large meadow to the north of Curry Village (also called Camp Curry).

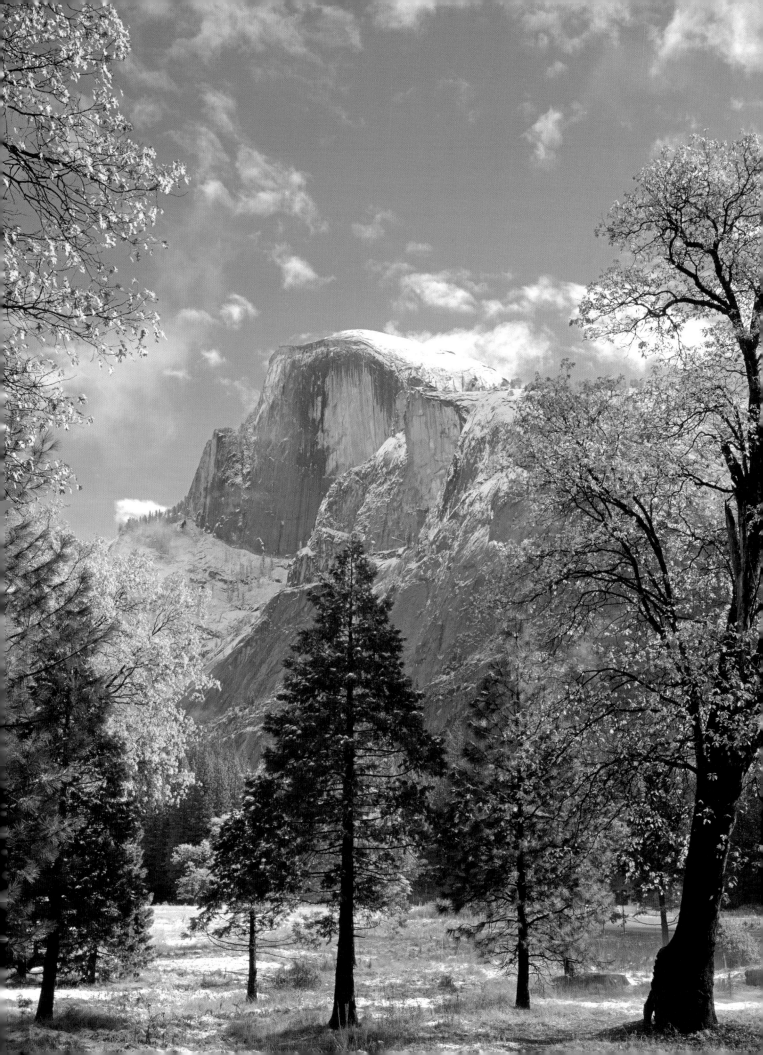

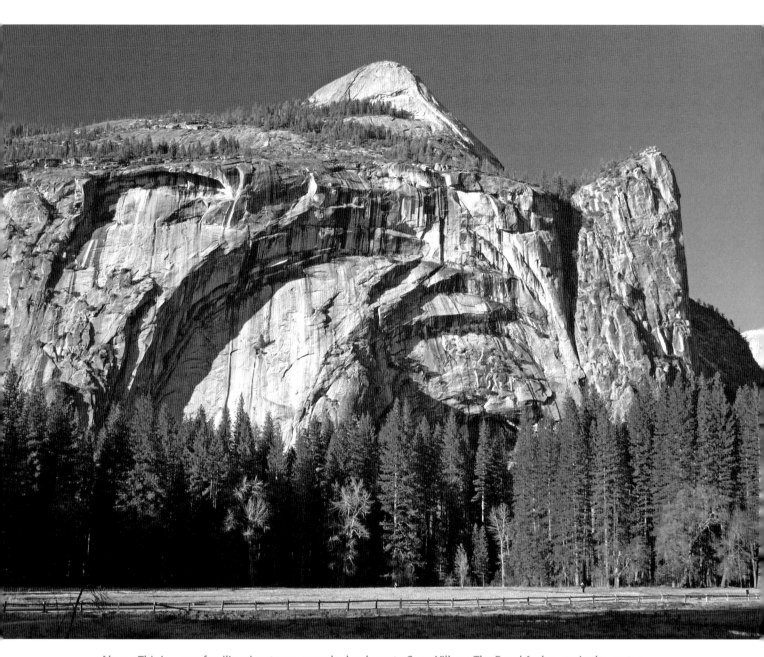

Above: This is a very familiar view to anyone who has been to Curry Village. The Royal Arches are in the center, Washington Column is on the right, and North Dome is at the top. The large open meadow at the bottom is just north of the village.

Facing page: This classic black-and-white image of the northwest face of Half Dome (a telephoto shot) was taken right next to the road at the edge of the large meadow north of Camp Curry.

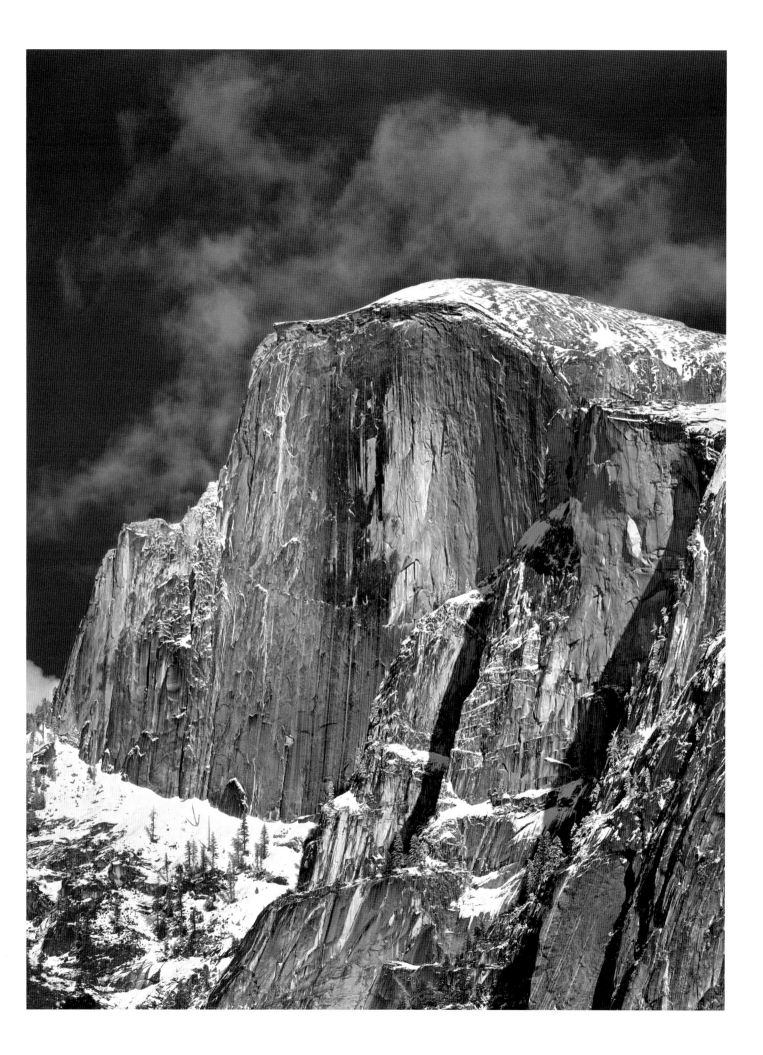

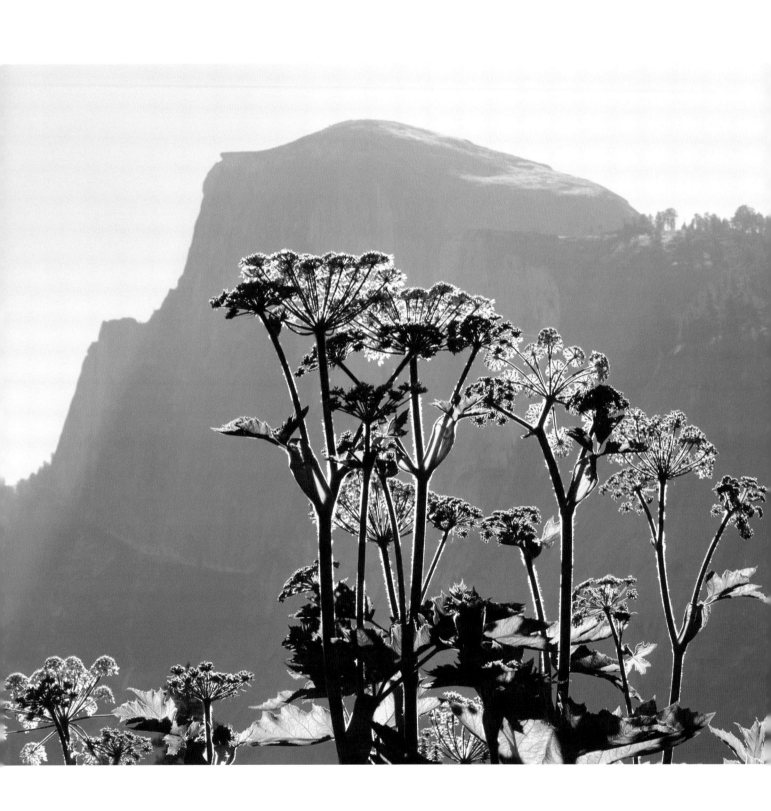

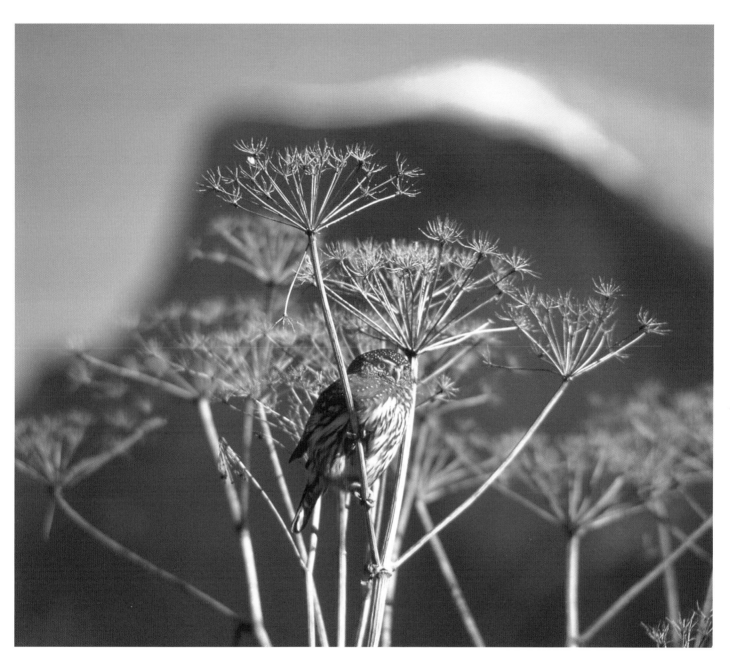

Facing page and above: These two views utilize the shaded Half Dome to highlight the foreground. The first shot shows cow parsnip, *Heracleum lanatum*. The second shot shows the northern pygmy owl, *Glaucidium gnoma*, perched in cow parsnip. Both views were taken from the same Camp Curry meadow, which offers a myriad of perfect picture possibilities.

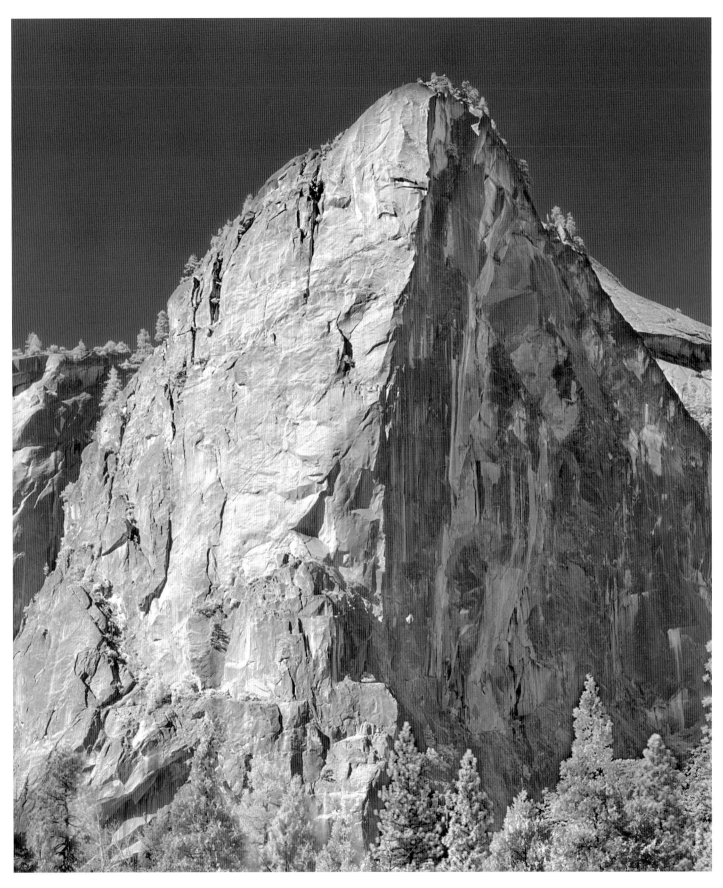

Above and facing page: At one time, the short road to Mirror Lake was open to all vehicles. It is now open only to shuttle buses and vehicles displaying handicapped placards (as well as bicycle and foot traffic). Both of these views of Washington Column were taken from along the Mirror Lake road. The first shows the south face of the column in the sun, the overhanging east face in the shade, and the Prow dividing the two. The second, taken farther along the road, shows details in the rock of the overhanging east face, one of Yosemite's more challenging rock climbs.

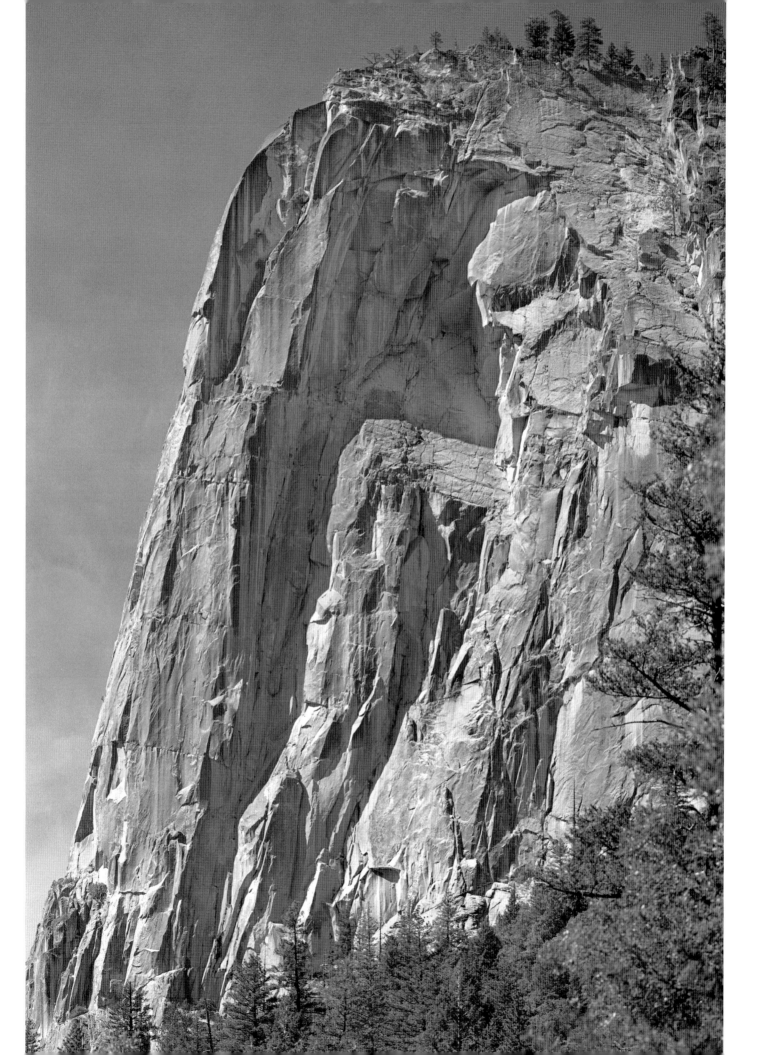

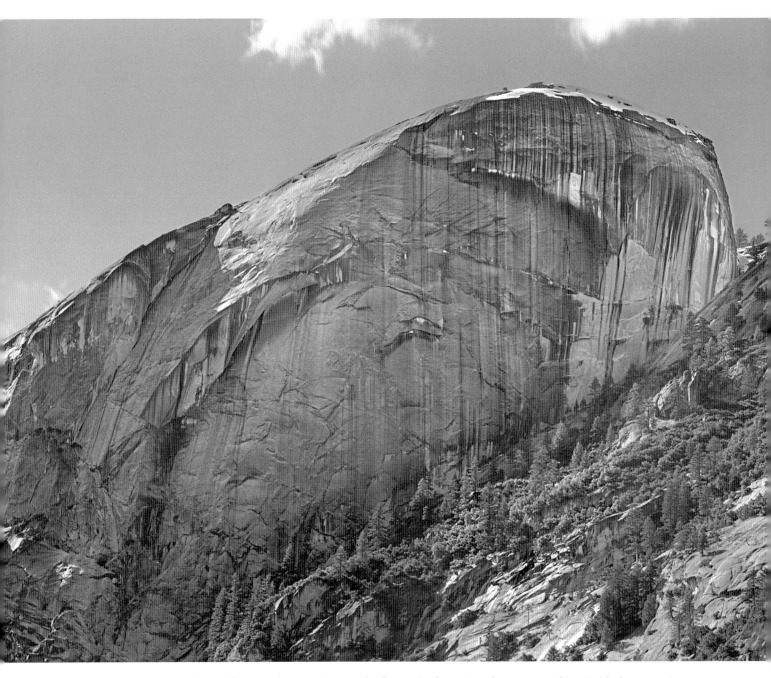

As one hikes into the wilderness of Tenaya Canyon, the first major formation that appears above (with the exception of Half Dome) is Basket Dome, located on the north side of the canyon. This view shows Basket Dome's east face.

▲▲▲

T E N A Y A C A N Y O N

Tenaya Canyon is a wilderness canyon. It is accessed from Mirror Lake by hiking a short distance on a loop trail into the canyon. The trail ends in little more than a mile, with an extension that climbs numerous switchbacks up Snow Creek and joins other trails leading to the Tioga Pass Road and Tuolumne Meadows. A portion of the southern leg of the loop was buried by a major rockfall from Ahwiyah Point (below Half Dome) on March 28, 2009, the largest rockfall in Yosemite Valley since the Middle Brother rockfall of 1987. This portion of the loop trail is now permanently closed. A rudimentary unmaintained trail continues for a short distance beyond the end of the maintained trail, but this path (such as it is) soon disappears in rock slides and brush.

This section contains images of Tenaya Canyon and the peaks above. The photos are shown in order of progression up the canyon; some are taken in the canyon and others from above, looking into the canyon.

Interestingly, Mirror Lake itself was the result of a mega-rockfall thousands of years ago that peeled off the north side below North Dome, creating a natural dam. The valley behind gradually filled with water. At its maximum extent, the lake was about 1.25 miles long (2km). This original lake gradually filled up with silt, and the current Mirror Lake is the small remnant that remains. Natural processes will result in the disappearance of this remnant as well, unless another enormous rockfall creates another dam.

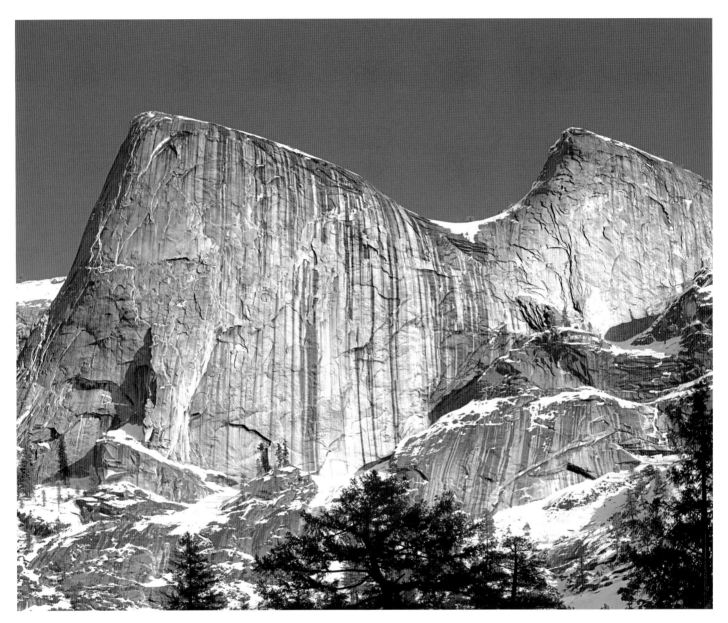

Above: Taken from almost the same location in Tenaya Canyon as the photo of Basket Dome, this image shows the highly aesthetic Quarter Domes, which tower above the south side of the canyon.

Facing page: This view, taken from the summit of Half Dome, shows the south side of Tenaya Canyon. The major feature is the approximately 4,000 vertical feet (1,220m) of granite slabs leading to the summit of Clouds Rest, at 9,926 feet (3,025m). Quarter Domes appear at right center, below Clouds Rest.

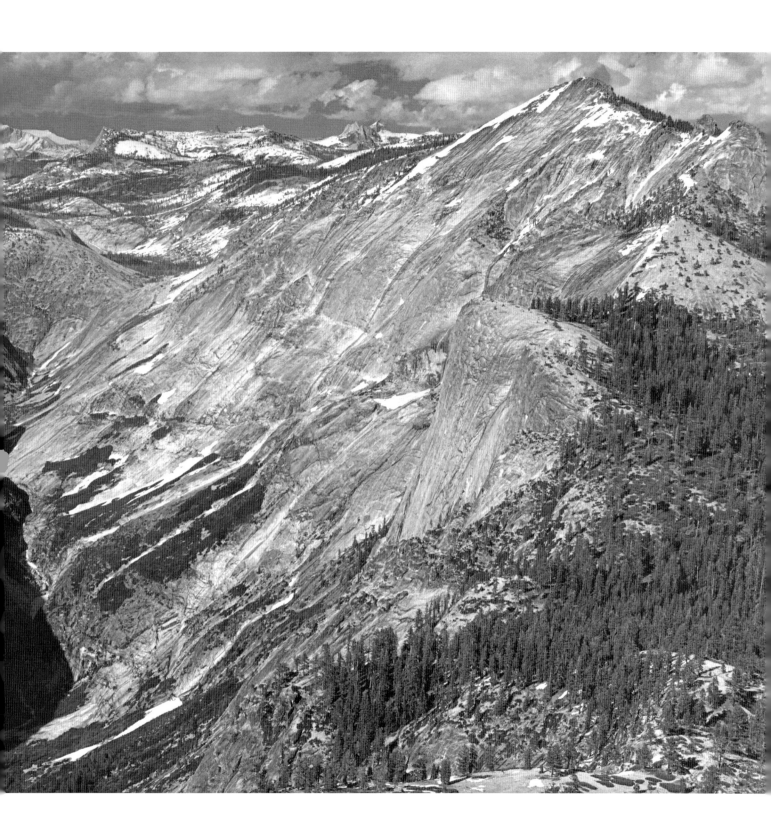

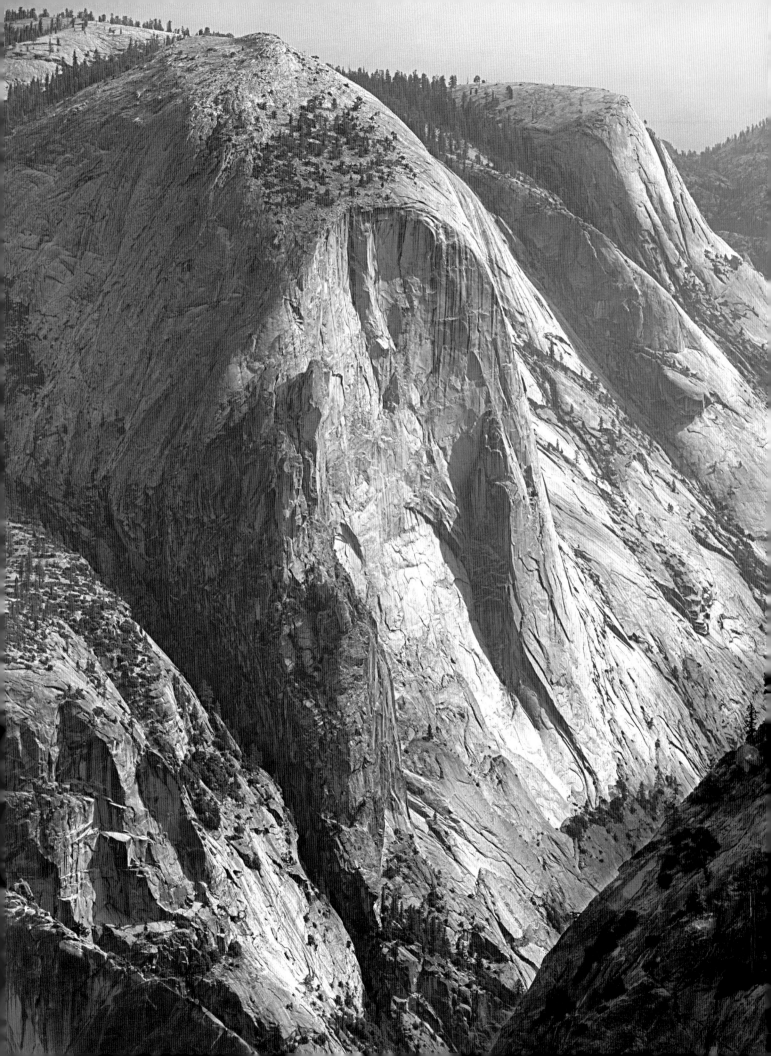

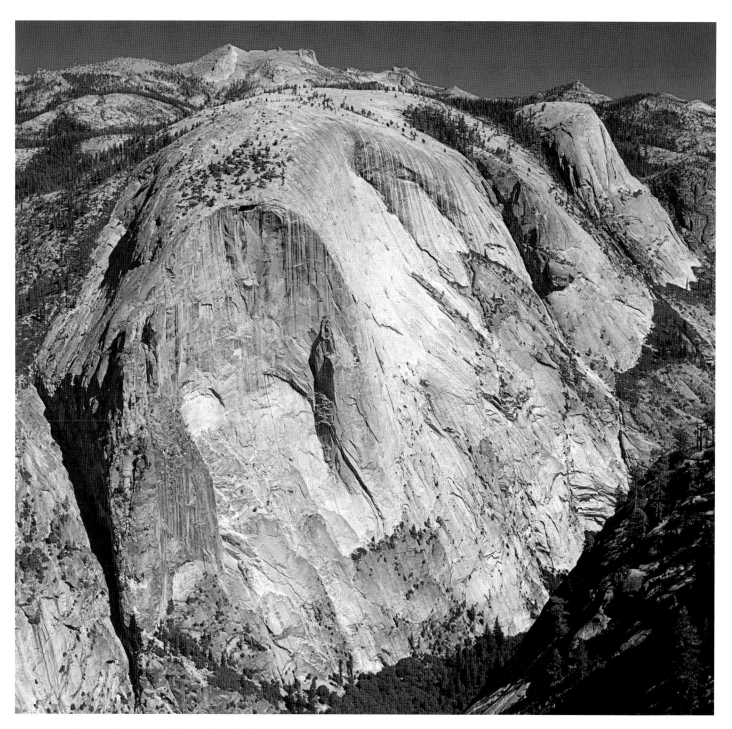

Above: This view of Mount Watkins from Half Dome gives a better idea of the extent of the south face of Mount Watkins. Mount Hoffman, 10,850 feet (3,307m), rises in the distance, and YaSoo Dome is at the upper right.

Facing page: The massive rock form of Mount Watkins rises farther up Tenaya Canyon. This view is from the Diving Board, at the base of the southwest face of Half Dome. YaSoo Dome appears at the upper right.

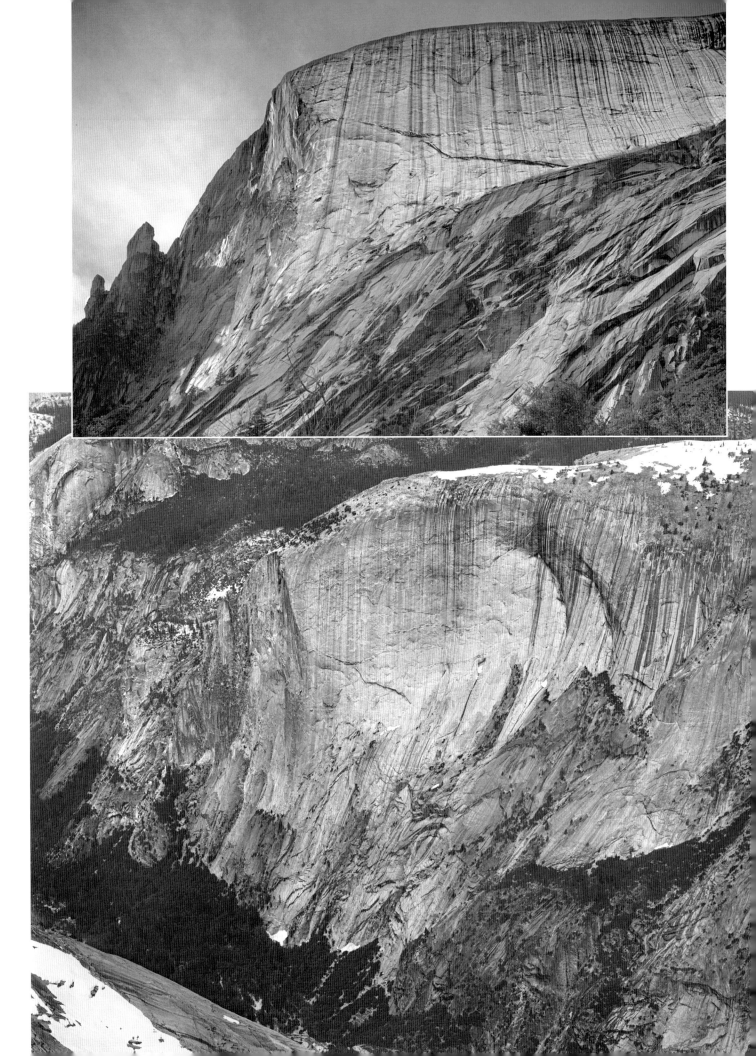

Facing page, top: This view, taken in the upper reaches of Tenaya Canyon, highlights the water streaks on the southeast face of massive Mount Watkins.

Below: A 3-mile-wide (4.8km) swath of granite on the north side of Tenaya Canyon is shown in this image. The view, taken from the top of Clouds Rest, captures what is certainly one of the widest expanses of solid granite in the Sierra Nevada. The massive Mount Watkins is at left center, YaSoo Dome at right center, and Pywiack Cascade at the right edge. Basket Dome is at the upper left corner. This remarkable panorama was created by scanning two 4 x 5 black-and-white negatives and then digitally stitching them together.

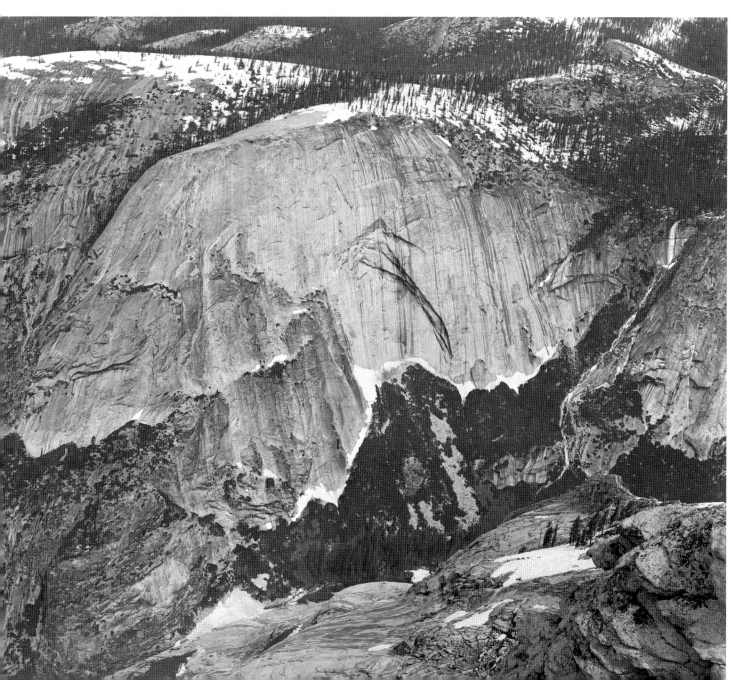

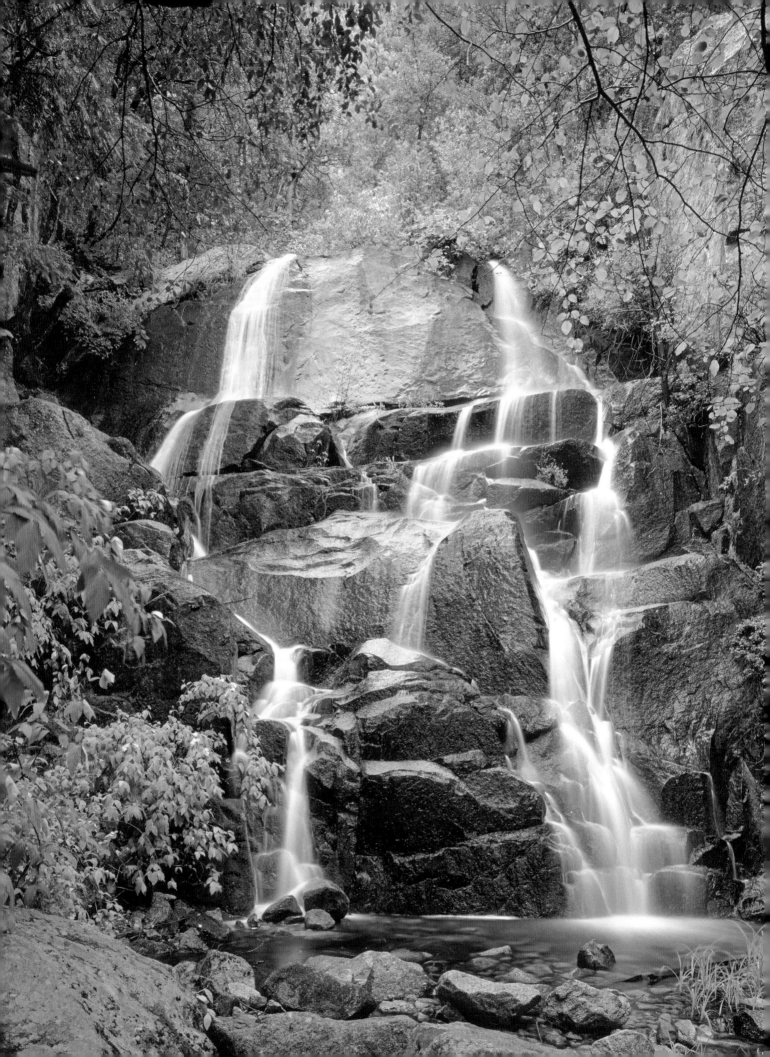

MISCELLANEOUS
VIEWS IN
THE VALLEY

This section contains those views in Yosemite Valley that really don't fit well into any other category. They include rock and water (and ice), rock and fall foliage, rock and trees, and an amusing portrait.

Facing page: A small lovely waterfall pours over granite rock near Cascade Falls, which is located near the El Portal entrance to Yosemite Valley.

Below: Snow-covered granite boulders in the Merced River on a cold January morning.

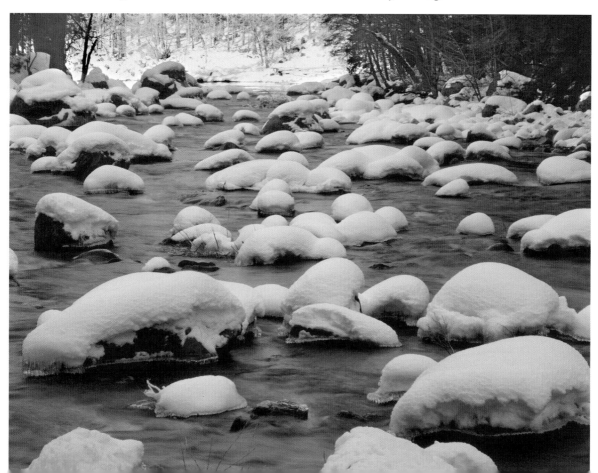

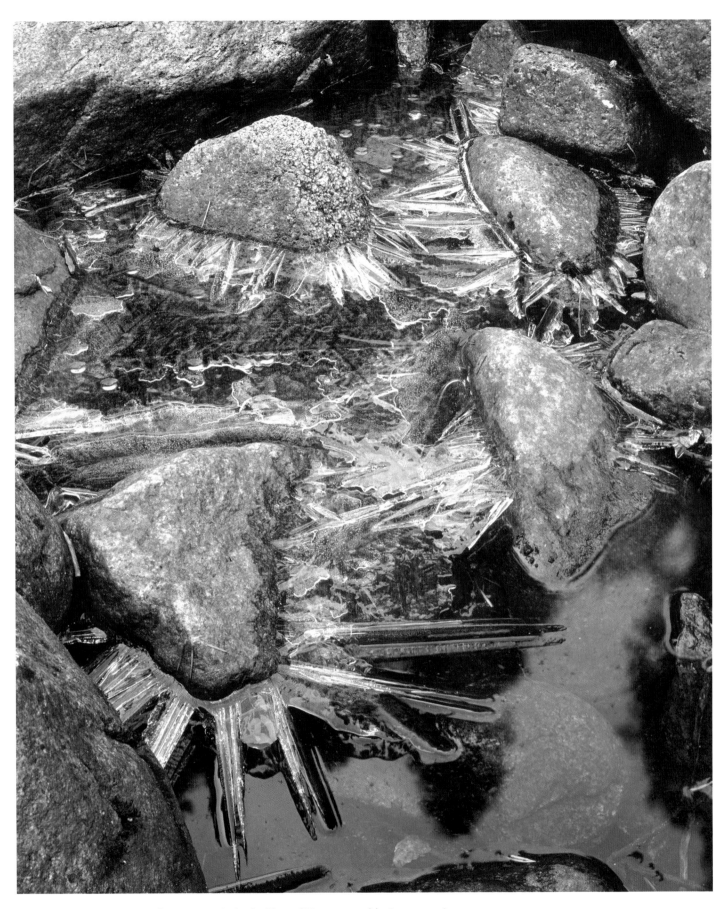

Above: Ice crystals encase rocks in the Merced River on a cold winter morning.

Facing page: Granite boulders and the foliage of bigleaf maple trees, *Acer macrophyllum,* on the floor of Yosemite Valley.

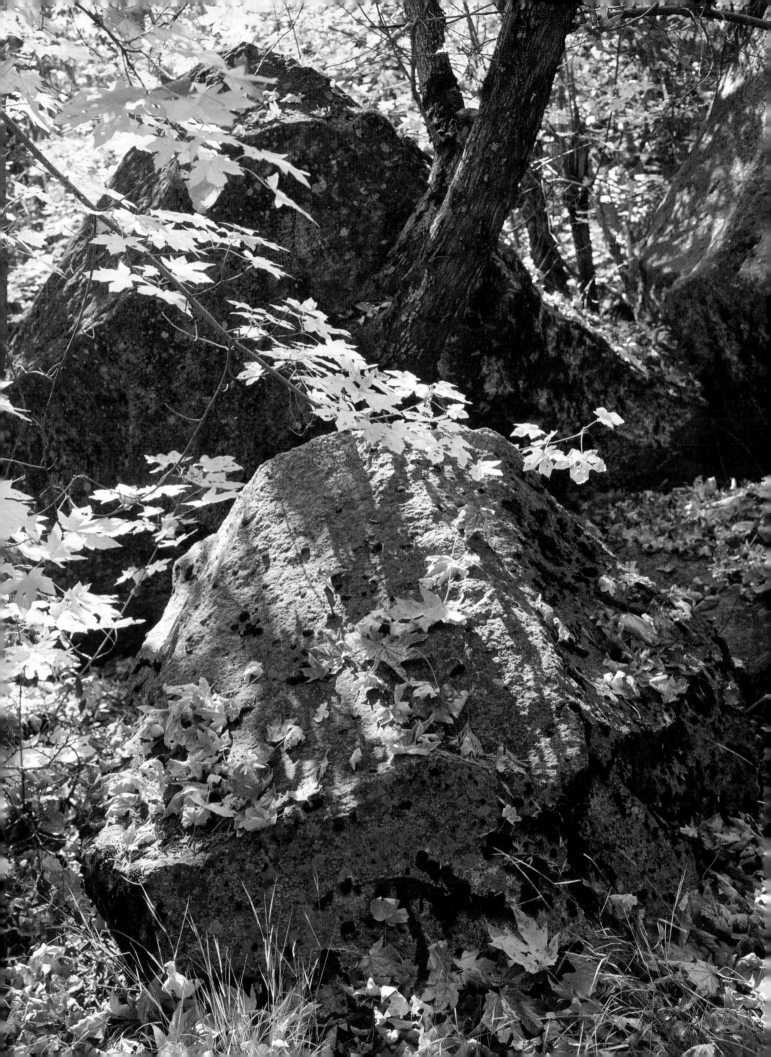

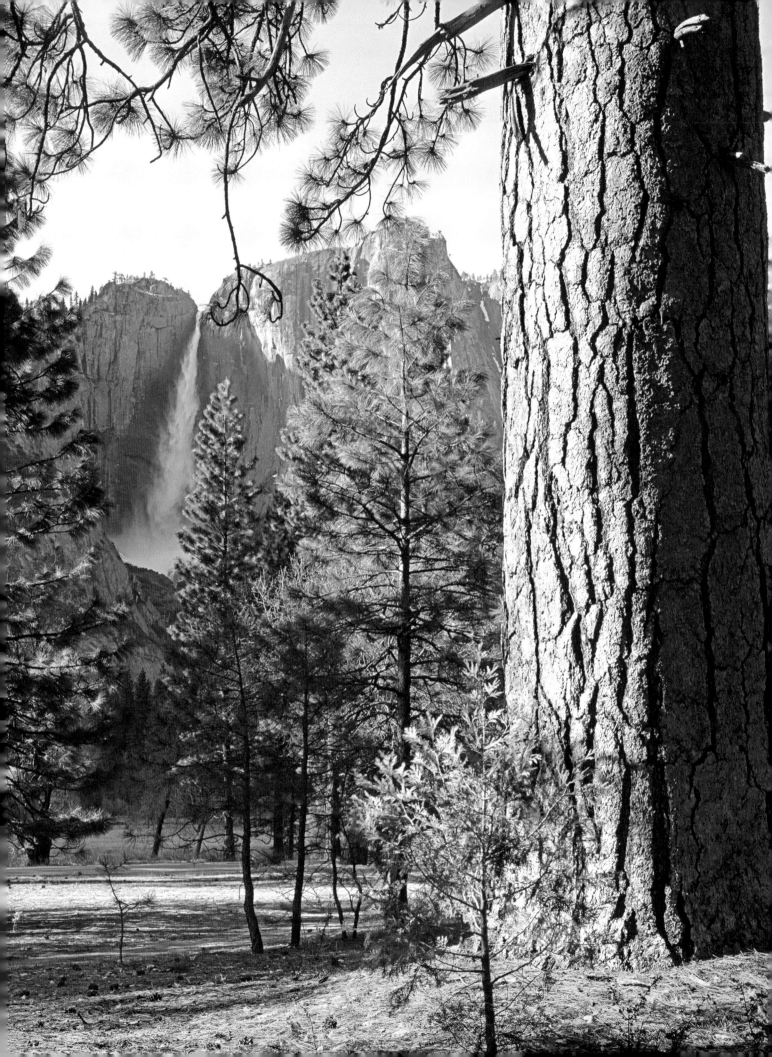

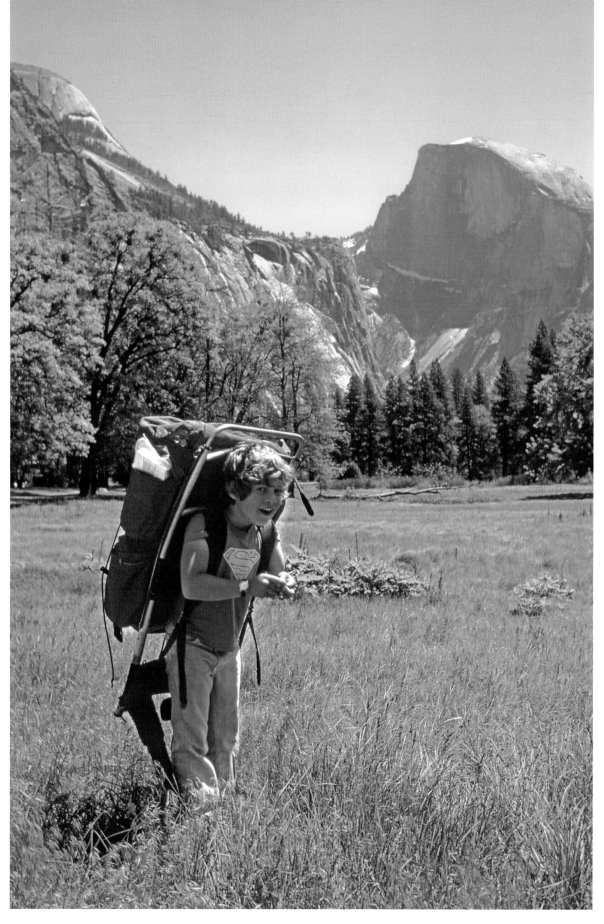

Above: Little boy, big pack! My son Matthew, at about age six, hefts a load in Yosemite Valley with Half Dome as a backdrop. It was actually my pack, full of 4 x 5 camera equipment.

Facing page: A ponderosa pine tree frames a scene of granite rock walls and Upper Yosemite Fall.

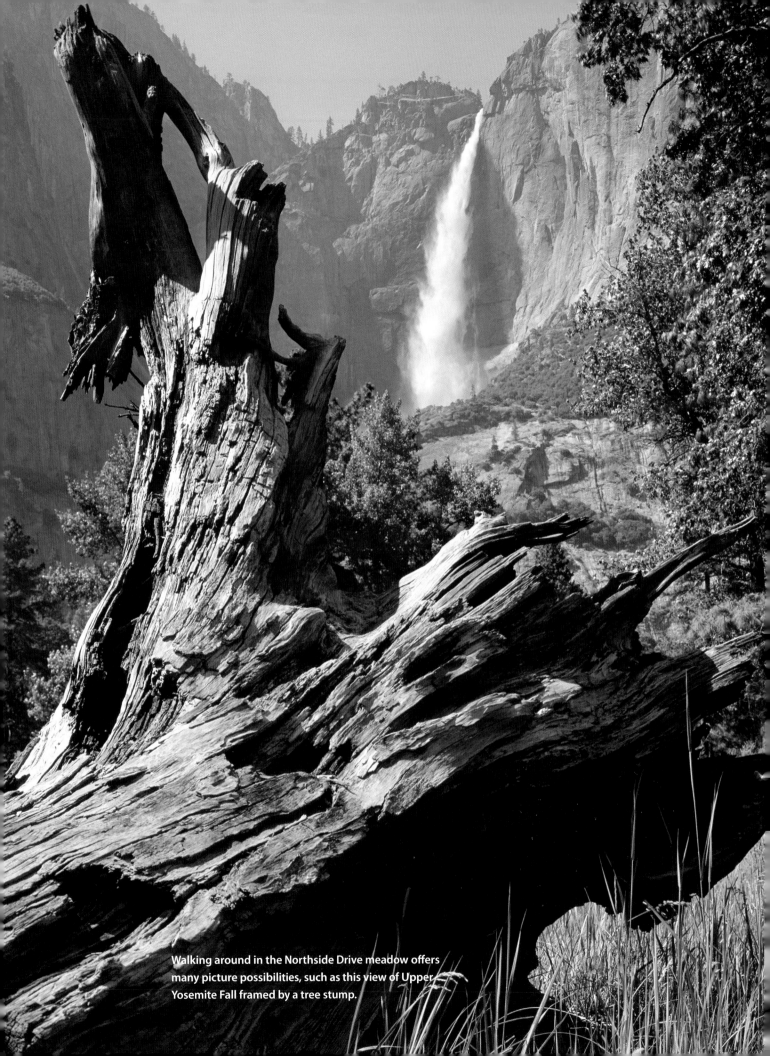

Walking around in the Northside Drive meadow offers many picture possibilities, such as this view of Upper Yosemite Fall framed by a tree stump.

5

N O R T H S I D E D R I V E

This section contains images taken along Northside Drive of formations in the order of their appearance as you travel from Yosemite Village toward the west end of Yosemite Valley. Some formations, like El Capitan and the Cathedral Rocks, have portraits in the Southside Drive chapter, but the perspective from this side of the valley is different. Views of Yosemite Falls, Horsetail Falls, and Sentinel Rock are also presented here.

Below: This picture was taken in a meadow on the south side of Northside Drive between Yosemite Village and Yosemite Lodge. Both Upper Yosemite Fall and a portion of Lower Yosemite Fall, surrounded by granite walls, are shown. There is something very unusual about this picture. See if you can guess what it is. The answer appears on page 68.

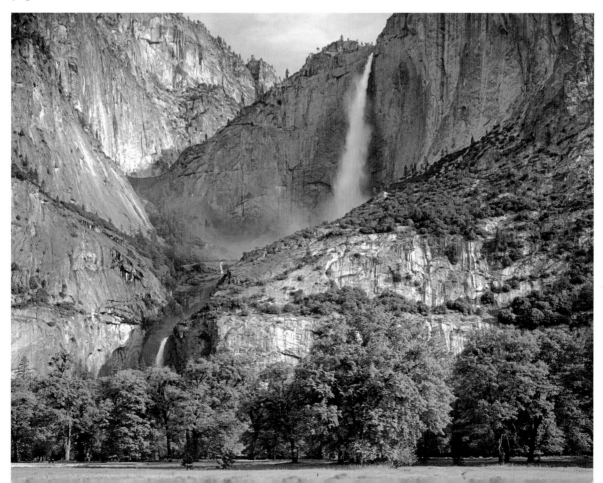

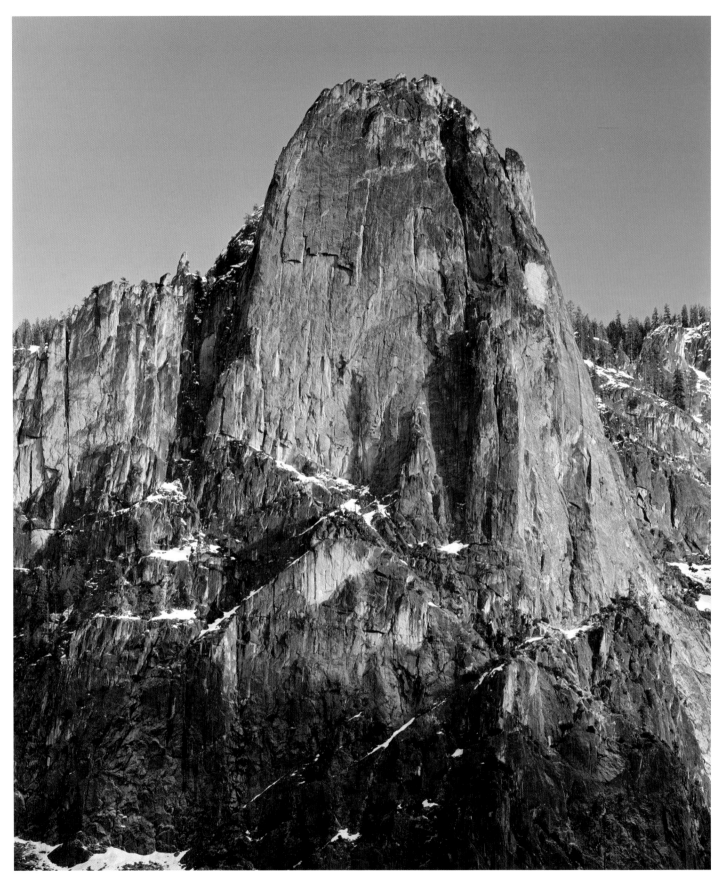

Above: A number of excellent viewpoints of Sentinel Rock lie a little west of Yosemite Lodge along Northside Drive, the first of which is this frontal view of the north face, shown with the sun setting on it.

Facing page: From a clear area farther west along Northside Drive, Sentinel Rock presents this noble profile. The north face is in the shade while the west face is sunlit.

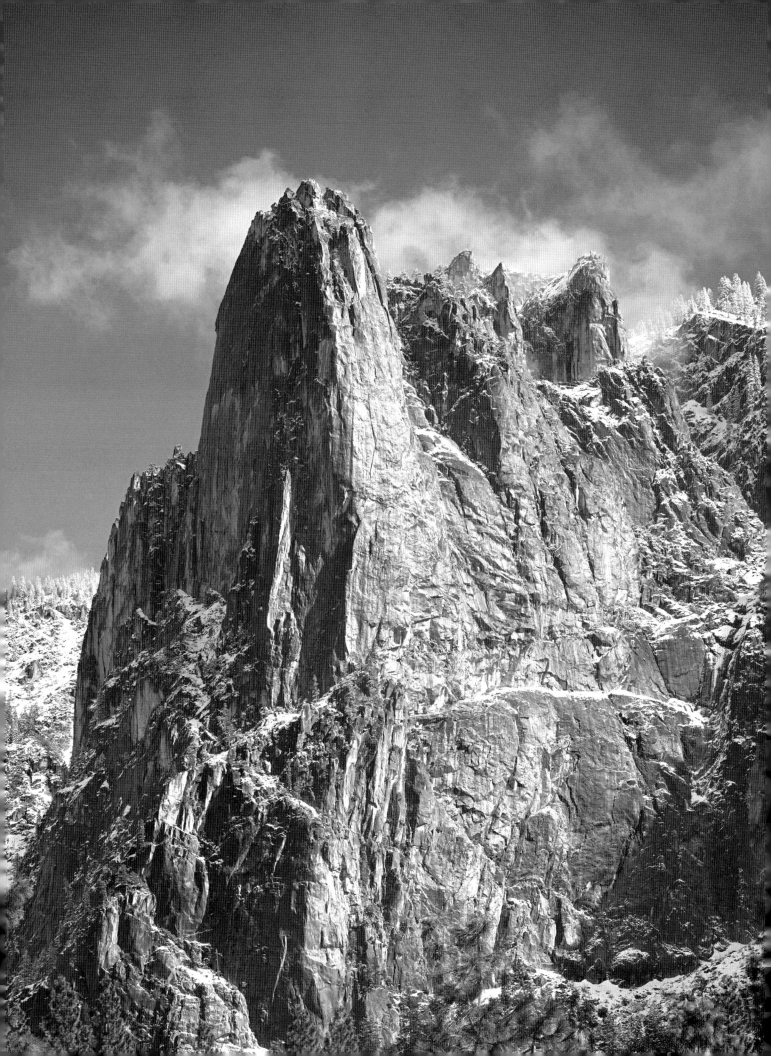

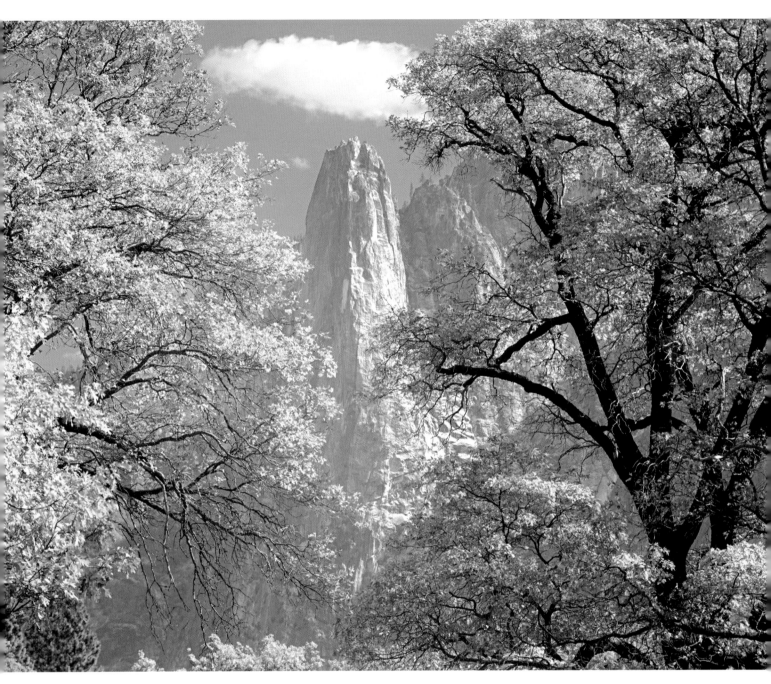

Above: Taking advantage of November's fall colors in the oak trees alongside Northside Drive yielded this picture-perfect image of Sentinel Rock.

Facing page: Proceeding west along Northside Drive, you first see El Capitan in profile. In this image, Horsetail Falls is highlighted on the southeast face. This waterfall exists only in the spring when there has been a heavy winter snowfall. The photo was taken in May 1967, years before the falls became a popular photographic subject.

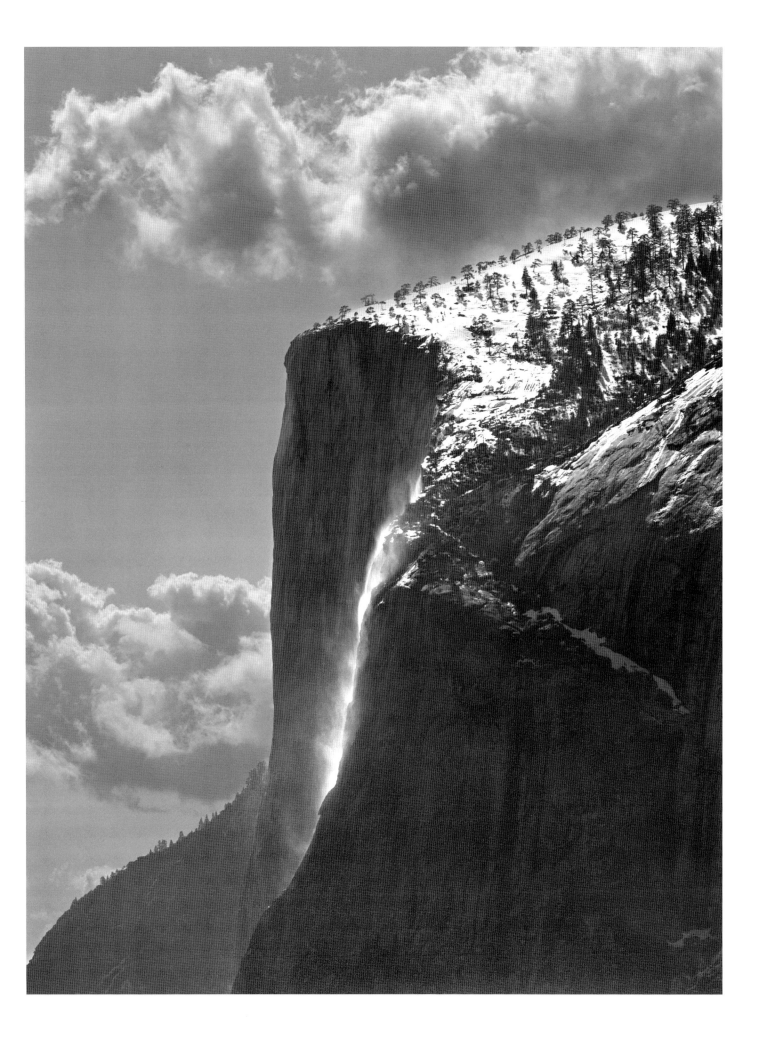

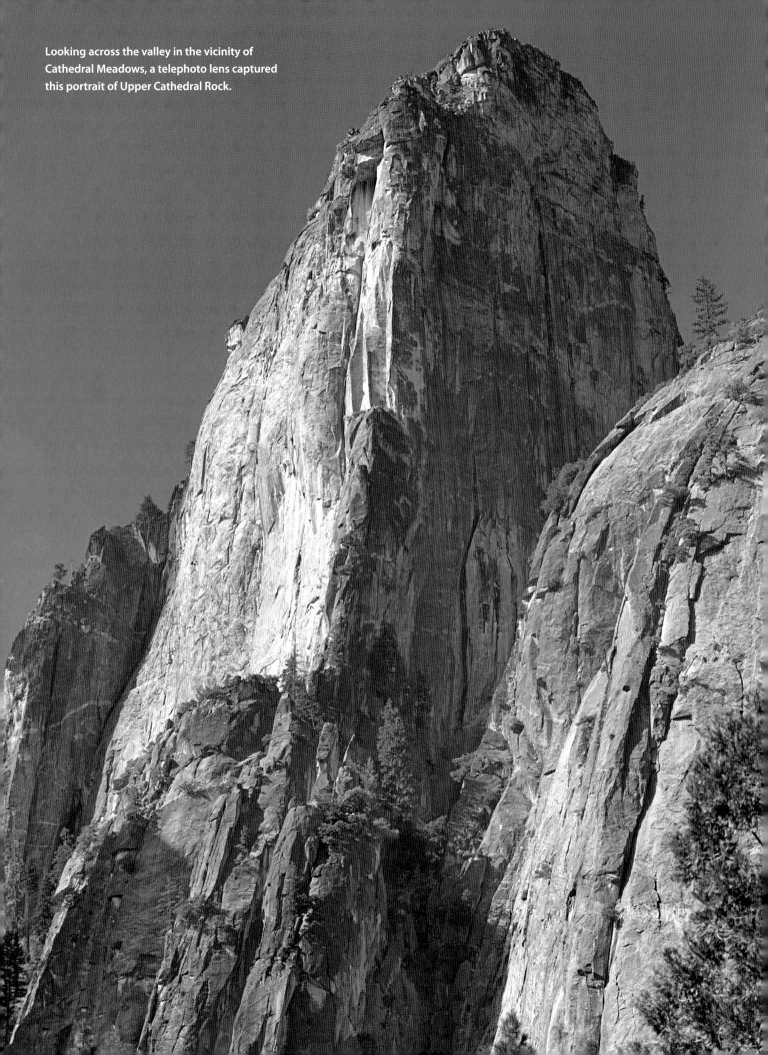

Looking across the valley in the vicinity of
Cathedral Meadows, a telephoto lens captured
this portrait of Upper Cathedral Rock.

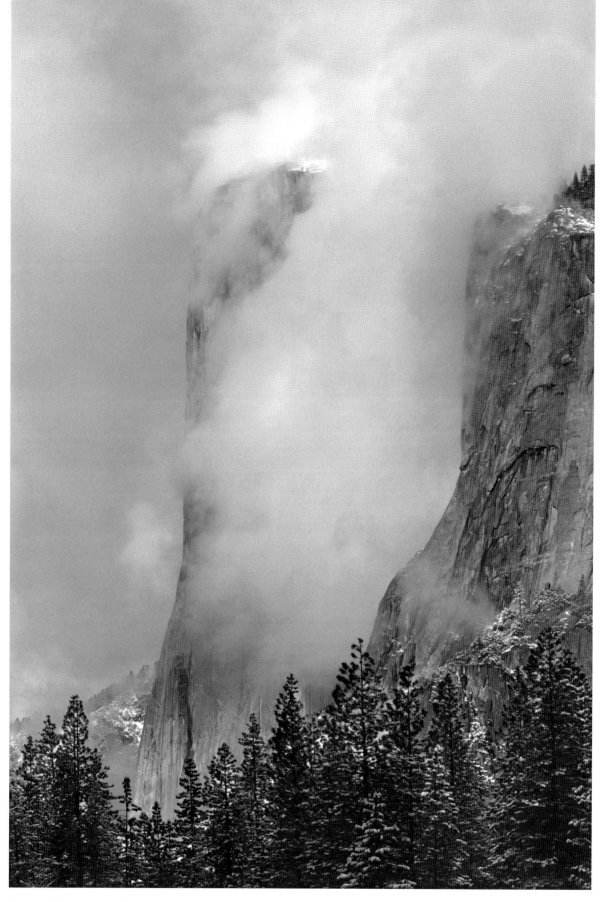

Above: Winter storm clouds swirl about El Capitan, with the Nose barely visible.

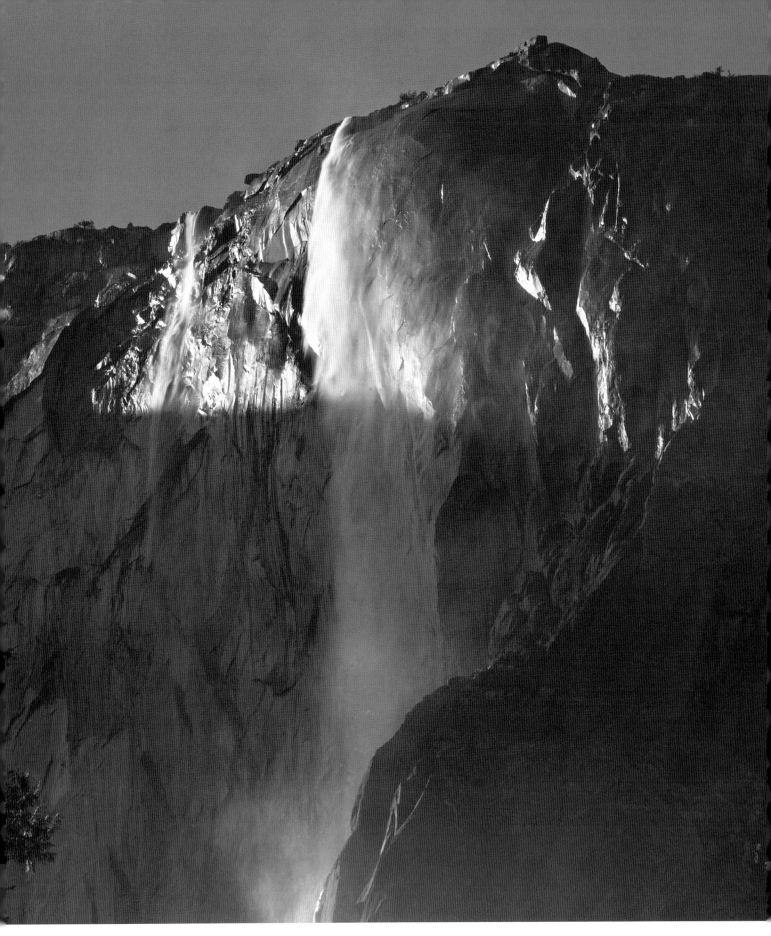

Above: Moving farther west along Northside Drive, a more direct view of Horsetail Falls is seen. The ridge at lower right is part of the east buttress of El Capitan. This photo was taken in May 1967.

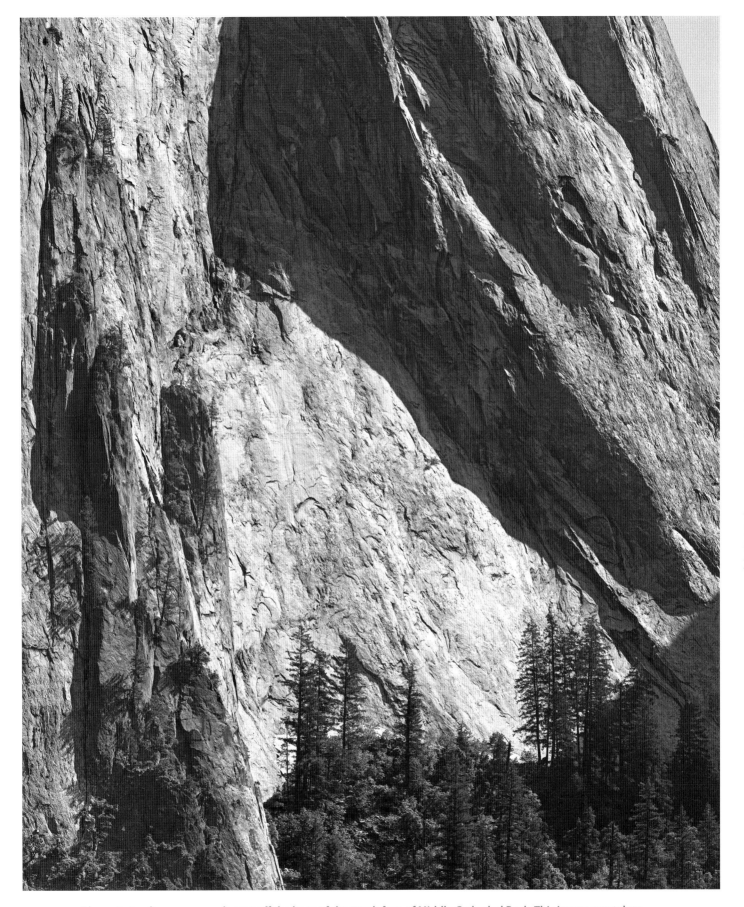

Above: Late afternoon sun glances off the base of the north face of Middle Cathedral Rock. This image was taken from El Capitan Meadow.

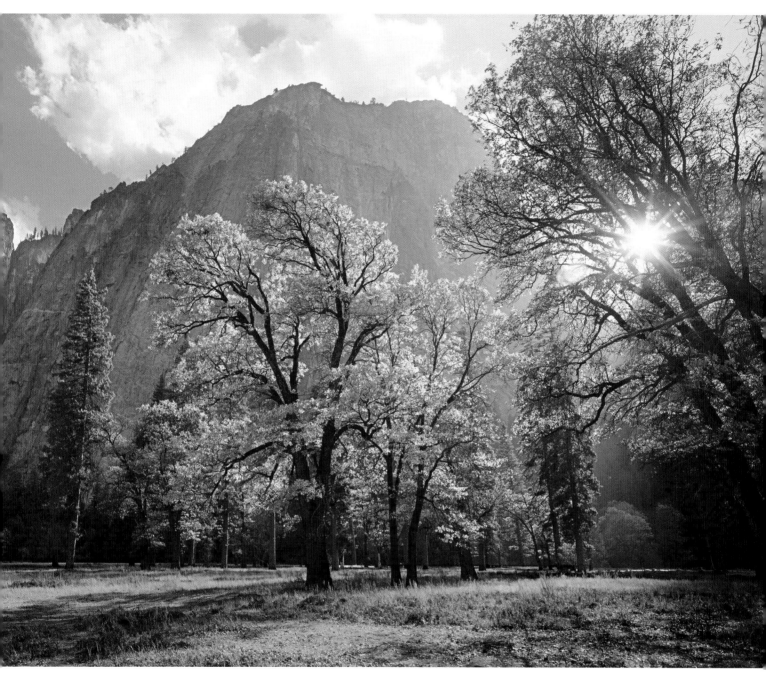

Above: A sunburst shines through oak trees in autumn in El Capitan Meadow, with Middle Cathedral Rock in the background.

Facing page: A second view of oak trees in autumn, highlighted against Middle Cathedral Rock.

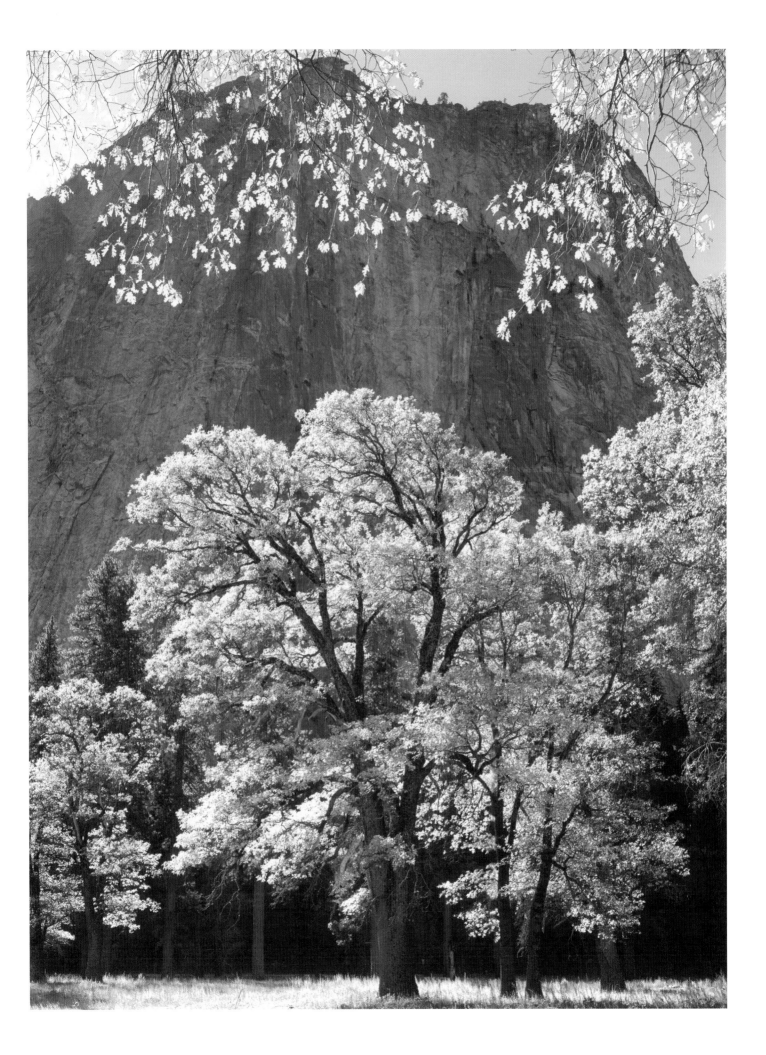

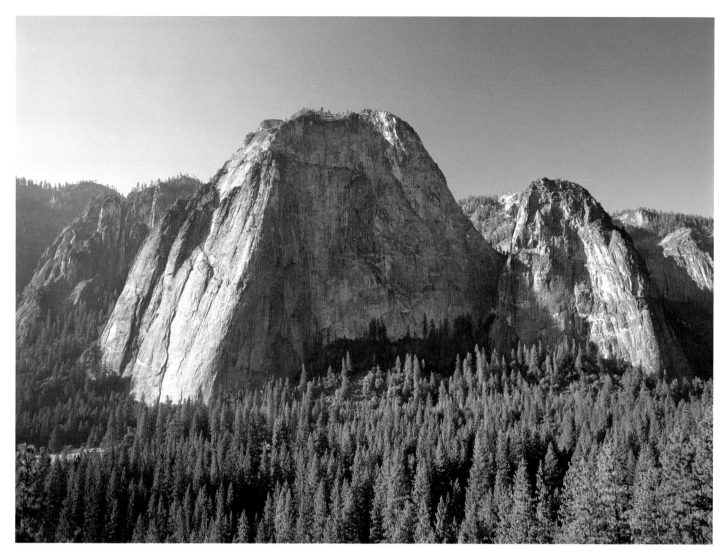

Above: A short walk up toward the base of El Capitan from Northside Drive yields this view of the valley floor, showing Middle Cathedral Rock in the center and Lower Cathedral Rock on the right. Taft Point appears in the distance.

Facing page: Moving west along Northside Drive, the Cathedral Rocks and oak trees in autumn are captured from a different angle. Lower Cathedral Rock is on the right (and appears higher); it blends in with Middle Cathedral Rock in the center.

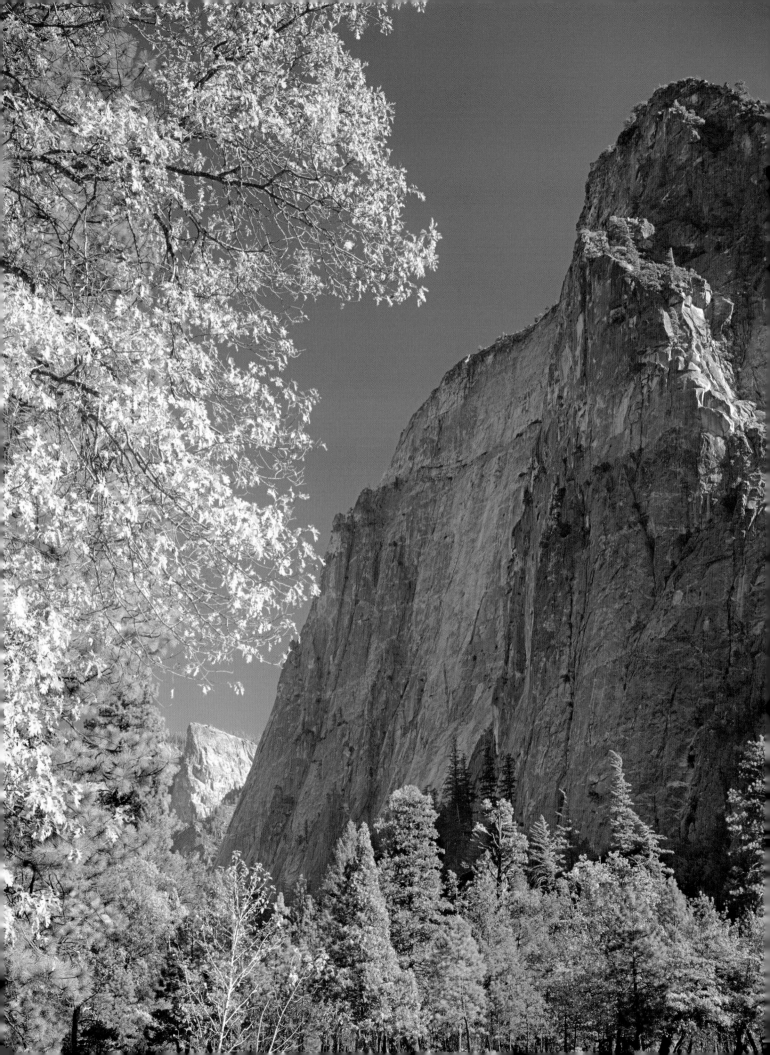

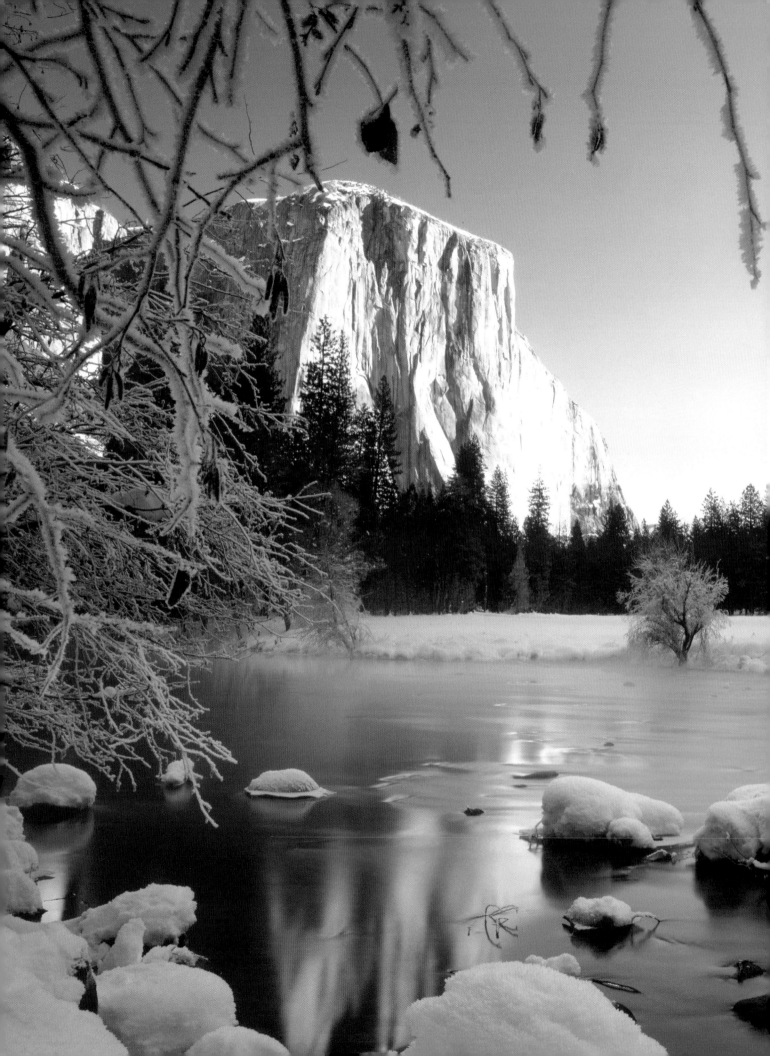

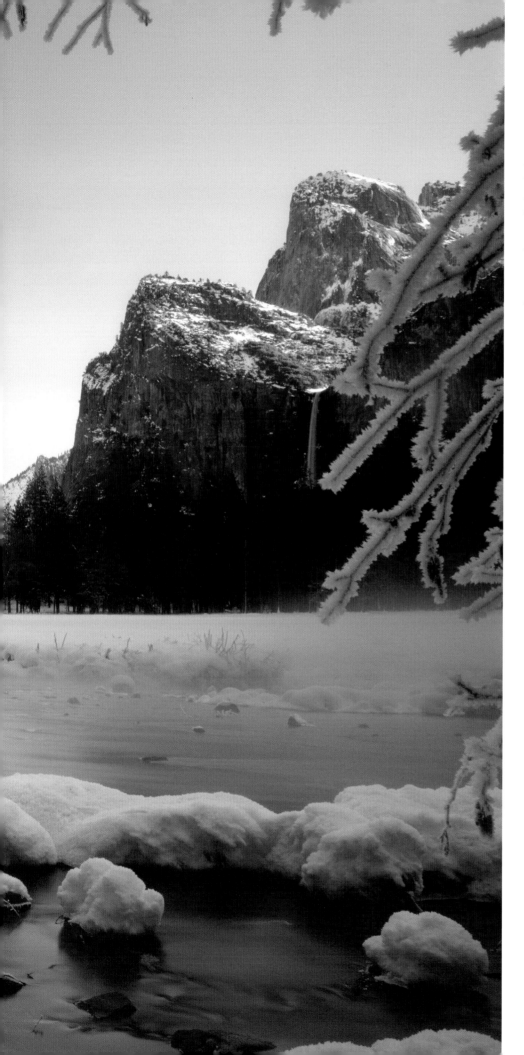

Valley View is a favorite picture-taking spot in Yosemite Valley, although not as popular as it once was. Once a two-way road, Northside Drive is one way going away from this view. Since the view is behind them, many motorists miss it altogether. Shown here on an early morning in January, the Merced River is in the foreground, El Capitan is on the left, and the Cathedral Rocks and Bridalveil Fall are on the right.

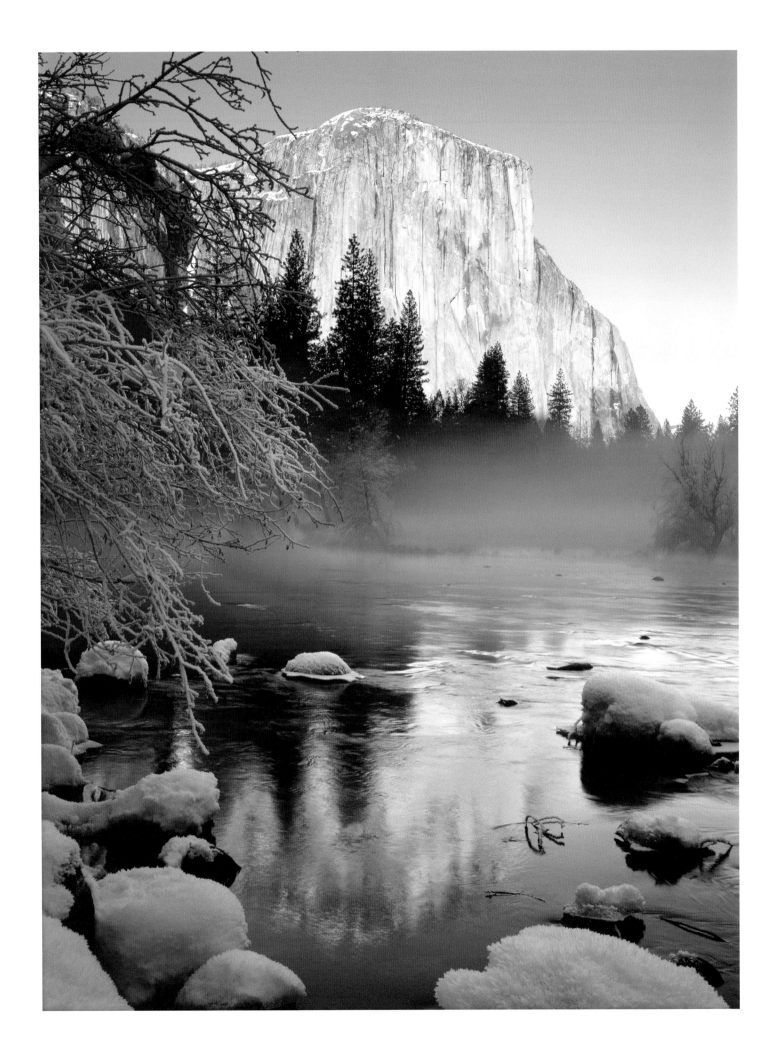

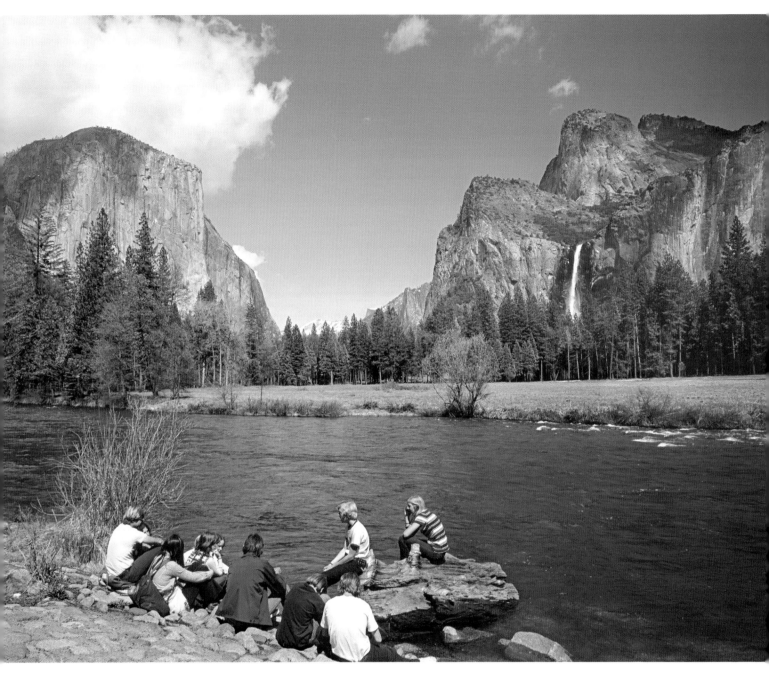

Above: A perfect classroom! A group of students gather at Valley View for a lesson.

Facing page: A winter view from the same vantage point as the photo on pages 65 and 66 shows a wondrous sunset on El Capitan reflected into the Merced River.

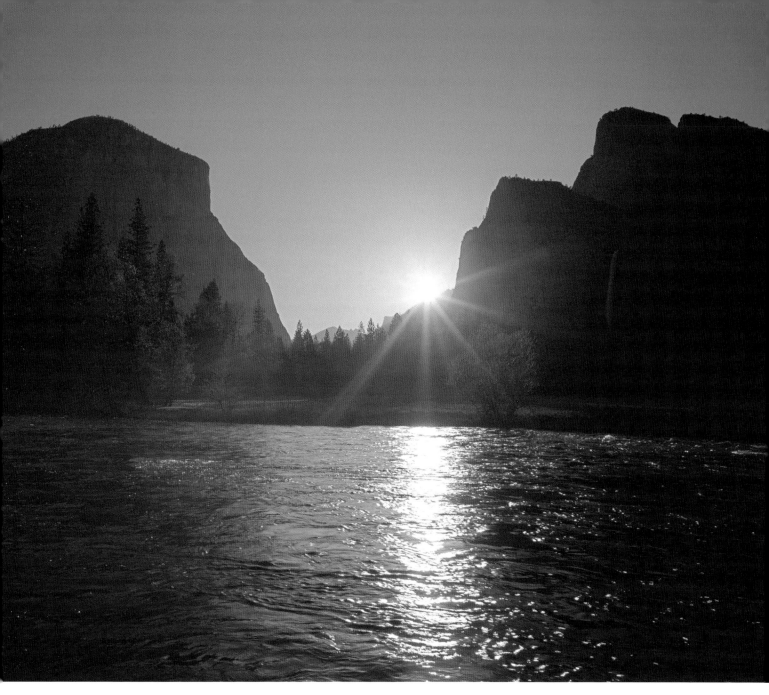

Above: Sunrise shows another mood at Valley View.

Facing page: Rockfall is a possibility at any time in Yosemite Valley, and there have been hundreds of recorded rockfalls since the late 1800s, when record keeping began. This picture, taken in March 1971, shows the rockfall off Elephant Rock that took place in February 1971. Another rockfall in the same location took place in the winter of 1980–81. This image was taken about 2.75 miles (4.5km) west of Valley View.

The answer to the question posed in the caption for the Yosemite Falls picture, first in this chapter: The picture is unusual because there are no cars lining Northside Drive, which is at the edge of the meadow below the trees. Normally a long line of parked cars stretches alongside this main valley thoroughfare. Perhaps the fact that I took this photo in the late 1970s or early 1980s has something to do with it. It just shows how the increase in visitation has affected even photography.

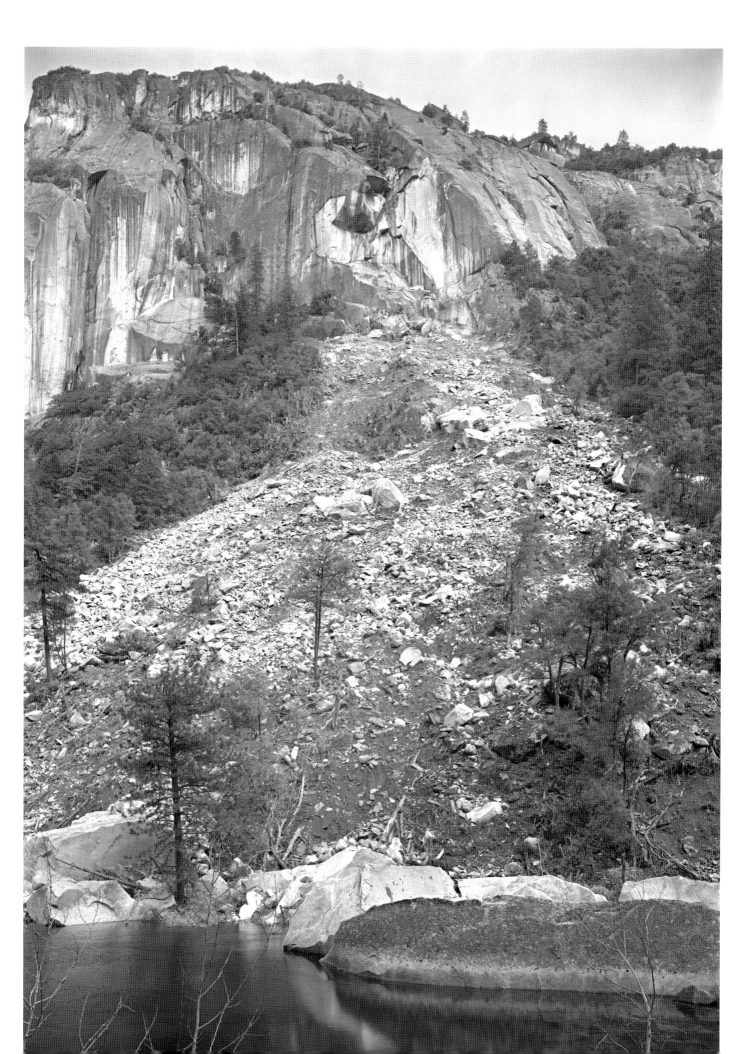

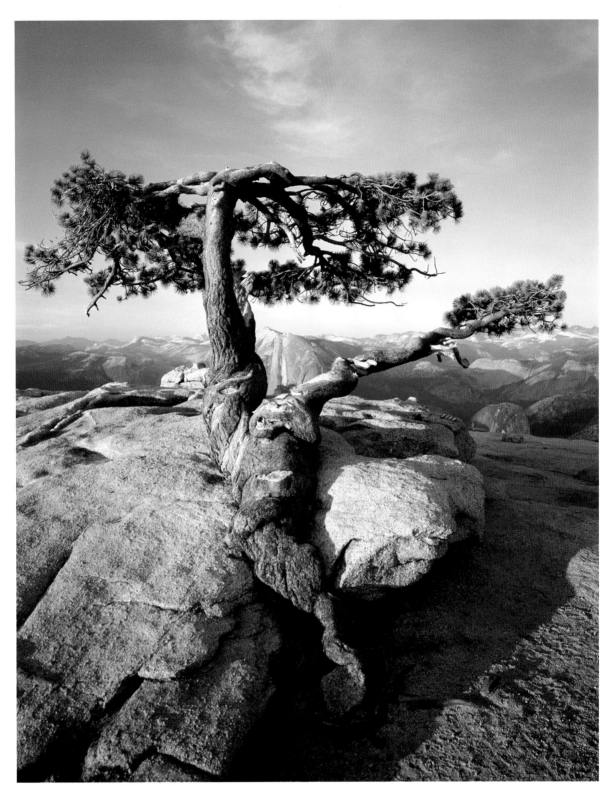

Above and facing page: This historic Jeffrey pine (*Pinus jeffreyi*) grew on top of the 8,122-foot high (2,476m) Sentinel Dome for an estimated 400 years. I feel fortunate to have seen and photographed this noble tree, made famous by Ansel Adams, while it was still alive. It is said that it died as the result of the drought of 1976–77, despite efforts of park rangers and other volunteers who carried buckets of water to the top of Sentinel Dome to water it. The tree finally fell over in August 2003. My personal belief is that this tree was simply loved to death—too many adults and children walking around it, posing on it, etc. The facing view shows Mount Hoffman, 10,850 feet (3,307m) in the background. The view above shows Half Dome in the background, between the tree's trunks. These pictures were taken in 1975, and I have never wanted to return to this spot after learning of the tree's fate.

6

GLACIER POINT ROAD

The Glacier Point Road leaves from Wawona Road (CA 41) at Chinquapin. From here it is about 16 miles (26km) to Glacier Point. Total mileage from Yosemite Valley to Glacier Point is about 30 miles (48km). This road is open from about May to November depending on the snowpack, although during the winter it is open to the Badger Pass Ski Area (6 miles, or approximately 10km).

Though the views from Glacier Point (which is often very crowded) are magnificent, vistas are just as spectacular from the more remote Sentinel Dome. The trail to Sentinel Dome starts about 2 miles (3.2km) before the end of the Glacier Point Road. The trail from the road to the top of Sentinel Dome is a little over 1 mile (1.6km) and gains about 400 feet (122m) in elevation.

Another trail far less frequented, which leaves from the same trailhead as the route to Sentinel Dome, leads to Taft Point. This trail is featured in the chapter on The Valley from Above.

Glacier Point is remembered for the firefall, which became a Yosemite tradition starting in 1872 and—with several interruptions—continued until 1968. Burning embers were pushed off the edge of Glacier Point in the evening after the sky had become dark, and Yosemite Valley visitors would *ooh* and *ah* at the red streak falling from the point. I remember the firefalls, which were indeed spectacular.

But such a practice was deemed unsuitable in a national park famed for its outstanding scenic values, and the National Park Service banned its continuance. The last firefall occurred January 25, 1968. The following year the historic Glacier Point Hotel, whose employees had helped manage the firefall, burned to the ground and was never rebuilt, thus marking the end of an era.

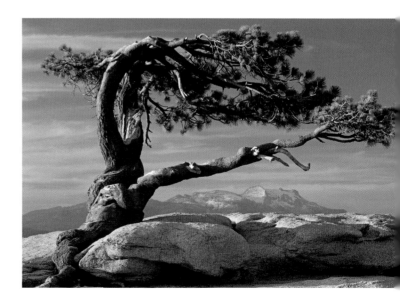

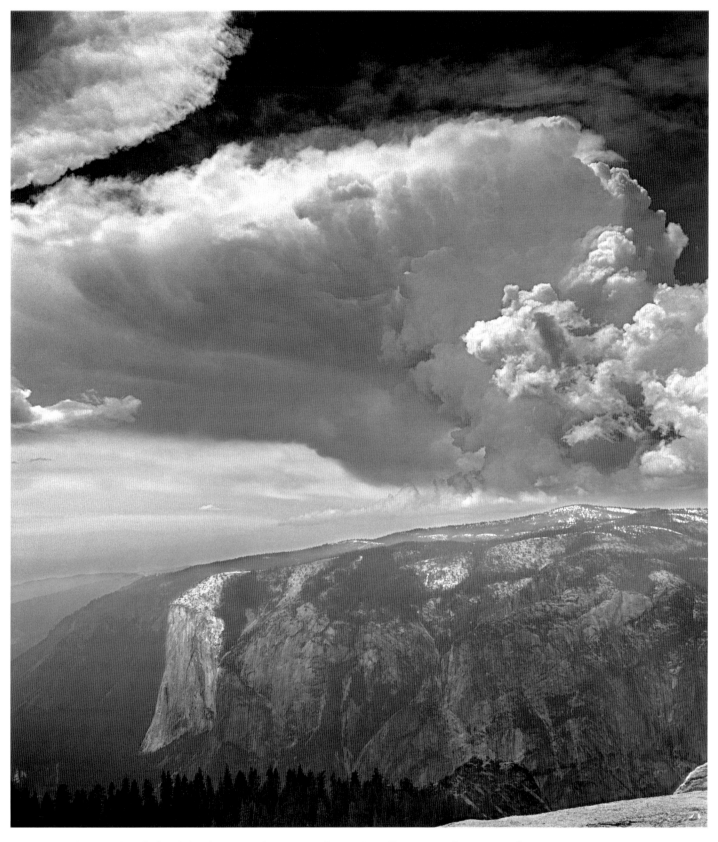

Above: A thunderhead develops over El Capitan and Yosemite Valley, as seen from Sentinel Dome.

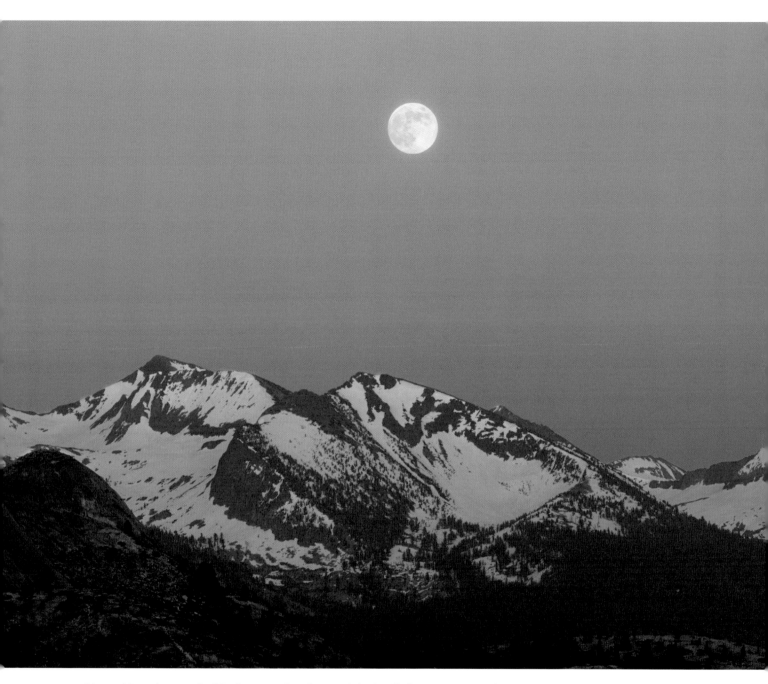

Above: Moonrise over Red Peak, 11,699 feet (3,566m), in the Clark Range, as seen from near Glacier Point. No, I have *not* inserted a fake moon—a common practice among postcard manufacturers.

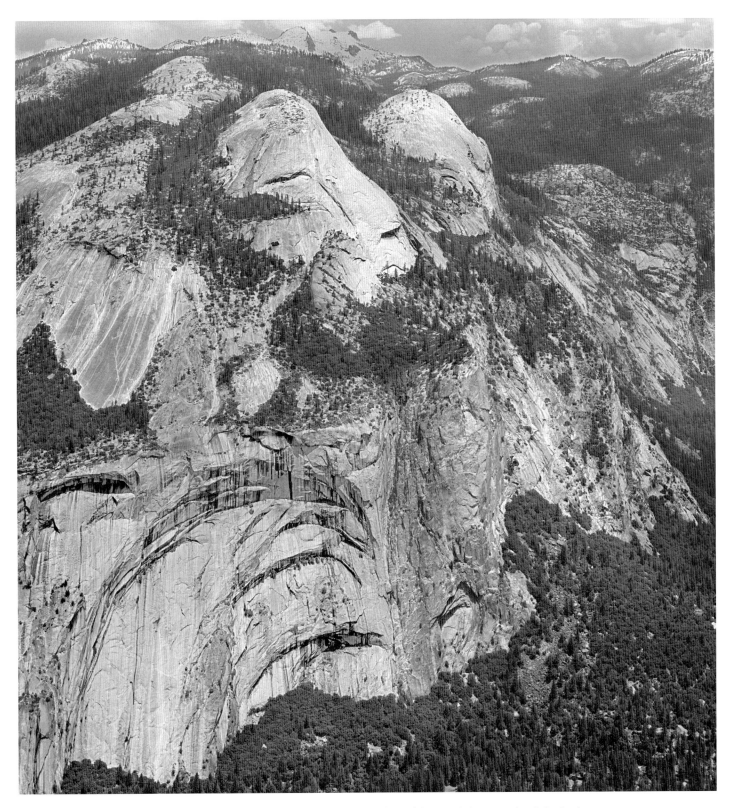

Above: In the lower part of the frame are the Royal Arches, with Washington Column to the right. In the upper portion is North Dome, with Basket Dome to the right of it. This view is from a location near Glacier Point.

Facing page: Sunset on Half Dome as seen from Glacier Point. Clouds Rest is the peak in the background to the right of Half Dome and is actually considerably higher than Half Dome.

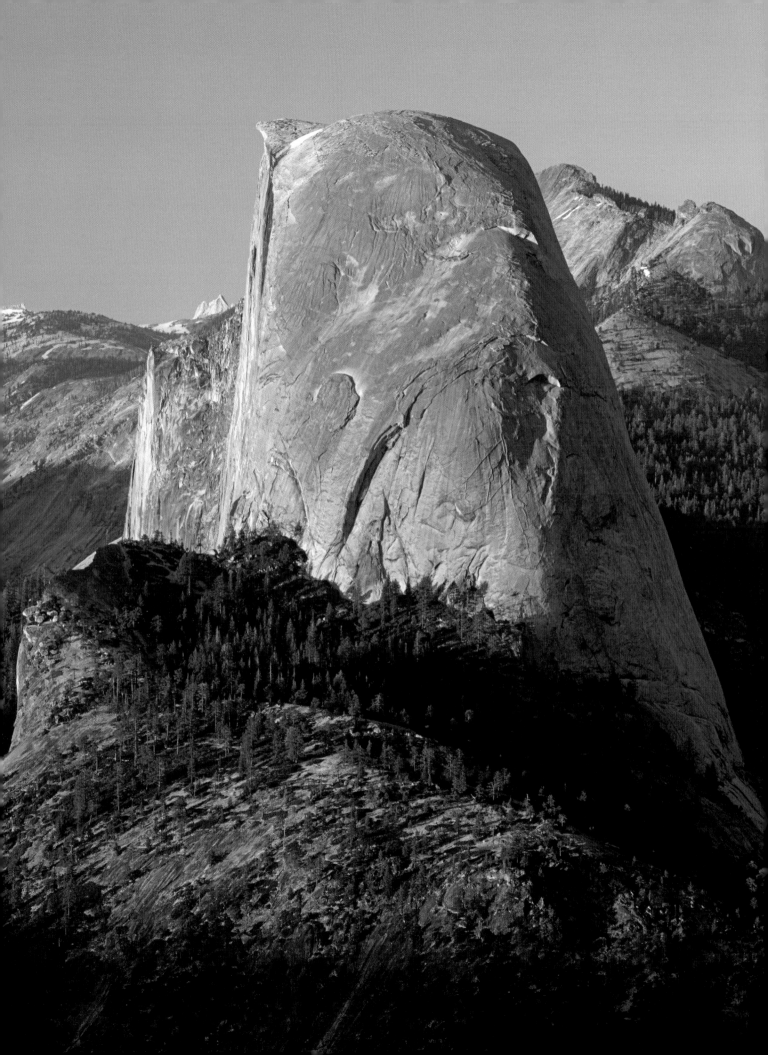

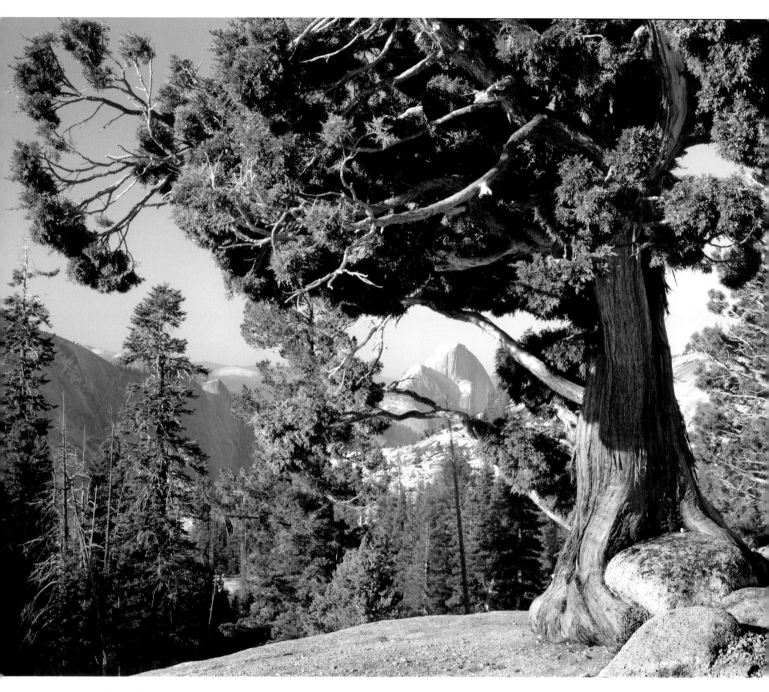

Above: The really spectacular vistas in Yosemite's high country start at Olmsted Point, which is 29.5 miles (47.4km) along the Tioga Pass Road. In this photo Half Dome is seen through the branches of a western juniper (aka Sierra juniper/*Juniperus occidentalis*). This picture was taken from the parking lot at Olmsted Point.

7

T I O G A P A S S R O A D

The Tioga Pass Road extends about 59 miles (94km) from its junction with the Big Oak Flat Road on the west side of Yosemite National Park to Lee Vining on the east side of the Sierra Nevada, where it ends at US 395. The road's mileage to Tioga Pass itself, which marks the boundary between Yosemite National Park and the Inyo National Forest, is about 47 miles (75km). Mileage from the junction of Big Oak Flat Road and Northside Drive in Yosemite Valley to where Big Oak Flat Road connects with the Tioga Pass Road is 10 miles (16km). All mileages in this chapter are given from the start of Tioga Pass Road at its west end.

The total elevation gain for both roads (Big Oak Flat and Tioga Pass) is about 6,000 feet (1,829m), reaching its peak at Tioga Pass at 9,945 feet (3,031m). Besides being the highest road in the park, the Tioga Pass Road also has the highest pass crossing the Sierra Nevada.

The Tioga Pass Road offers access to Tenaya Lake and Tuolumne Meadows, one of Yosemite National Park's most popular destinations and site of a number of distinctive granite domes. Peaks in the Cathedral Range form a spectacular backdrop to the meadows.

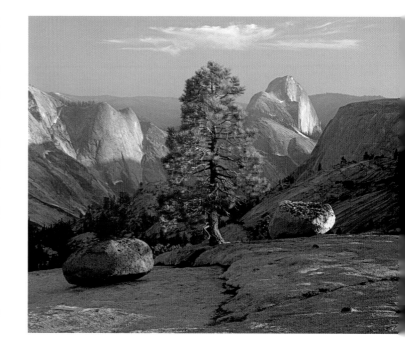

Right: Walking out on granite slabs a short distance from Olmsted Point brings into view Quarter Domes on the left, Half Dome on the right, and Tenaya Canyon.

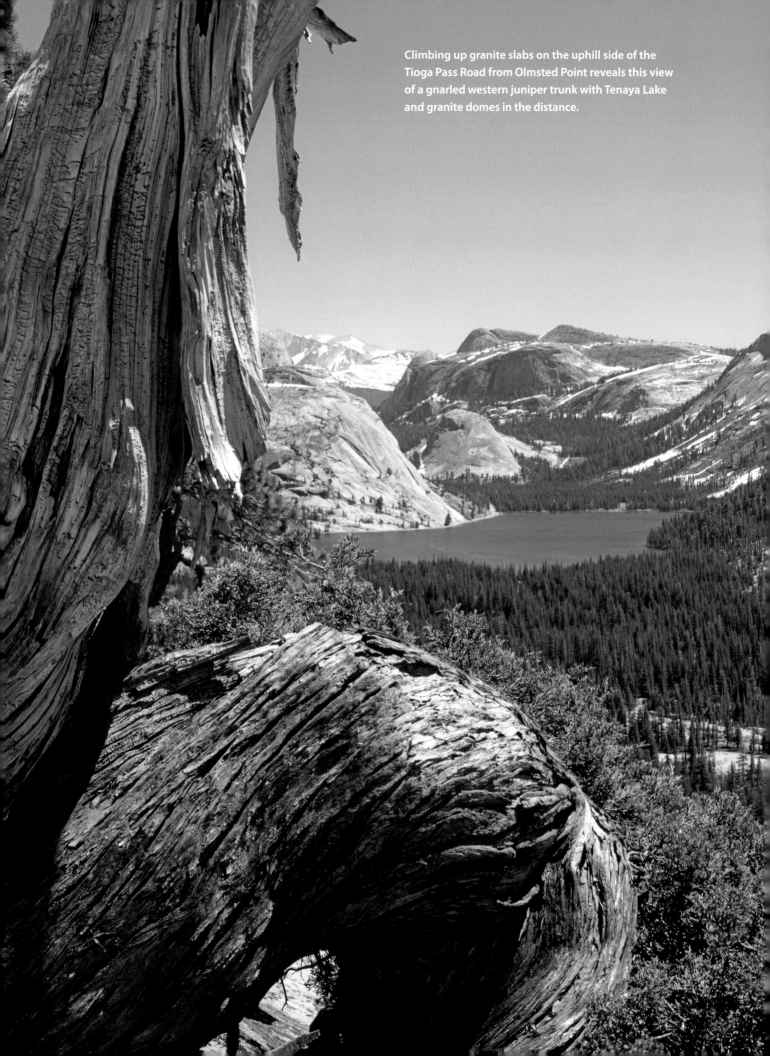

Climbing up granite slabs on the uphill side of the Tioga Pass Road from Olmsted Point reveals this view of a gnarled western juniper trunk with Tenaya Lake and granite domes in the distance.

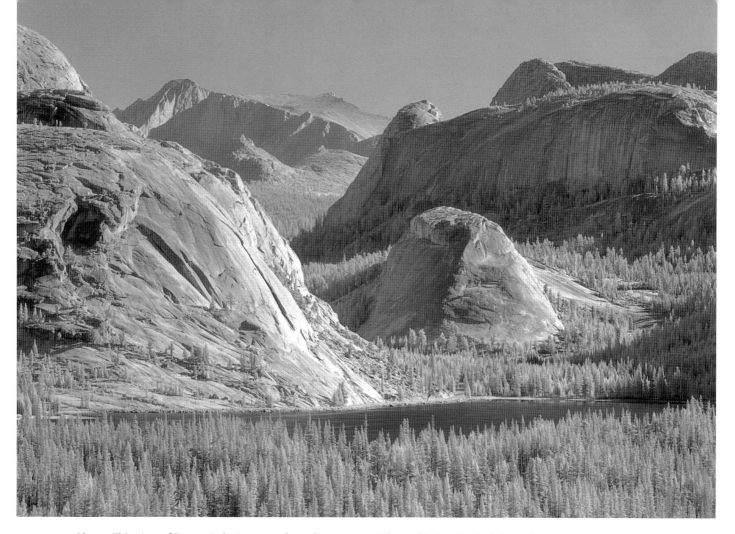

Above: This view of Tenaya Lake is a very short distance past Olmsted Point. Pywiack Dome is in right center, with Medlicott Dome above and behind it. The Tioga Pass Road skirts the north (left) side of the lake below Pleasure Dome.

Below: Granite slabs lining the Tioga Pass Road offer plenty of opportunities in the summer to capture wildflowers that appear to grow right out of the rock. This photo shows rock penstemon (aka cliff penstemon/*Penstemon rupicola*) and granite slabs.

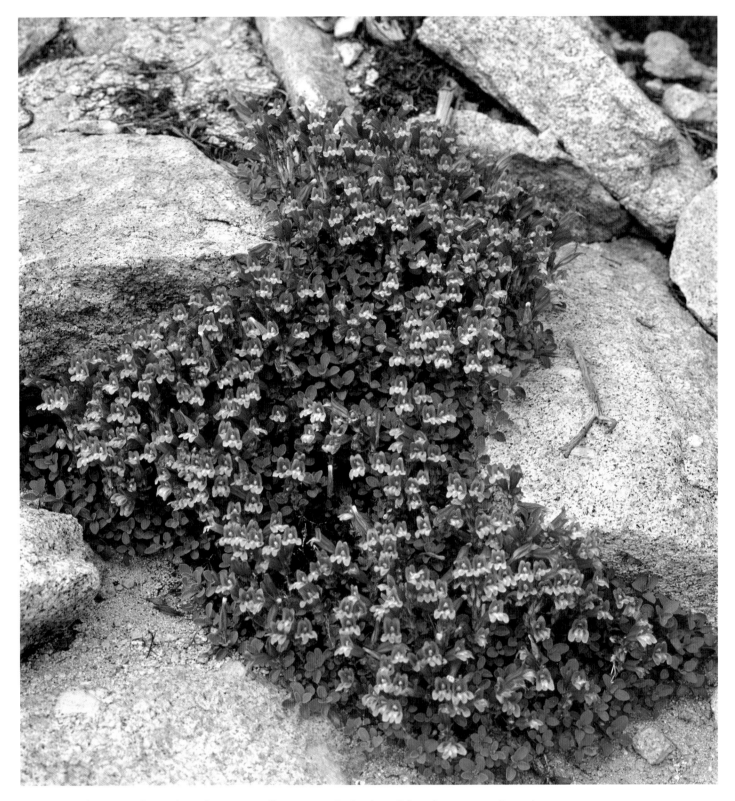

Above: Another variety of penstemon flower grows in the dry soil found among granite rocks.

Facing page: Glacial polish on granite slabs, visible in several spots along the Tioga Pass Road, bears witness to the passage of glaciers in the last Ice Age.

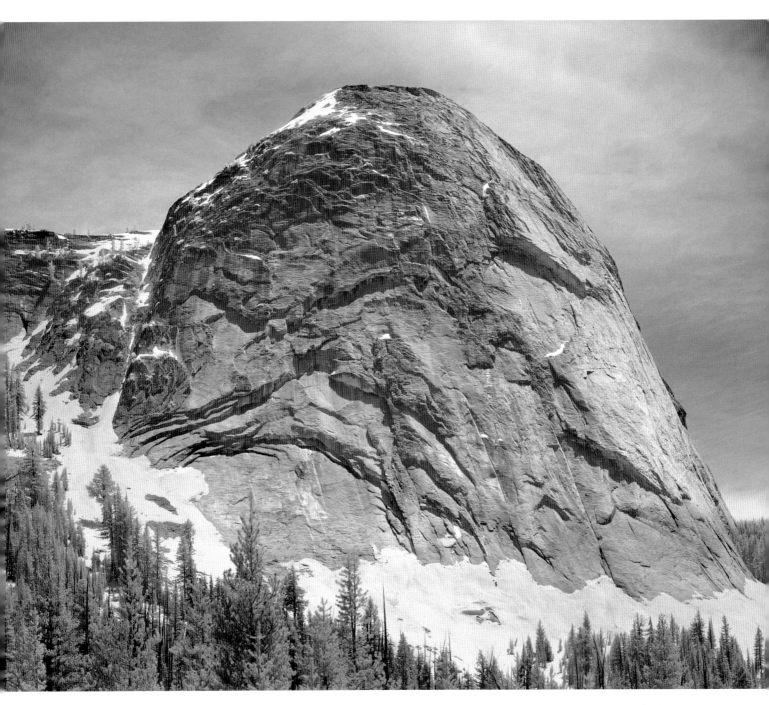

Above: Proceeding along the Tioga Pass Road into scenic Tuolumne Meadows, you will see Fairview Dome, the largest and most spectacular of the Tuolumne domes.

Facing page: A short walk on the granite slabs to the north of the Tioga Pass Road turned up this view of a cloud formation over Fairview Dome, which is on the right.

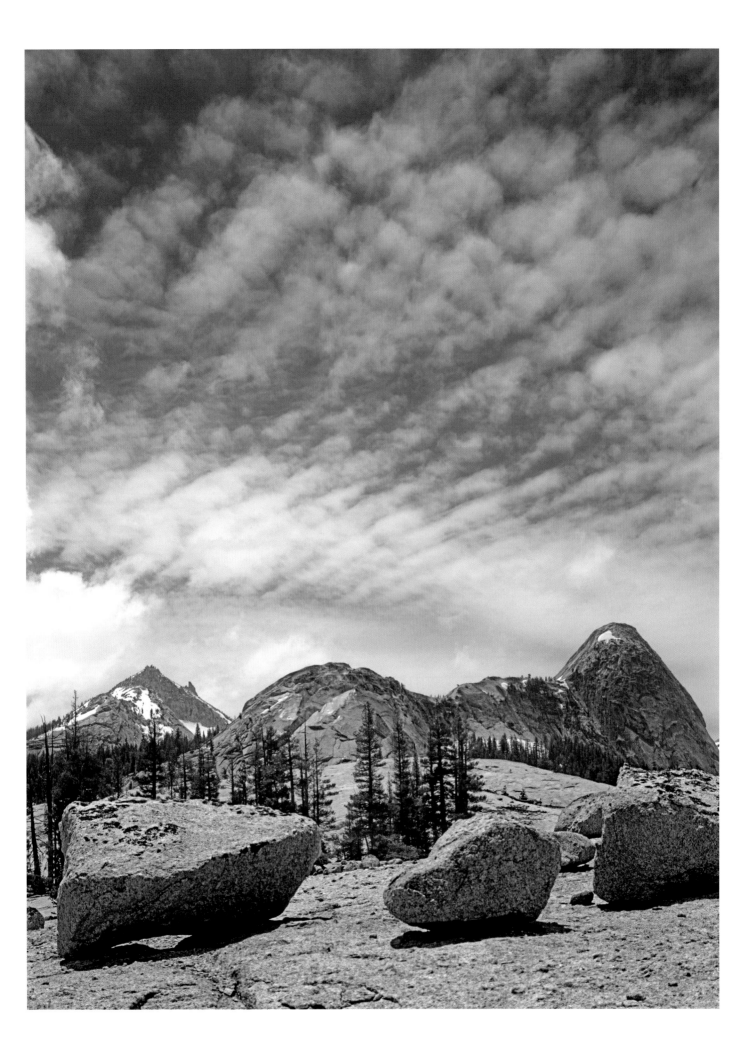

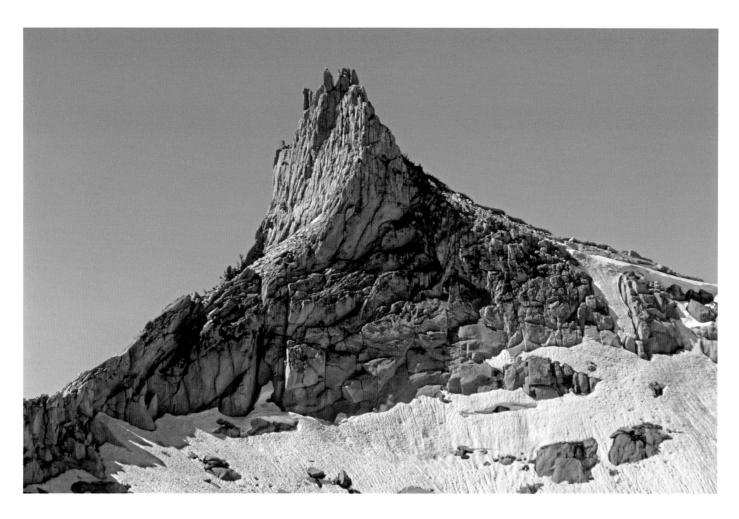

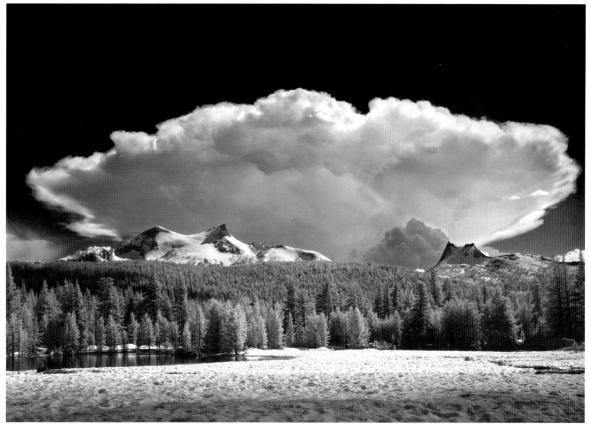

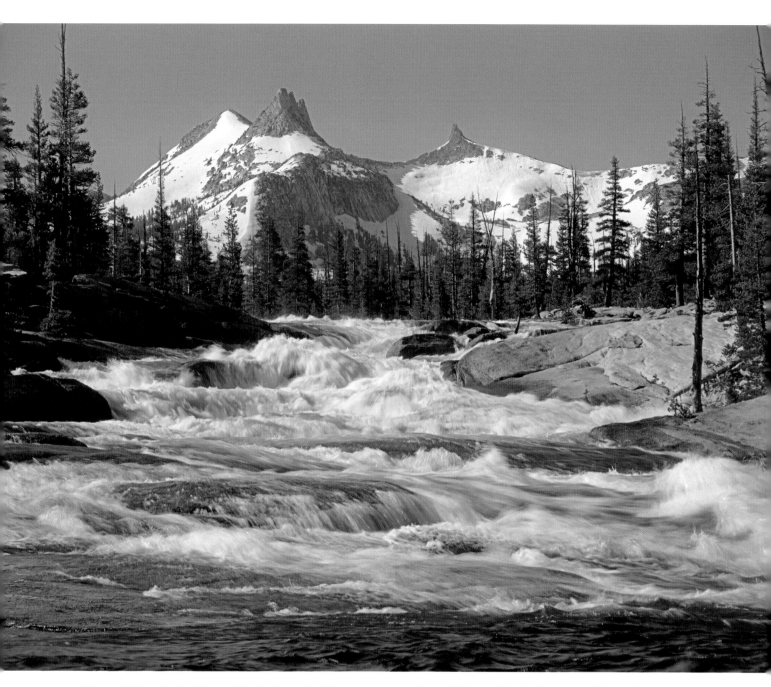

Above: Unicorn Peak, left, and the Cockscomb, right, appear over a beautiful cascade in the Tuolumne River. This picture was taken about 2 miles (3km) along the Glen Aulin Trail, which begins at a locked gate at the end of a 0.3-mile dirt road that leaves from the Lembert Dome parking lot. This parking lot in turn is located about 40 miles (64km) along the Tioga Pass Road.

Facing page, top: The Cockscomb, 11,065 feet (3,373m), is one of the peaks in the striking Cathedral Range, which rises just to the south of Tuolumne Meadows. This view is from the northeast and was taken near the popular Cathedral Lakes Trail, which begins from the Tioga Pass Road.

Facing page, bottom: This classic image of a thunderhead over Tuolumne Meadows was taken on June 17, 1967, with an 8 x 10 view camera using infrared film. Unicorn Peak, 10,823 feet (3,299m), is on the left and Cathedral Peak, 10,940 feet (3,335m), is on the right. Iconic Yosemite photographer Ansel Adams was conducting a photographic workshop less than 100 yards away, and I have always wondered whether any of his students managed to capture a similar image.

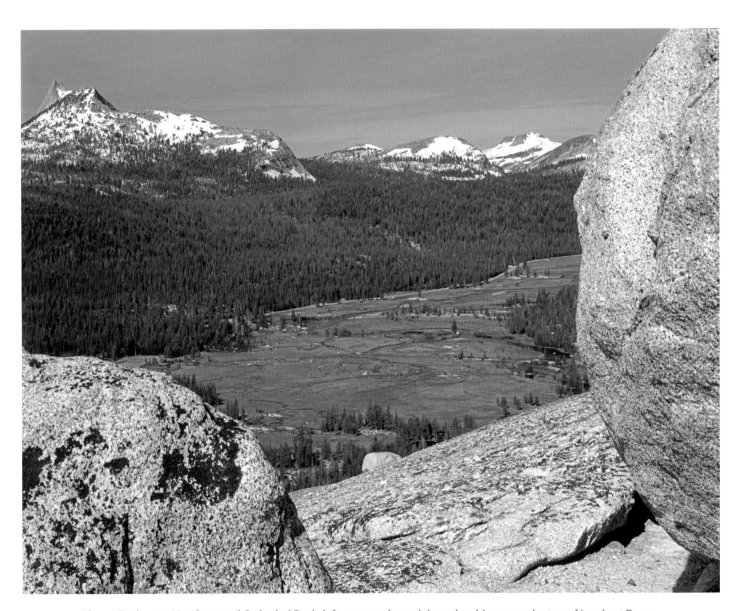

Above: Tuolumne Meadows and Cathedral Peak, left, as seen through large boulders near the top of Lembert Dome, 9,450 feet (2,880m). A short trail from the Lembert Dome parking lot leads to this magnificent viewpoint.

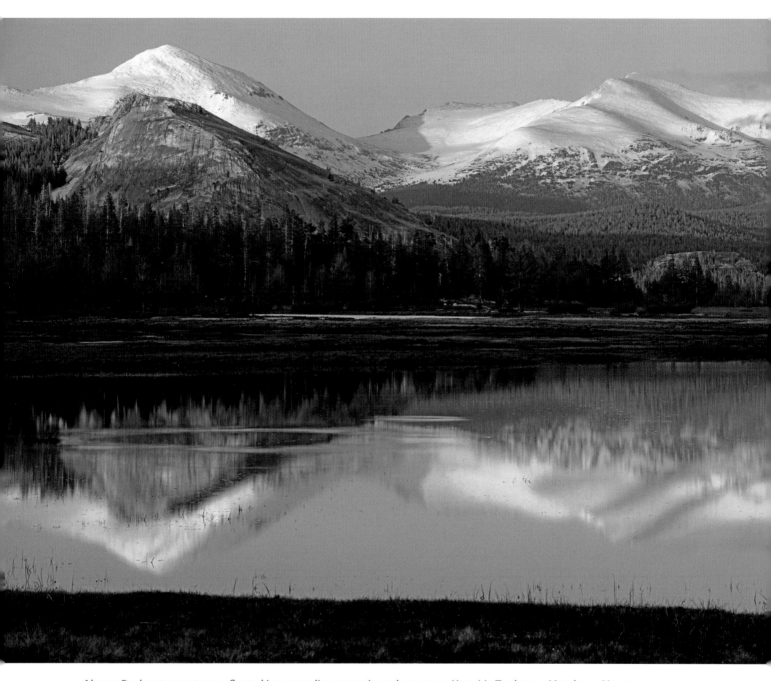

Above: Peaks at sunset are reflected into standing water in early summer (June) in Tuolumne Meadows. Mount Dana, 13,057 feet (3,979m), is on the left, with Lembert Dome in front of it. On the right is Mount Gibbs, 12,764 feet (3,890m).

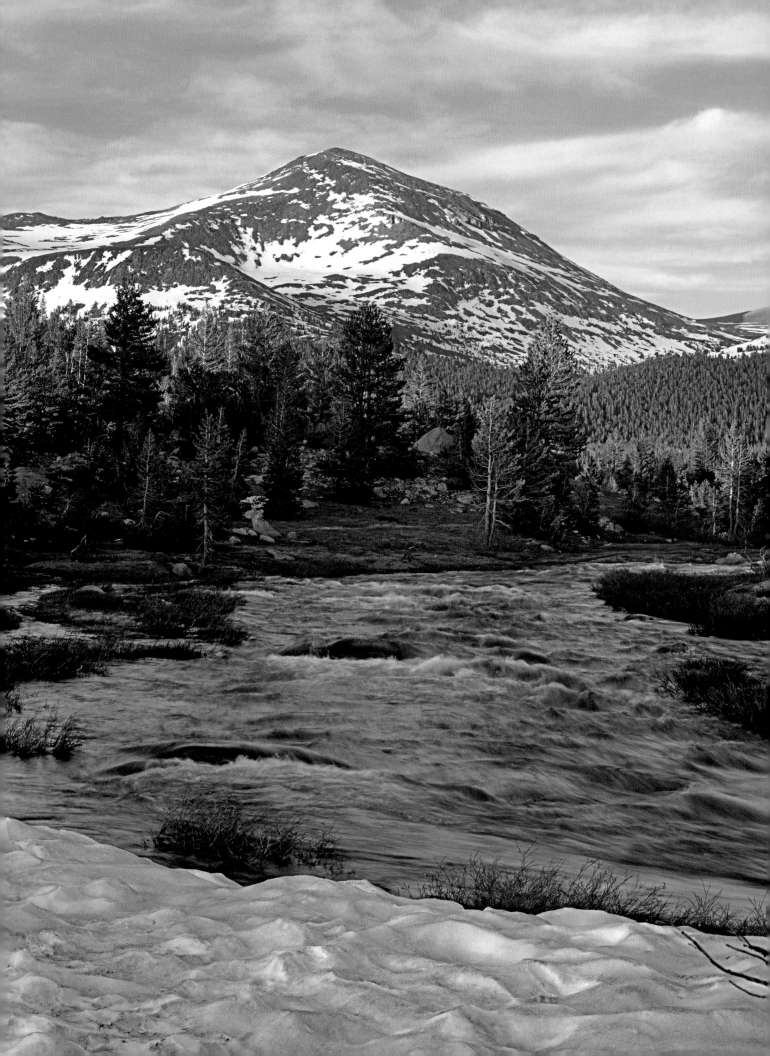

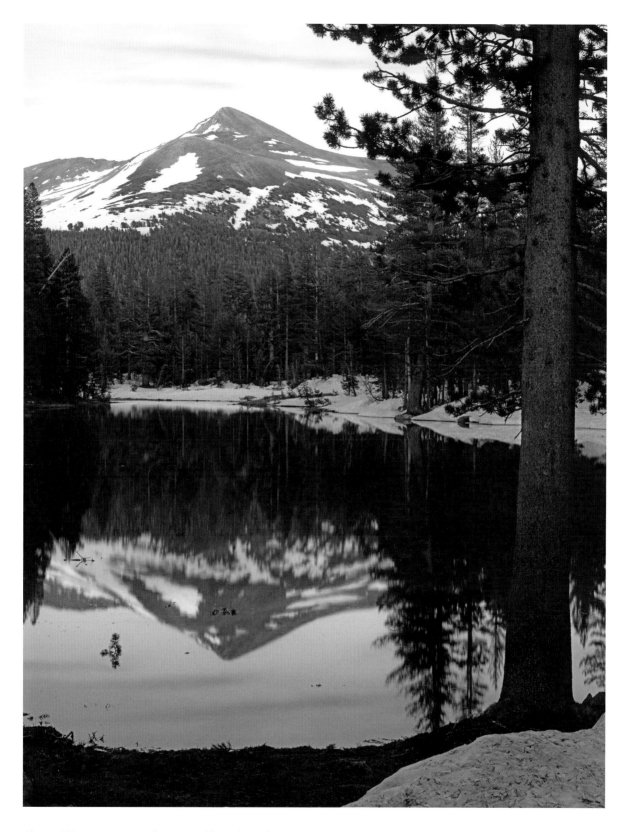

Above: This sunset view of Mount Gibbs reflected in a small pond at Dana Meadows was taken a very short distance farther along the Tioga Pass Road from the Dana Fork photo.

Facing page: Sunset on Mount Dana, as seen over the Dana Fork of the Tuolumne River. This view, right next to the road, is about 44 miles (71km) along the Tioga Pass Road.

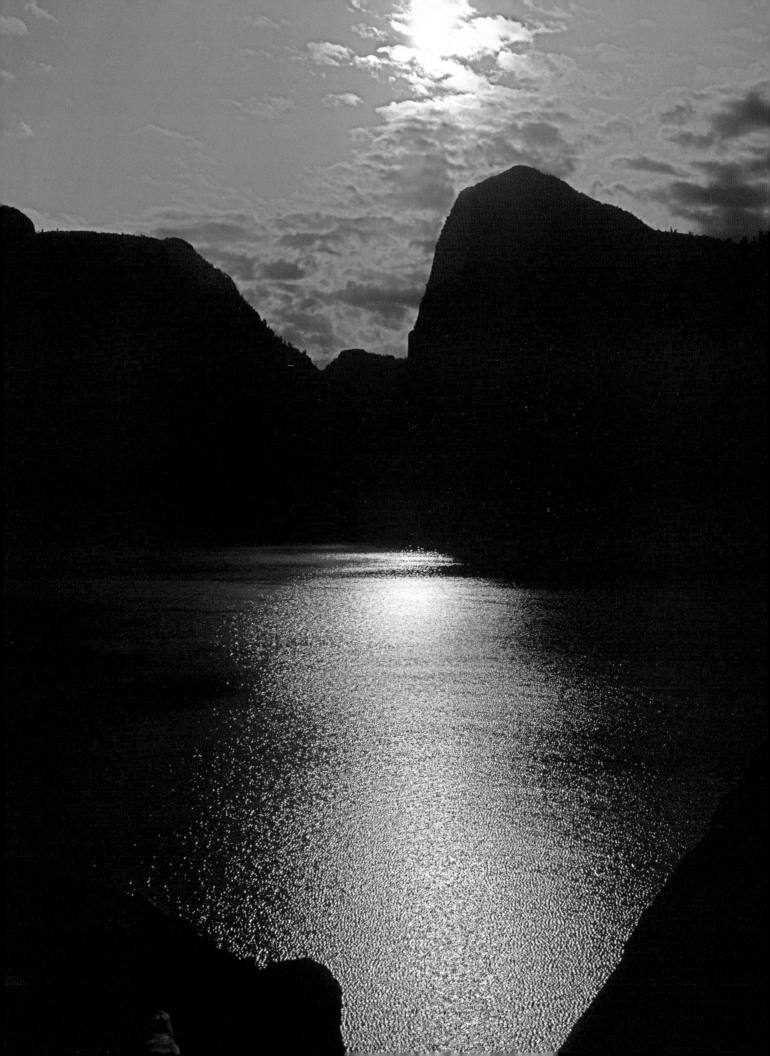

8

▲▲▲

HETCH HETCHY

Tucked away in the northwestern portion of Yosemite National Park, the Hetch Hetchy
Valley contains the O'Shaughnessy Dam and Hetch Hetchy Reservoir, source of the San
Francisco Bay Area's water supply. Hetch Hetchy was once referred to as "the other
Yosemite Valley."

Quite a bit of opposition to the building of the dam in the early 1900s was spearheaded by naturalist John Muir and the Sierra Club. Muir, also a prolific writer, observed: "Dam Hetch Hetchy! As well dam for water tanks the people's cathedrals and churches, for no holier temple has ever been consecrated by the heart of man."

There is no doubt that approval for construction of a dam at this site would never be granted in the present day. At the time, promoters of the dam painted rosy pictures of luxury hotels along the shores of the reservoir once it was filled, with boats cruising the lake while people fished, picnicked, and admired beautiful reflection views. It is said that approval for

construction of this dam, passed by Congress in the Raker Act of 1913, hastened the death of John Muir, which occurred the following year.

None of the projections of the promoters came to pass. There is no boating allowed on the reservoir, and no lodges of any kind were built along the shores or even along the road inside Yosemite National Park that leads to Hetch Hetchy. Overnight parking is not even permitted, except in the case of backpackers who have wilderness permits, and this area sees few visitors.

This having been said, there is still great natural beauty at Hetch Hetchy, despite the fact that the reservoir, in most years, has an unsightly "ring around the bathtub" appearance.

Facing page: Early morning sun shines on Hetch Hetchy Reservoir. Kolana Rock is on the right.

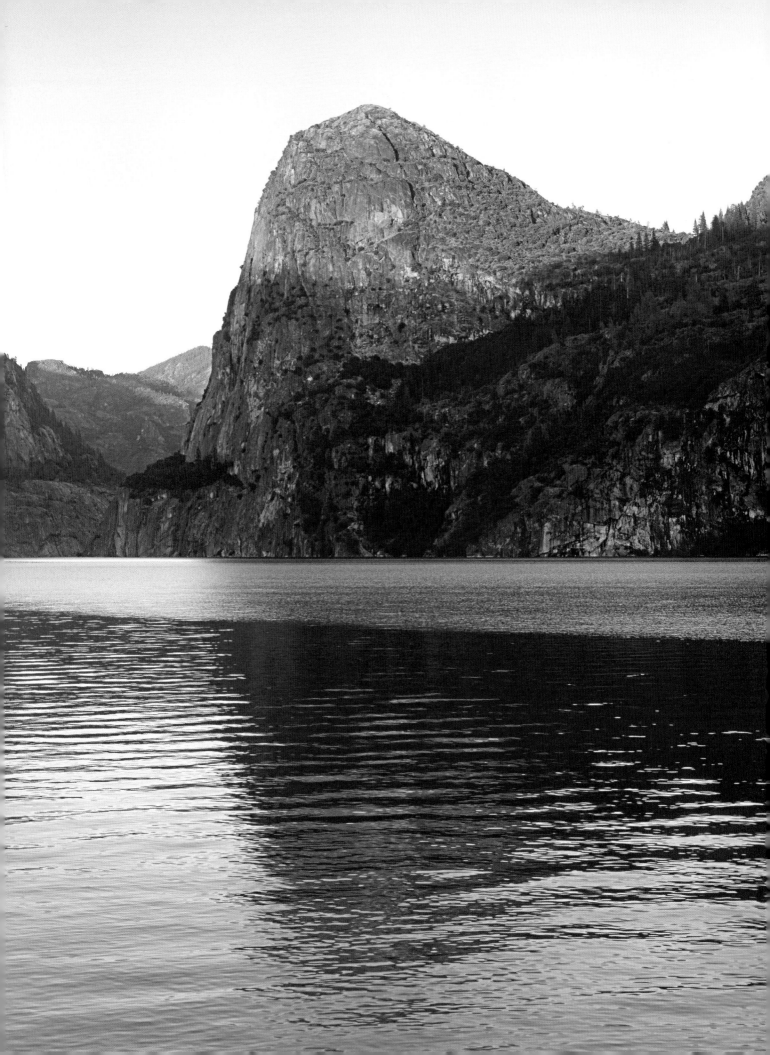

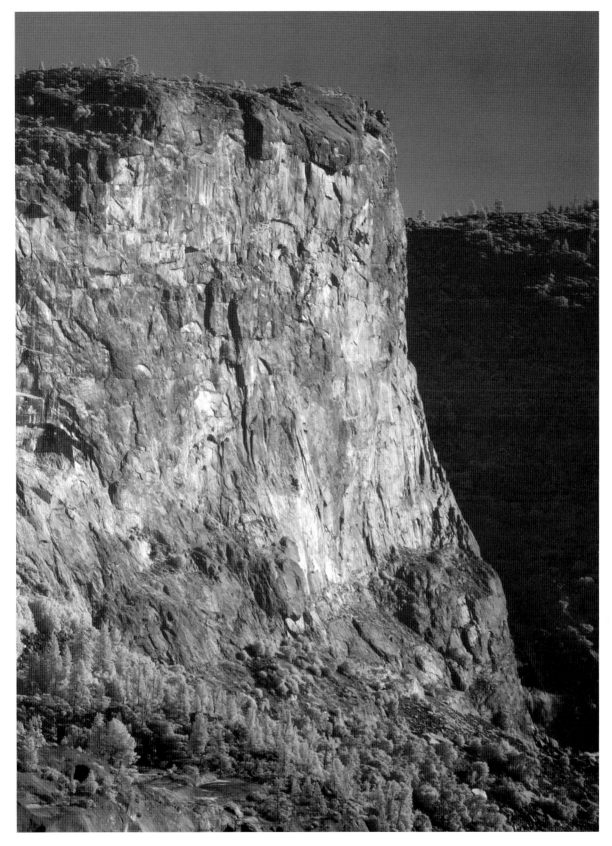

Above: Wapama Rock rises above Hetch Hetchy Reservoir. This rock face, 1,800 feet (549m) at its maximum extent, provides a Hetch Hetchy counterpart to Yosemite Valley's El Capitan.

Facing page: Sunset on Kolana Rock, 5,774 feet (1,760m), is reflected onto the Hetch Hetchy Reservoir. This was taken in one of those rare years when the reservoir was actually full (July 1995), and there is no "ring around the bathtub" effect.

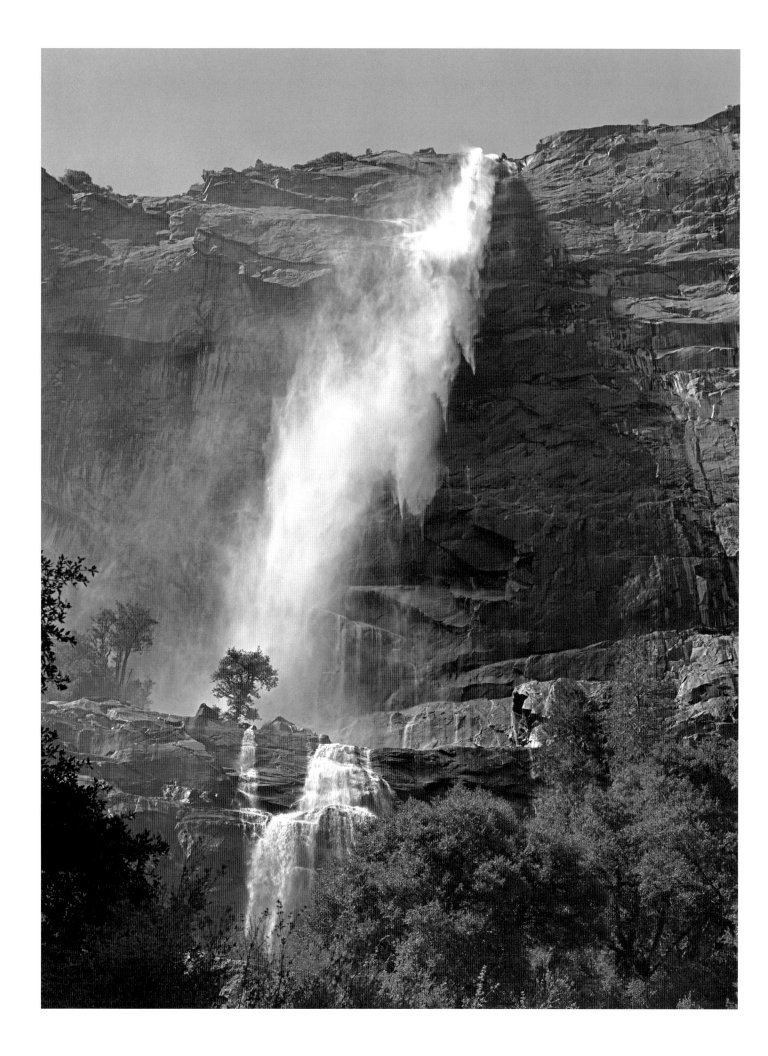

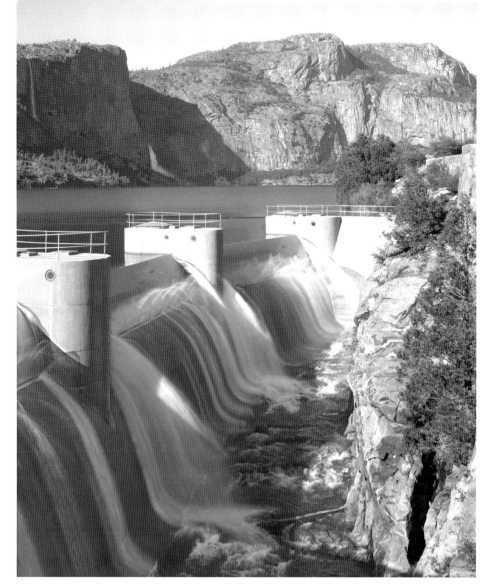

Facing page: Tueeulala Falls, with a drop of approximately 880 feet (268m), is located toward the left (west) end of Wapama Rock in Hetch Hetchy. This beautiful waterfall is just as outstanding as any in Yosemite Valley.

Left: This picture, though not artful in any respect, is included to show the spillways open at O'Shaughnessy Dam in one of those rare years when the Hetch Hetchy reservoir was actually full. The photo was taken July 10, 1995. Tueeulala Falls is at the upper left edge of the frame, and Wapama Falls is at upper left center. Between the two falls is Wapama Rock. Hetch Hetchy Dome, 6,197 feet (1,889m), is at the upper right center.

Below: A walk of about 2 miles (3.2km) along the Hetch Hetchy Trail on the north side of the reservoir yields this artistic view, taken in 1976, of the reservoir and rock forms of Hetch Hetchy, marred only by the "ring around the bathtub" effect caused by the drought at the time. Hetch Hetchy Dome is on the left and Kolana Rock is on the right. Manzanita, *Arctostaphylos manzanita*, provides color at the lower right.

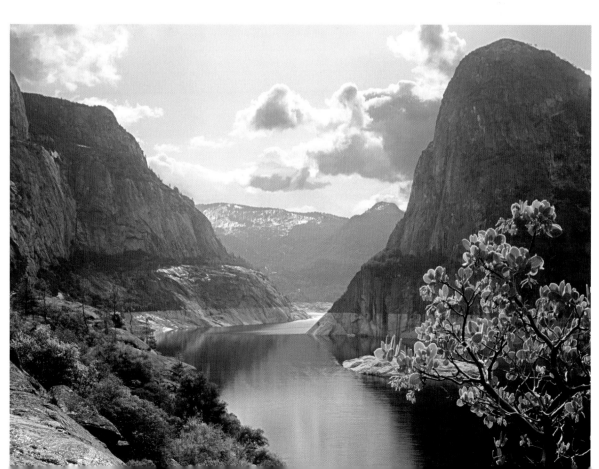

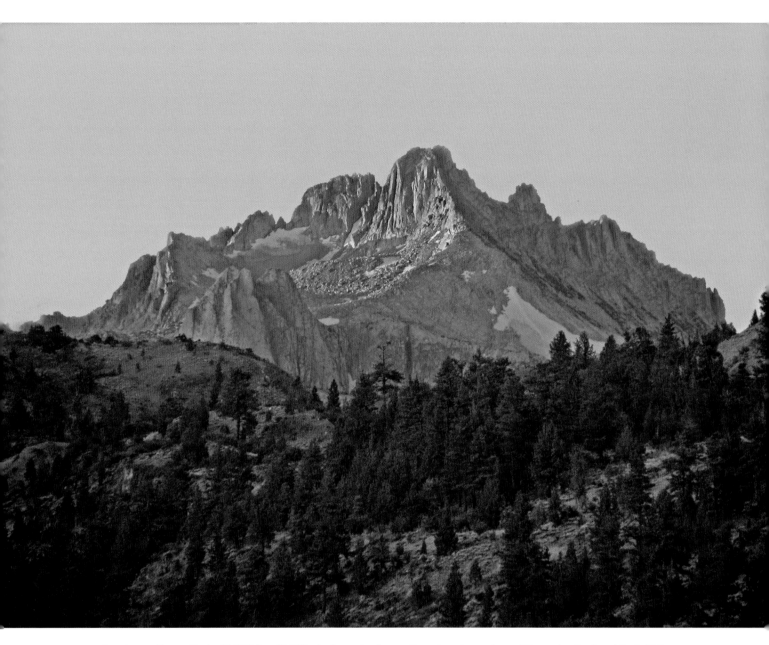

Sunrise on Tower Peak, 11,755 feet (3,583m), along the far northeastern boundary of Yosemite National Park. This view, looking south, was taken from CA 108, the Sonora Pass Highway, at Leavitt Meadows, right next to the U.S. Marine Corps Mountain Warfare Training Center. This digital photo was taken with a Nikon P90 set at 24x telephoto. This is the most northerly of the high granite peaks in the Sierra Nevada; north of here, the peaks are mostly of volcanic origin.

9

‎

EASTERN PERIPHERY

The most spectacular alpine scenery in Yosemite National Park is found along the northeastern and eastern boundaries of the park. So are the highest peaks, including Matterhorn Peak, Mount Conness, Mount Dana, and Mount Lyell, the loftiest in the park. Some of the best views of these peaks, ridges, and associated lakes, moraines, and glaciers, lie outside of the park's boundary, or on the peaks themselves. This section showcases the best of the peaks and views, with a description of where the photos were taken, whether from or near a road, or in a remote location. The progression is more or less from north to south.

7

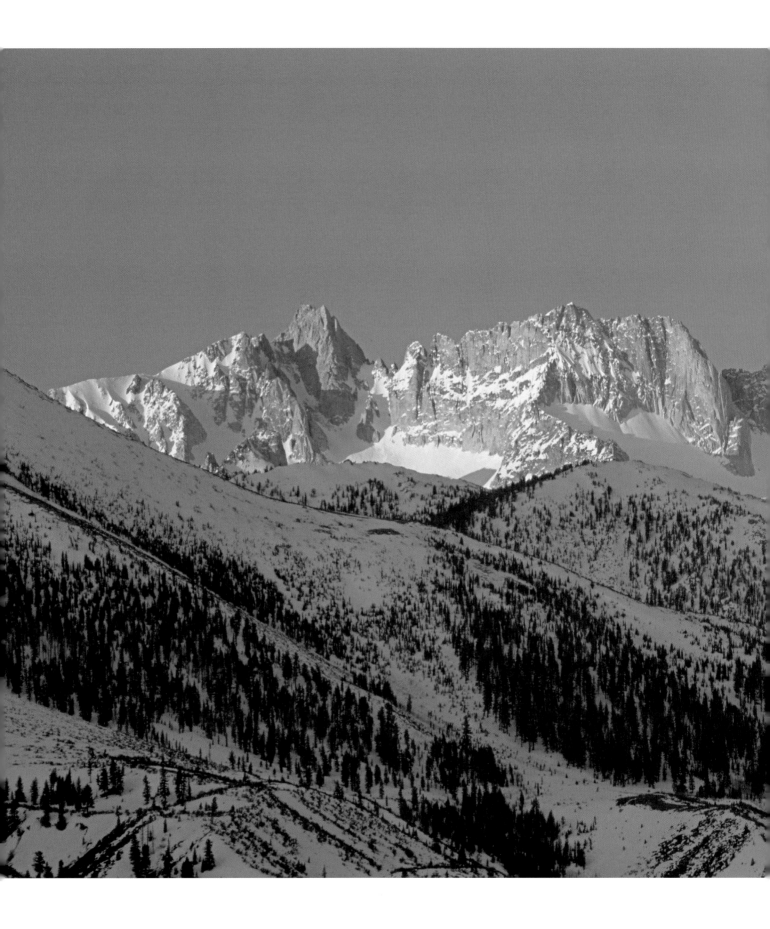

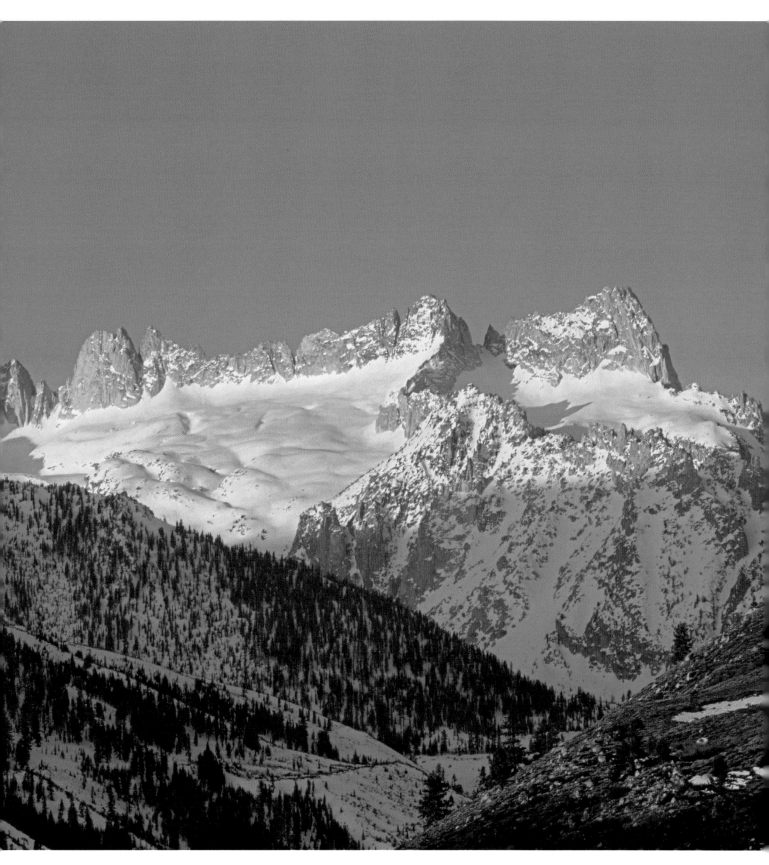

Sunrise on Sawtooth Ridge along the northeastern boundary of Yosemite National Park. This ridge forms the divide between the park and the Hoover Wilderness in Humboldt-Toiyabe National Forest, seen on this side of the divide. Matterhorn Peak, 12,279 feet (3743m), on the left, is the highest in the group. There are no peaks in the Sierra Nevada that reach 12,000 feet north of here. This view was taken along the Twin Lakes Road, which leaves US 395 at Bridgeport.

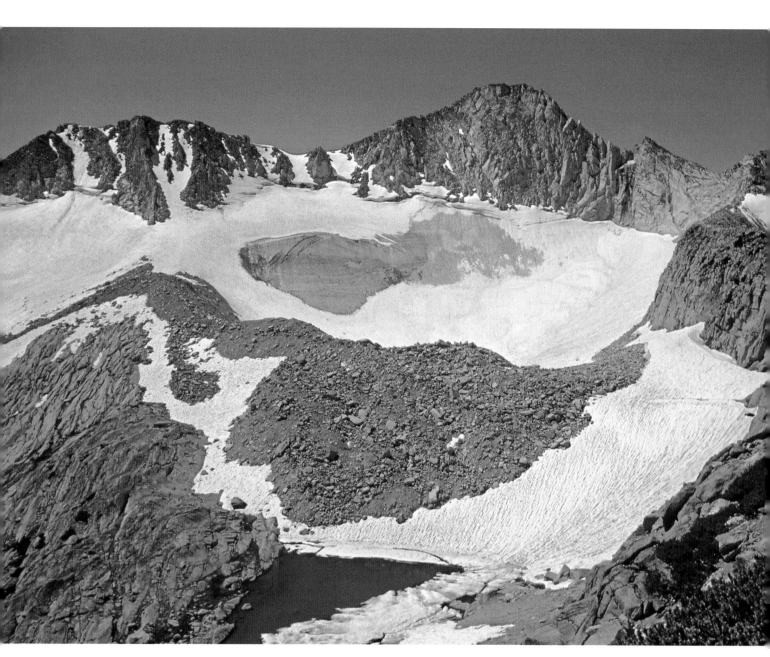

Above: Mount Conness, 12,590 feet (3,837m), on the eastern boundary of Yosemite National Park overlooking the Inyo National Forest. This view, taken from the Harvey Monroe Hall Research Natural Area, shows the Conness Glacier below the peak, the terminal moraine (the large pile of rocks) below the glacier, and one of the Conness Lakes below the glacier. This view was reached, partly by cross-country travel, from Saddlebag Lake. The road to Saddlebag Lake goes north from the Tioga Pass Road 2 miles (3.2km) east of Tioga Pass.

Facing page: This profile of the steep granitic southwest face of Mount Conness, one of the longest and most difficult alpine-style climbs in Yosemite's high country, is seen from near the summit of Mount Conness. The southwest face of the peak is prominently visible from Olmsted Point on the Tioga Pass Road.

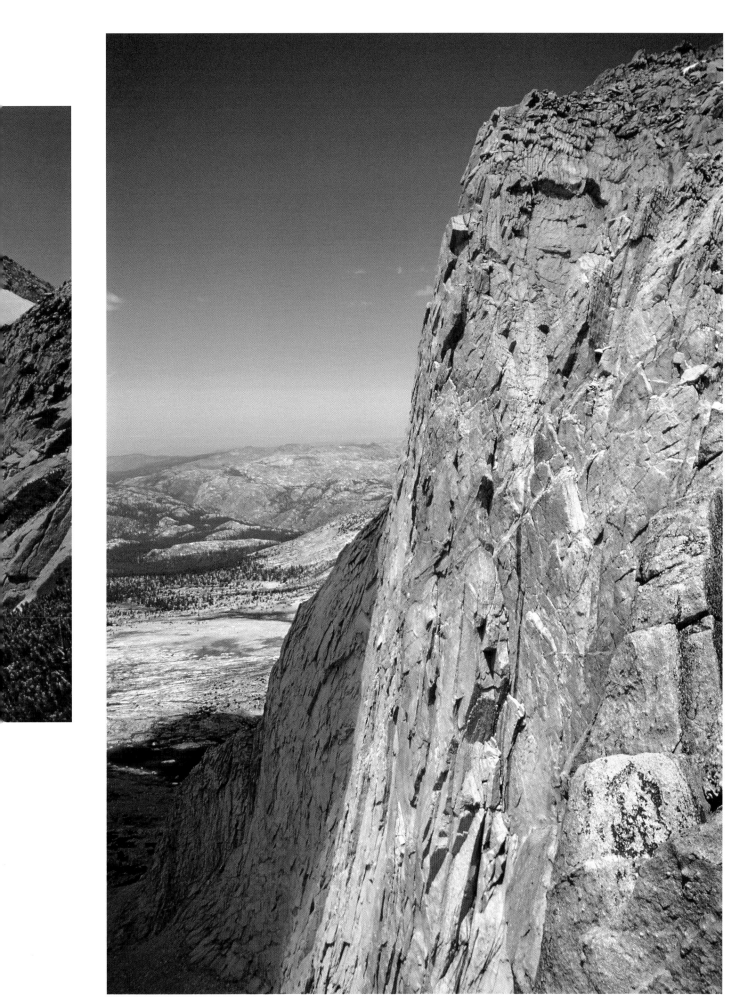

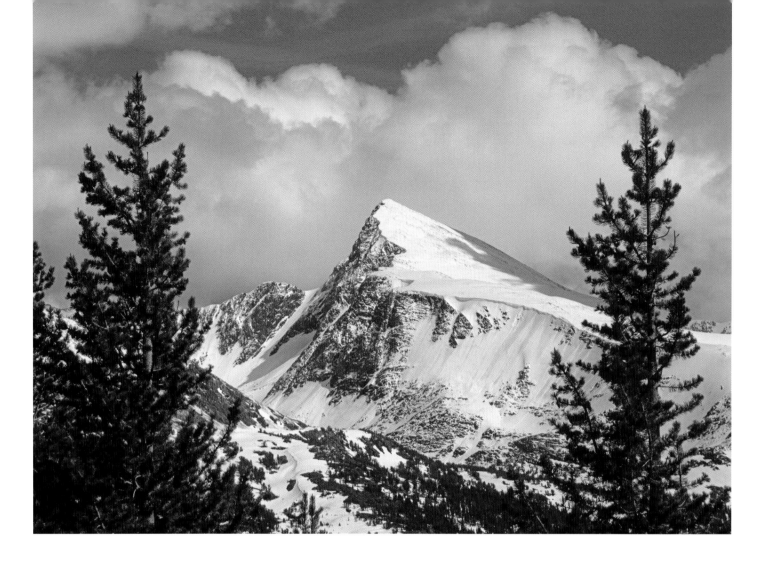

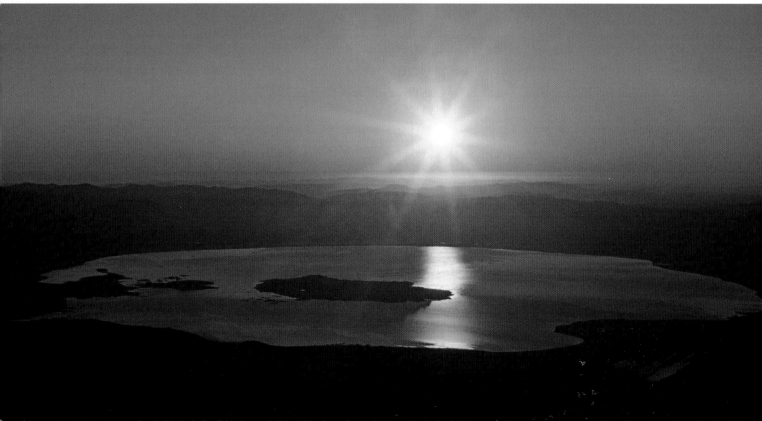

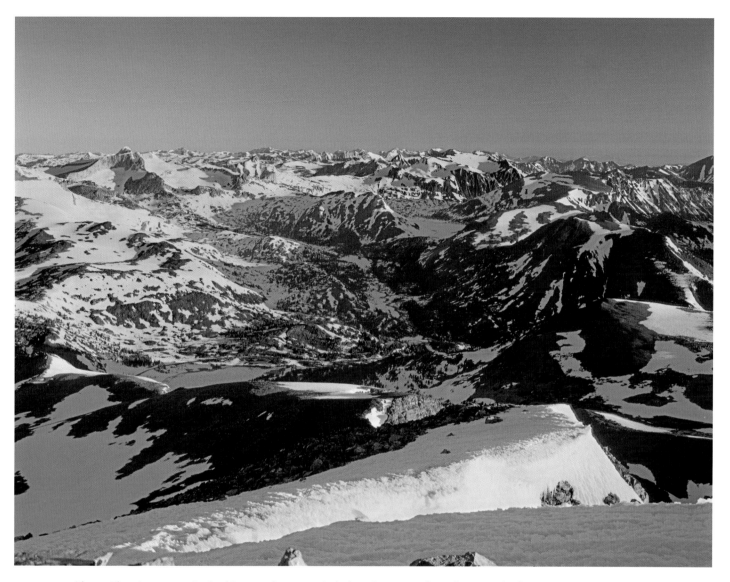

Above: The view at sunrise looking north to a myriad of peaks as seen from the summit of Mount Dana.

Facing page, top: This view of the sharp profile of the northeast face of Mount Dana, on the left, shows a very different aspect of this peak, which appears more rounded when viewed from Tuolumne Meadows. This image was taken near the northwestern shore of Saddlebag Lake.

Facing page, bottom: This view of sunrise over Mono Lake was taken from the summit of Mount Dana. The climb itself, starting from Tioga Pass, is fairly easy. The principal difficulty is the altitude, 13,057 feet (3,980m), and—for me—the cold and wind on the peak at the early hour I took the picture. Much of the climb was done by flashlight.

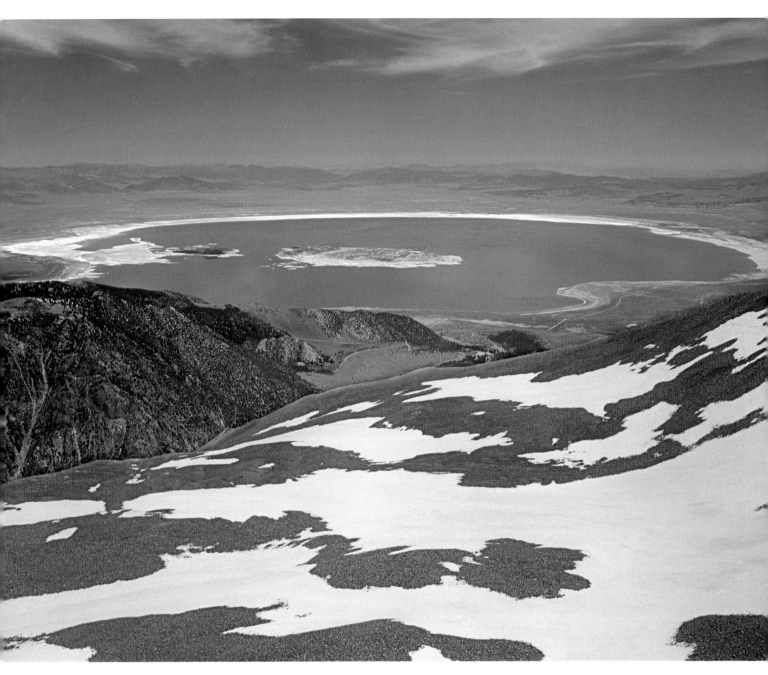

Above: A view of Mono Lake from near the summit of Mount Dana, showing the drawdown of the lake level to send water to thirsty Southern California. Fortunately, due to court action, the lake level will be stabilized at a level sufficiently high to make sure predators cannot reach bird nesting sites on Negit Island.

Facing page, top: The northeast face of Mount Dana and the Dana Glacier, showing a prominent terminal moraine at the lower left. The summit marks the boundary with Yosemite National Park, and the glacier is located within the neighboring Inyo National Forest. This glacier cannot be seen from any highway. To reach this viewpoint, contour around the east side of the peak from Tioga Pass and climb up on the Dana Plateau high enough to see the glacier.

Facing page, bottom: The northeast face of Mount Dana as seen from the eastern shoulder of the peak, reached by dropping down to the shoulder from the summit.

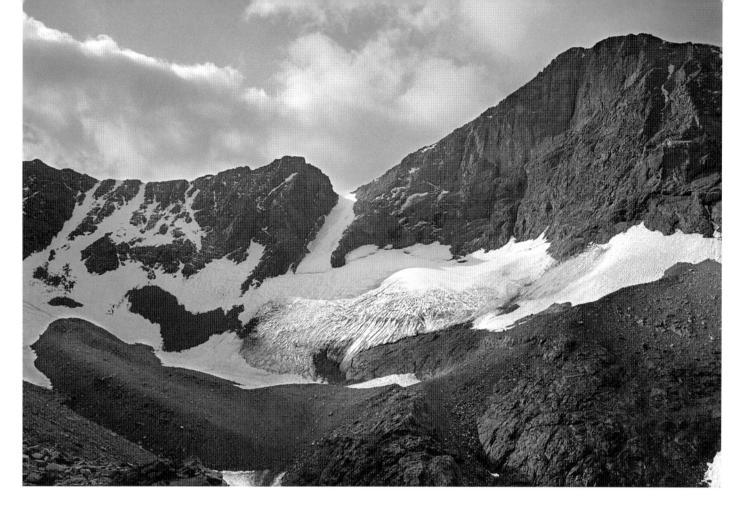

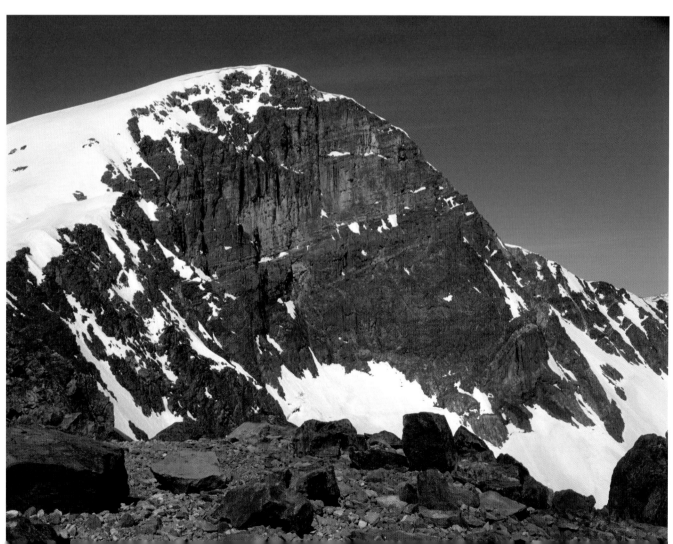

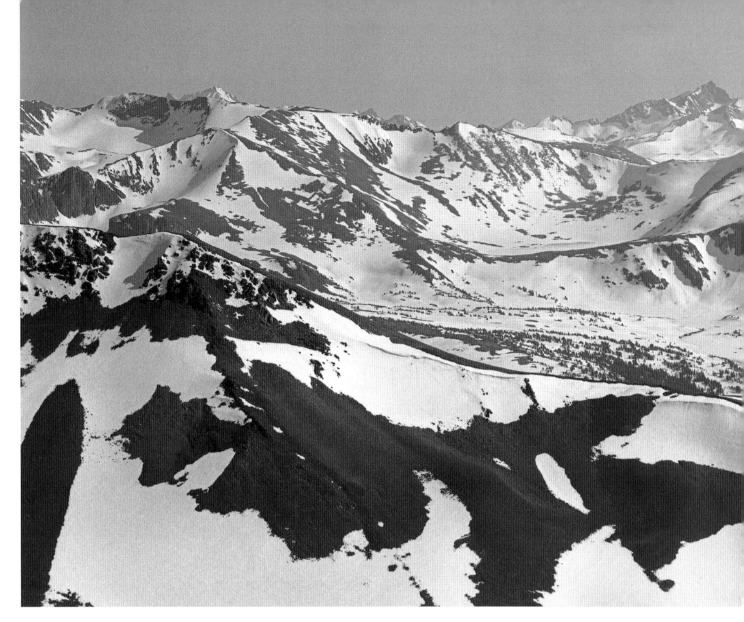

Above: This view looks south from the summit of Mount Dana. Mount Lyell, 13,114 feet (3,997m), the highest peak in Yosemite National Park, is on the skyline just to the right of center. The Lyell Glacier is immediately below the summit.

Facing page, bottom: This close-up view of the north side of Mount Lyell shows the Lyell Glacier. The mound of dirt and gravel at the lower center and right of the frame is the terminal moraine of the glacier. To obtain this photo, I made a detour slightly west off the John Muir Trail near Donahue Pass.

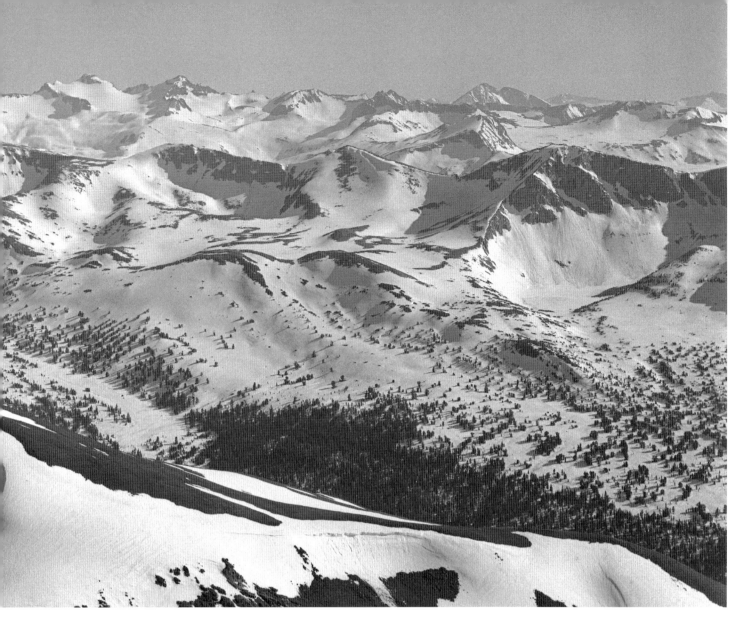

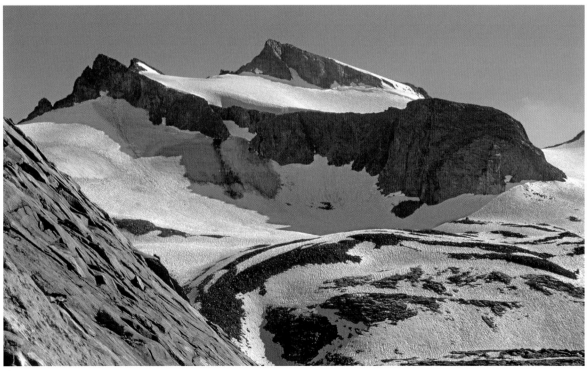

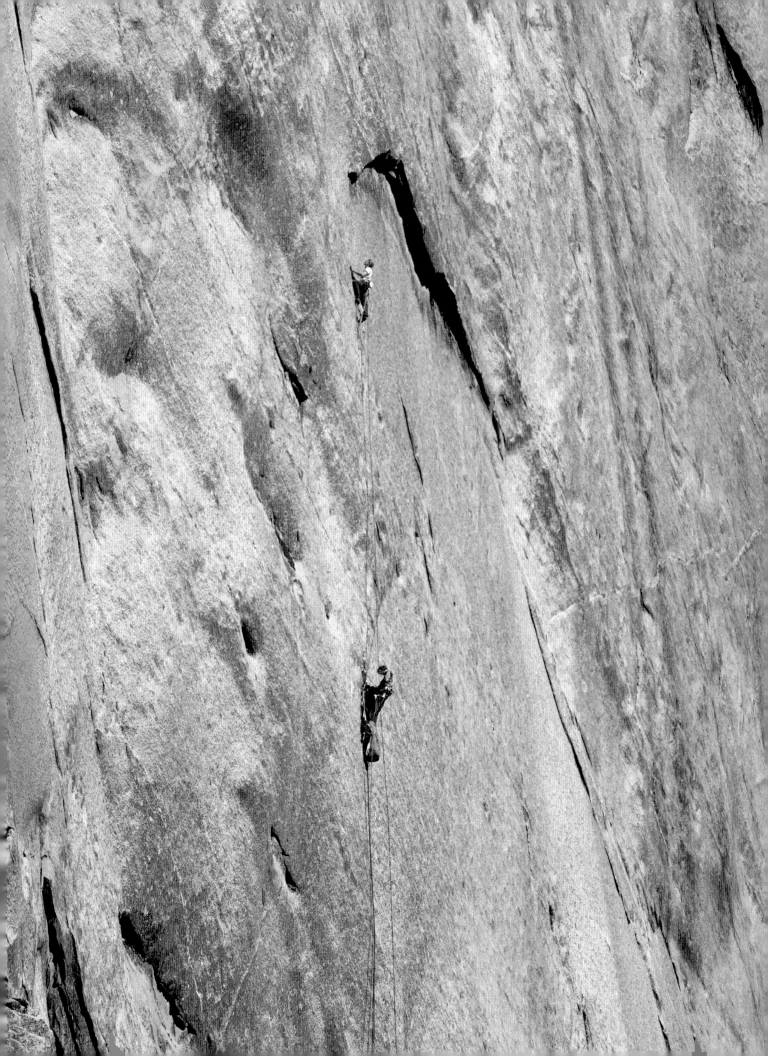

CLIMBING IMAGES

In many respects, Yosemite Valley is the rock climbing center of the world. Climbers from all over the globe come here to test their skills. Big-wall climbing techniques evolved here before being used anywhere else. Big-wall climbing in Yosemite was also the impetus for the development of hardware and equipment now commonly used by rock climbers everywhere in the world.

Camp 4, on the valley floor, was the center of the big-wall climbing world in the 1950s and 1960s, and the reputations of some of the climbing world's most respected members were made on these walls. Portraits of climbers on historic ascents or legendary routes, including Jim Bridwell, Galen Rowell, and Steve Roper, are shown in this chapter.

My involvement in Yosemite climbing was limited, but I did participate in the first ascent of the *Dihedral Wall* on El Capitan in 1962 with Jim Baldwin and Glen Denny. I look upon this experience from an aesthetic perspective; my photos show the unusual geometry as seen from Yosemite's walls. Climbing is another way of experiencing the *Soul of Yosemite*.

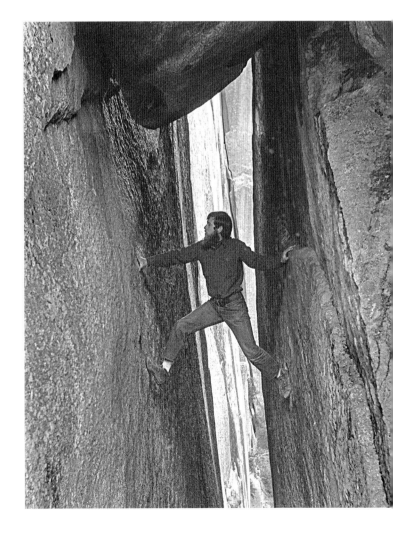

Right: Jim Stuart (1944–1988), climber and photographer, in the *Iota Chimney* above the Big Oak Flat Road leading into Yosemite Valley.

Facing page: Kim Schmitz and Jim Bridwell in the process of making the first ascent of the *Aquarian Wall* on El Capitan, seen on March 19, 1971.

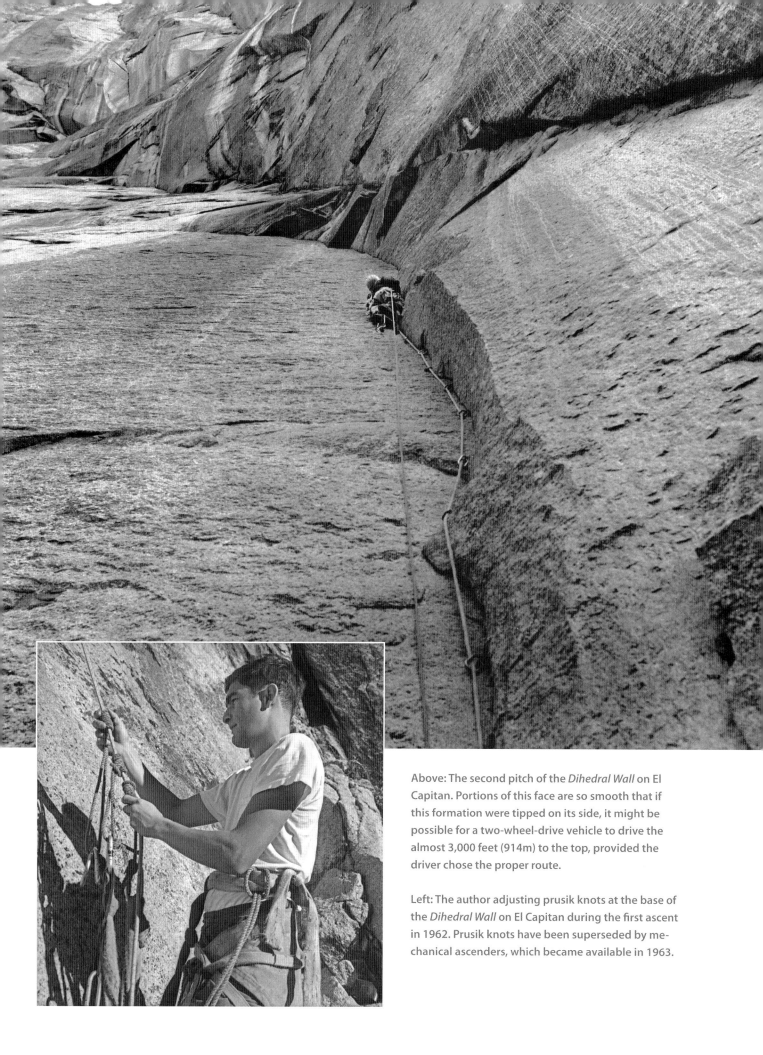

Above: The second pitch of the *Dihedral Wall* on El Capitan. Portions of this face are so smooth that if this formation were tipped on its side, it might be possible for a two-wheel-drive vehicle to drive the almost 3,000 feet (914m) to the top, provided the driver chose the proper route.

Left: The author adjusting prusik knots at the base of the *Dihedral Wall* on El Capitan during the first ascent in 1962. Prusik knots have been superseded by mechanical ascenders, which became available in 1963.

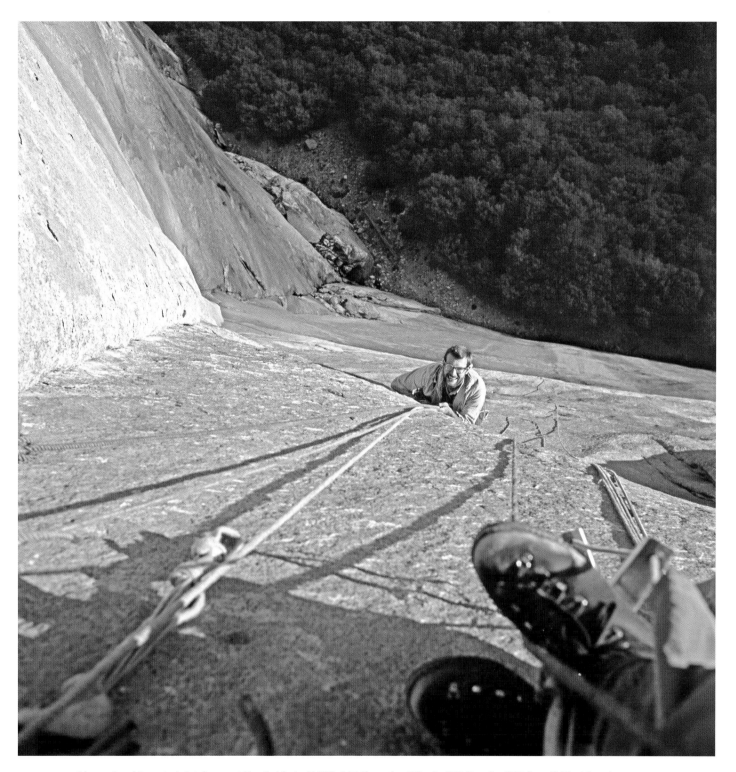

Above: Looking straight down at Jim Baldwin (1938–1964) on the *Dihedral Wall* at the 700-foot (213m) level.

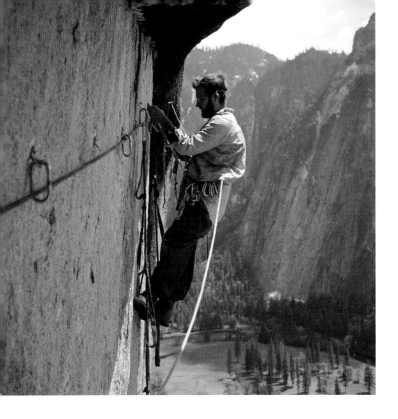

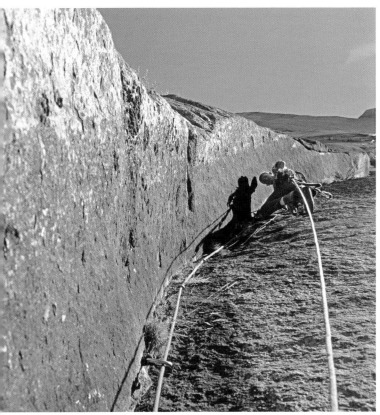
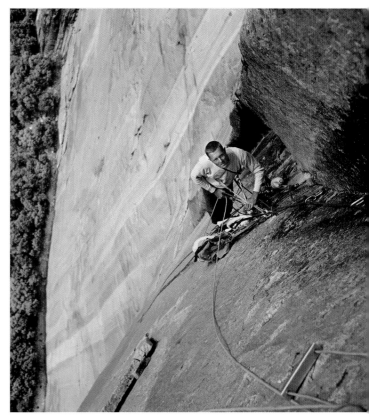

Top, left: Jim Baldwin at the triangular roof at the 700-foot level on the *Dihedral Wall*. Middle Cathedral Rock is in the background.

Top, right: Ascending a fixed rope at the 700-foot level on the *Dihedral Wall*.

Bottom, left: Glen Denny nearing the 900-foot level on the *Dihedral Wall*.

Bottom, right: Glen Denny at a belay station at about the 900-foot level on the *Dihedral Wall*.

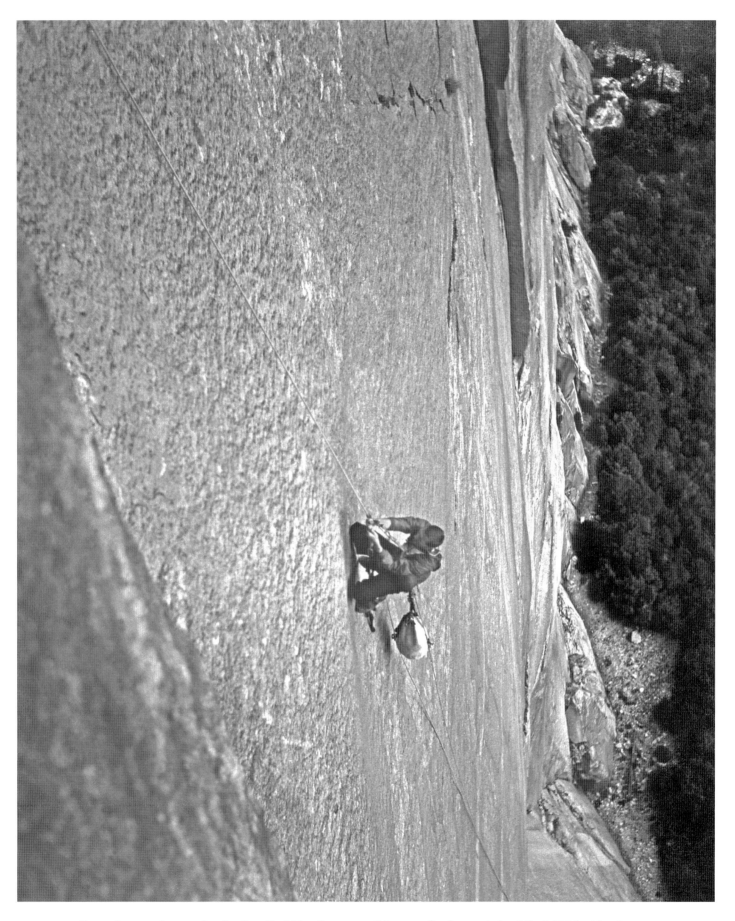

Above: Acres and acres of rock, all vertical! Glen Denny prusiking up a fixed rope at about the 1,000-foot level (305m) on the *Dihedral Wall*.

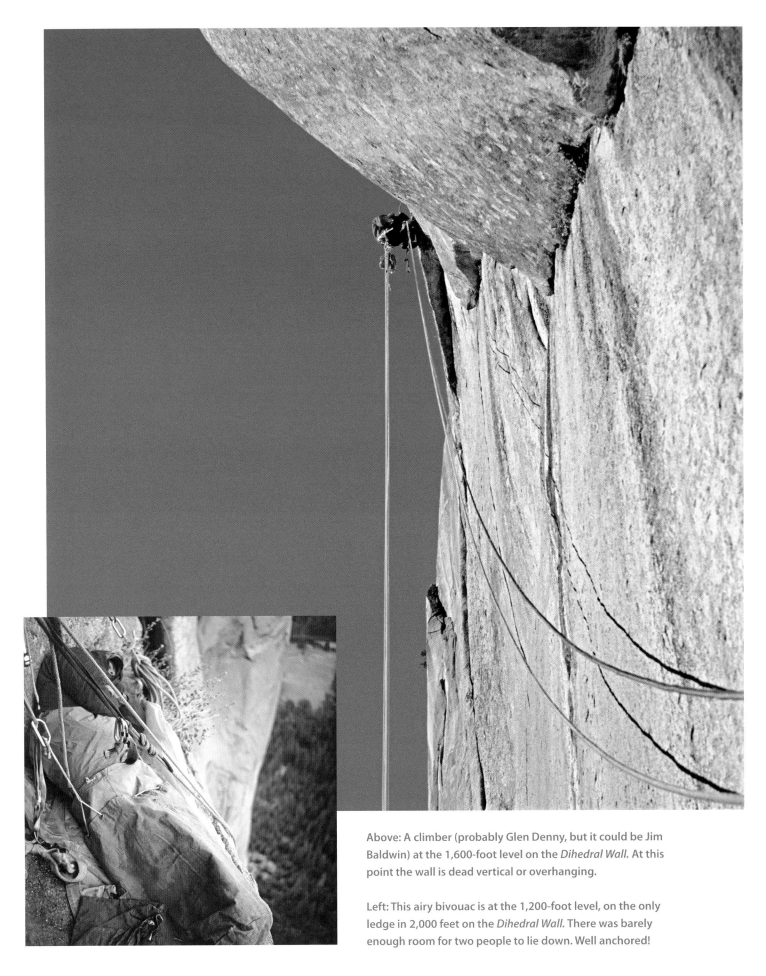

Above: A climber (probably Glen Denny, but it could be Jim Baldwin) at the 1,600-foot level on the *Dihedral Wall*. At this point the wall is dead vertical or overhanging.

Left: This airy bivouac is at the 1,200-foot level, on the only ledge in 2,000 feet on the *Dihedral Wall*. There was barely enough room for two people to lie down. Well anchored!

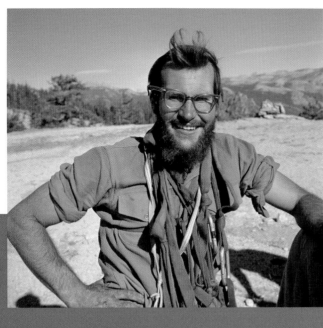

Left: Jim Baldwin on top of El Capitan after making the first ascent of the *Dihedral Wall* in November 1962. Jim was Canada's first full-time "climbing bum."

Below: Climbing at about the 1,700-foot level on the *Dihedral Wall*. The route goes over the overhang on the right side. The rope is hanging free. Again this is either Jim Baldwin or Glen Denny.

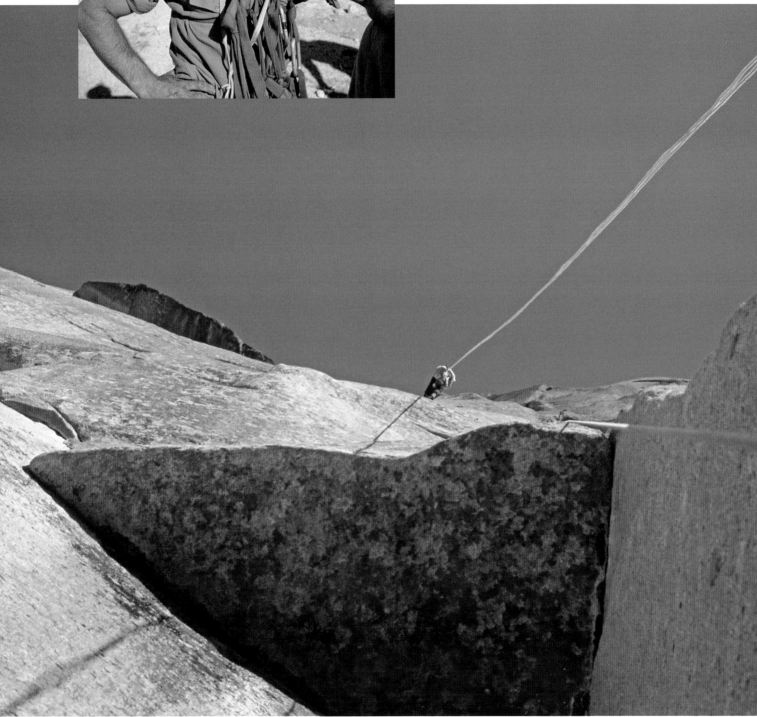

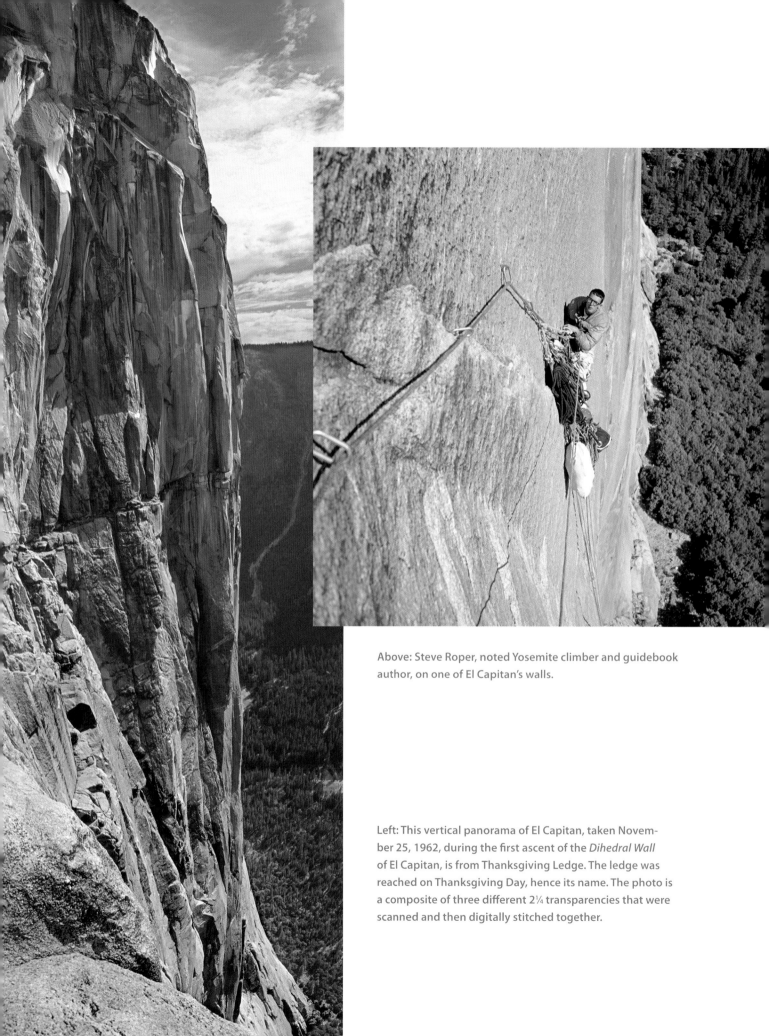

Above: Steve Roper, noted Yosemite climber and guidebook author, on one of El Capitan's walls.

Left: This vertical panorama of El Capitan, taken November 25, 1962, during the first ascent of the *Dihedral Wall* of El Capitan, is from Thanksgiving Ledge. The ledge was reached on Thanksgiving Day, hence its name. The photo is a composite of three different 2¼ transparencies that were scanned and then digitally stitched together.

Above: Dennis Hennek and Don Lauria on the second ascent of the *North American Wall* on El Capitan (April 7, 1968).

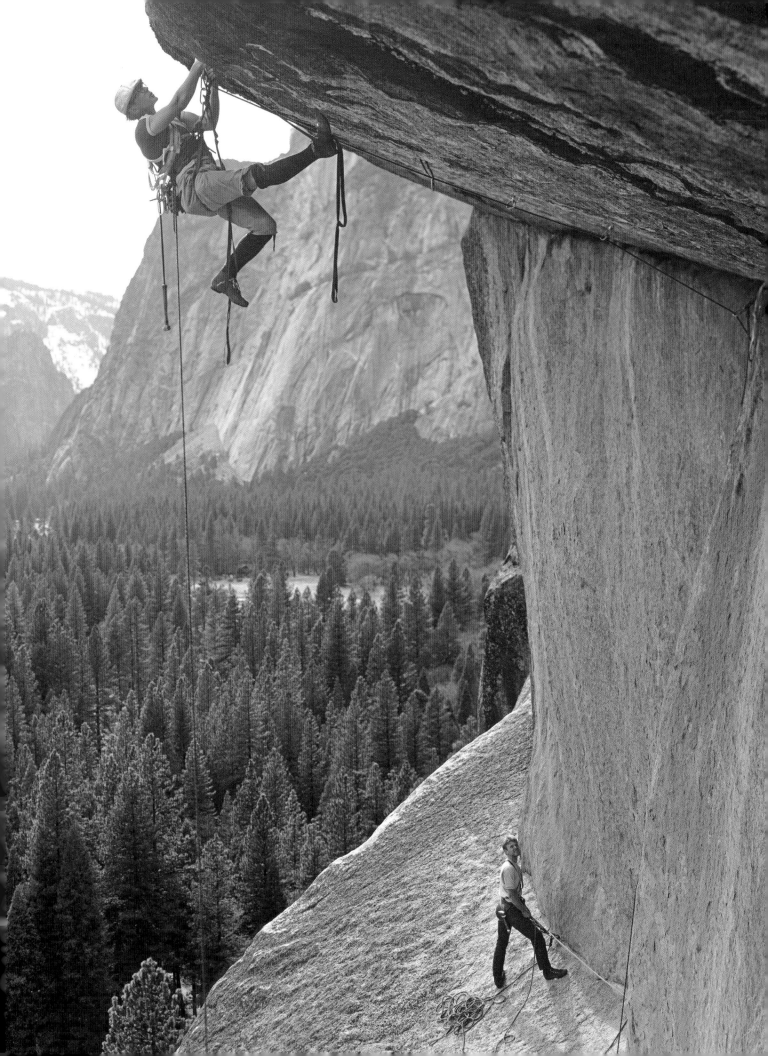

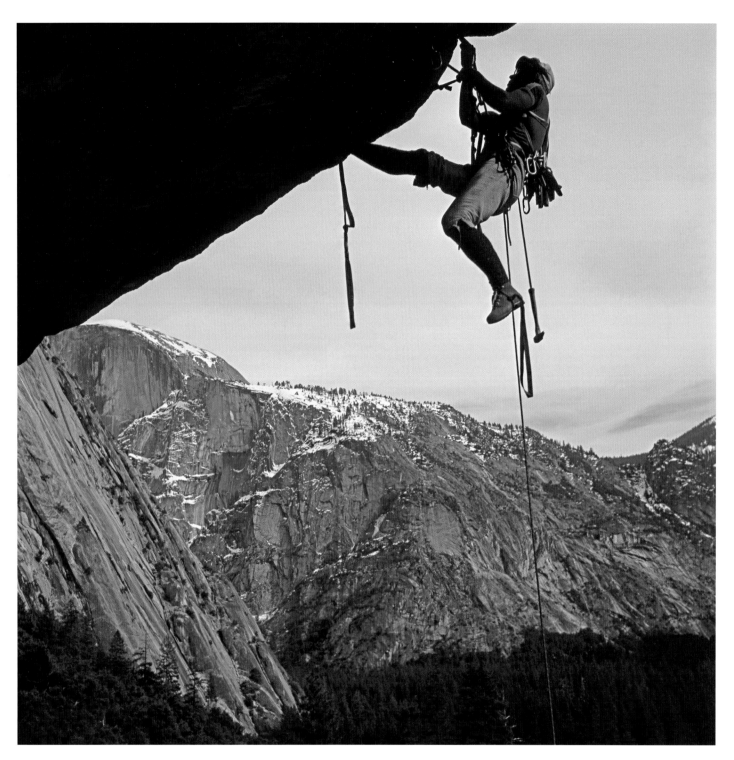

Above: Jack Miller on the Bishops Balcony roof above Bishops Terrace, with Half Dome in the background.

Facing page: Jack Miller, climber and sometime guide, on the Bishops Balcony roof above Bishops Terrace and an unidentified climbing partner. The rock in the background is part of the Three Brothers.

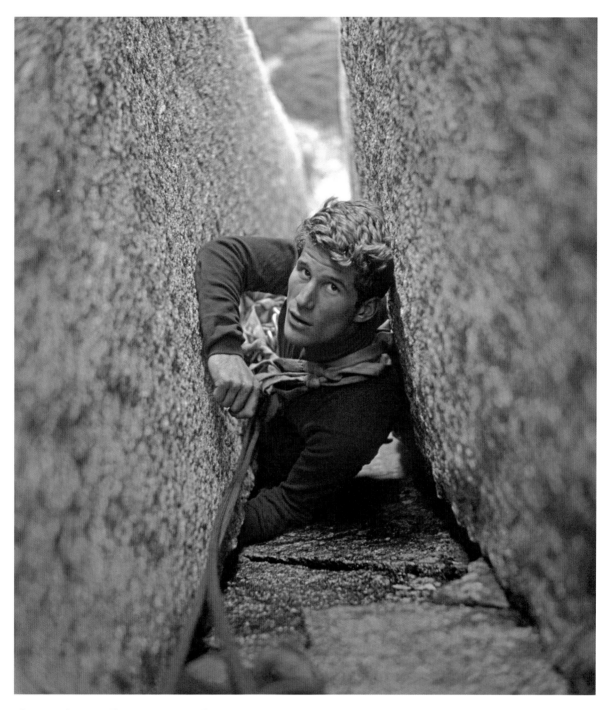

Above: Galen Rowell (1940–2002), well-known American mountaineer, photographer, and author, climbing in Yosemite Valley in 1963.

Facing page: Climbers near the top of the northwest face of Half Dome at sunset.

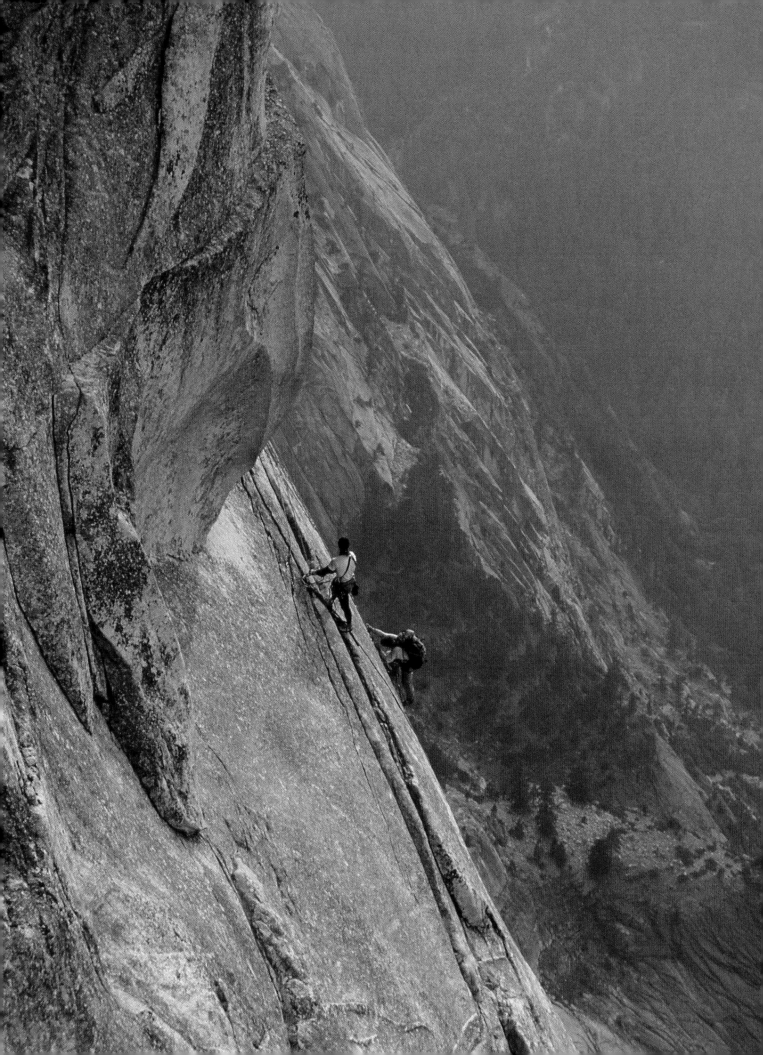

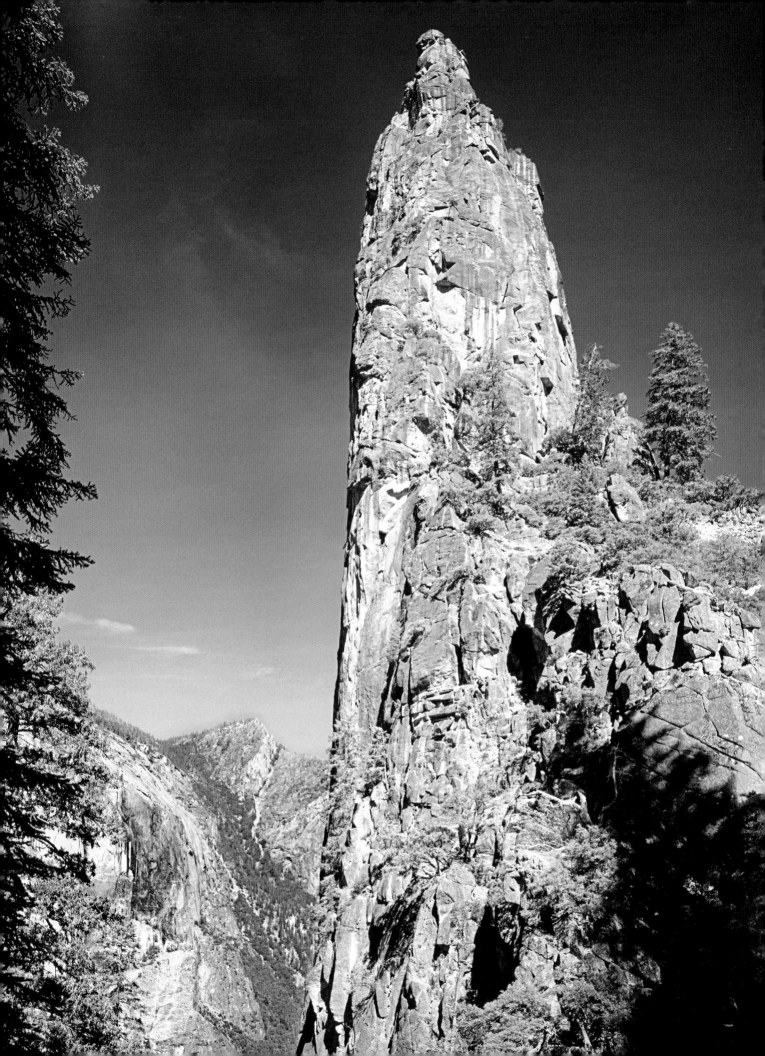

TRAILS AND HIKING VIEWS

Some of the best views of the great rock formations in the Yosemite Valley are found along park trails that climb from the valley floor into the high country. Or you can find them yourself by simply climbing upwards through forest and talus slopes, forging your own trail. This section profiles several such views, including images of Nevada Fall and Vernal Fall and the infamous cable route to the summit of Half Dome.

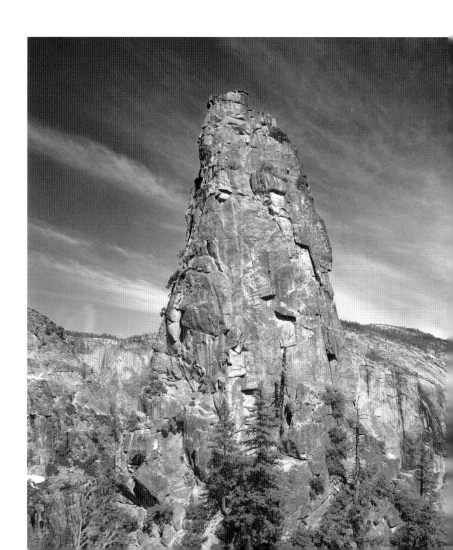

Right: A pullout along Southside Drive, close to the El Capitan Bridge, offers a good view of the Cathedral Spires. An easy-to-find climber's trail ascends steep talus slopes toward the spires from here. You can choose a variety of viewpoints just by exploring the area. This image pictures the Higher Cathedral Spire, site of the first technical rock climb done in Yosemite Valley in 1934.

Facing page: A second view of the Higher Cathedral Spire, taken slightly lower, shows the 1,000-foot (305m) vertical profile of the northwest face.

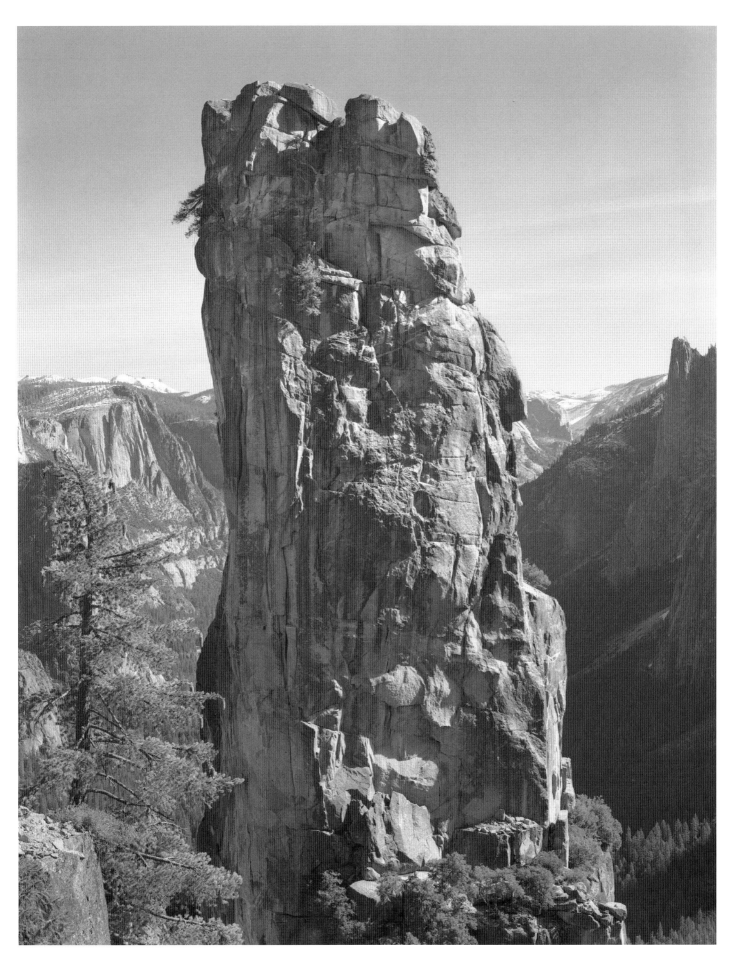

Above: Lower Cathedral Spire is shown against the background of Yosemite Valley. Lost Arrow Spire is visible in the distance on the left, and the sharp profile of Sentinel Rock is on the right.

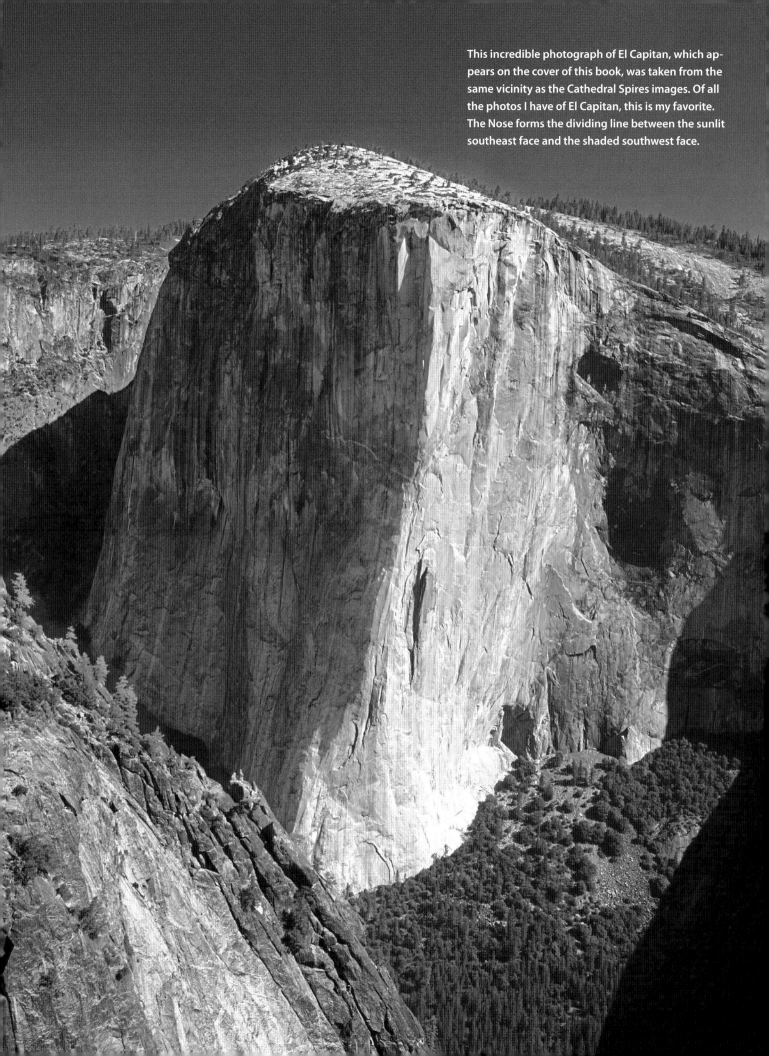

This incredible photograph of El Capitan, which appears on the cover of this book, was taken from the same vicinity as the Cathedral Spires images. Of all the photos I have of El Capitan, this is my favorite. The Nose forms the dividing line between the sunlit southeast face and the shaded southwest face.

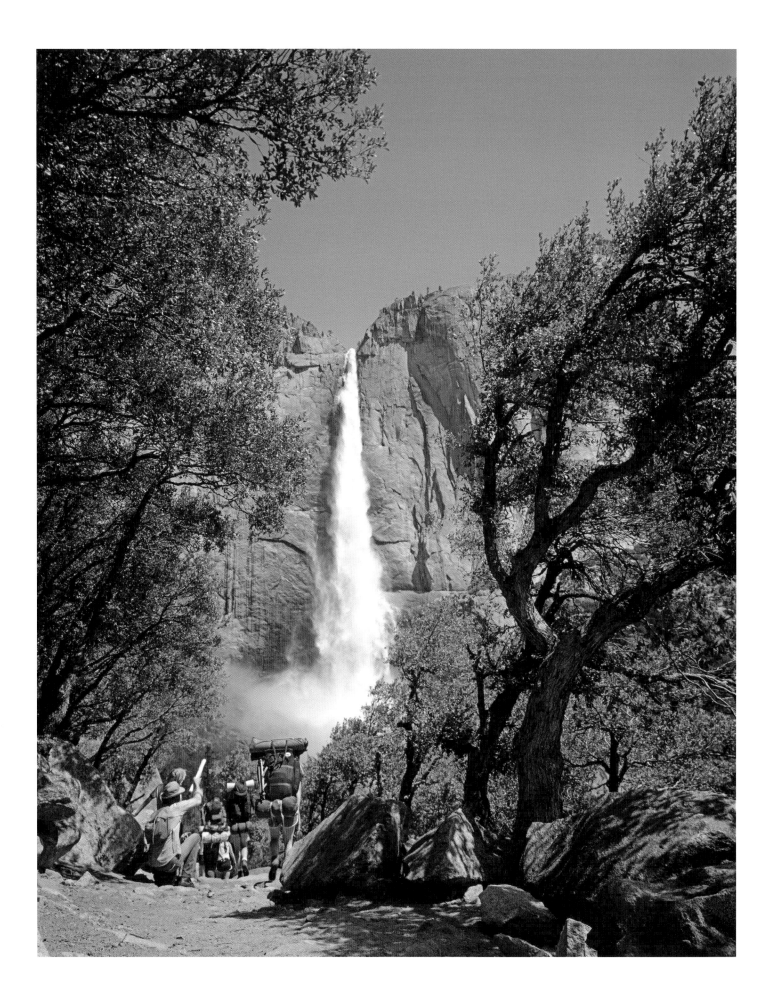

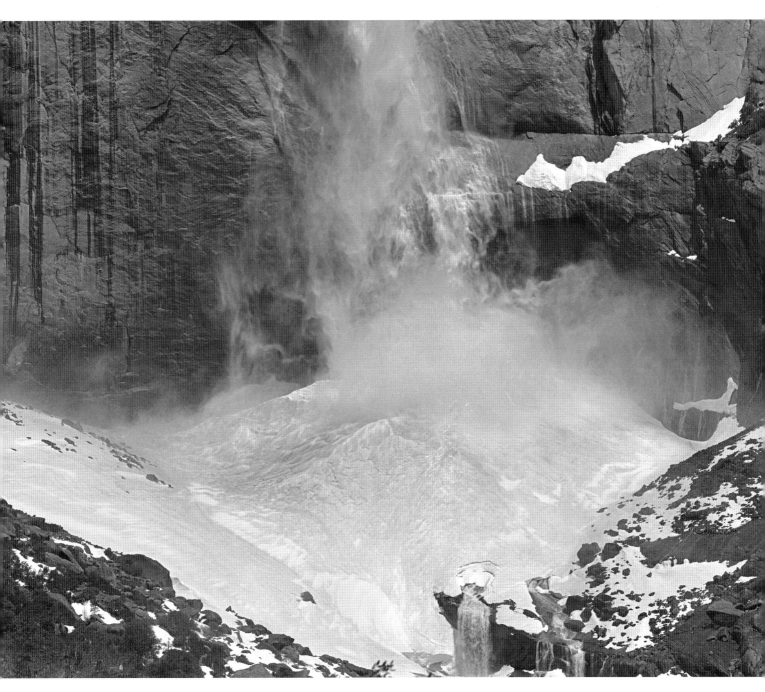

Above: Another view from the Yosemite Falls Trail shows the cone of ice that builds up at the base of Upper Yosemite Fall in early spring in years of heavy snowfall. This image was taken on May 7, 1967, after record snowfalls in March and April of that year.

Facing page: Hikers and backpackers on the Yosemite Falls Trail, with Upper Yosemite Fall in the background.

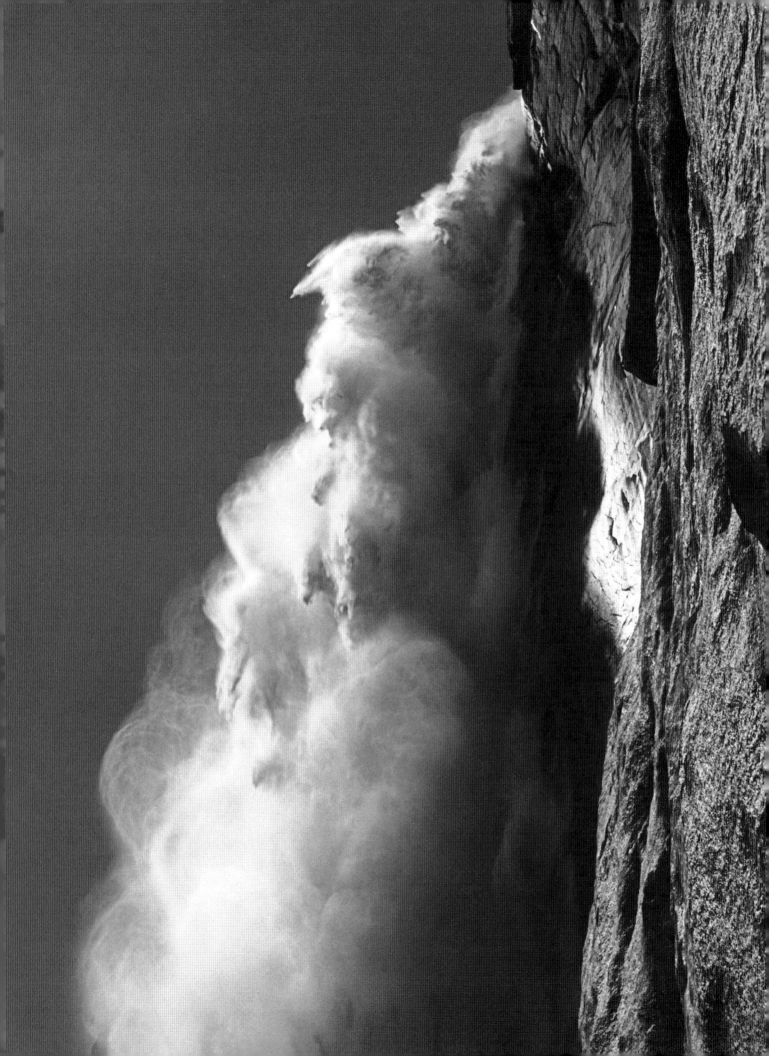

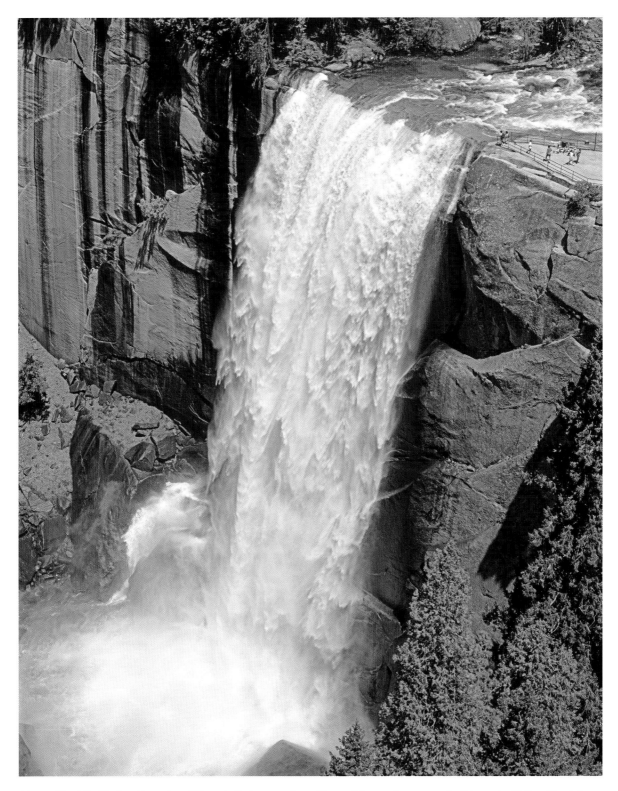

Above: The Mist Trail to Vernal and Nevada Falls starts from Happy Isles at the east end of Yosemite Valley. The John Muir Trail also starts here and follows a course somewhat parallel to and above the Mist Trail, joining the latter above Nevada Fall. Both trails offer a wealth of outstanding photographic opportunities. This image shows the Merced River at Vernal Fall, 317 feet (97m), from the John Muir Trail.

Facing page: This unusual view of Upper Yosemite Fall was obtained after scrambling up Sunny Bench and climbing up on the east side of the base of the fall.

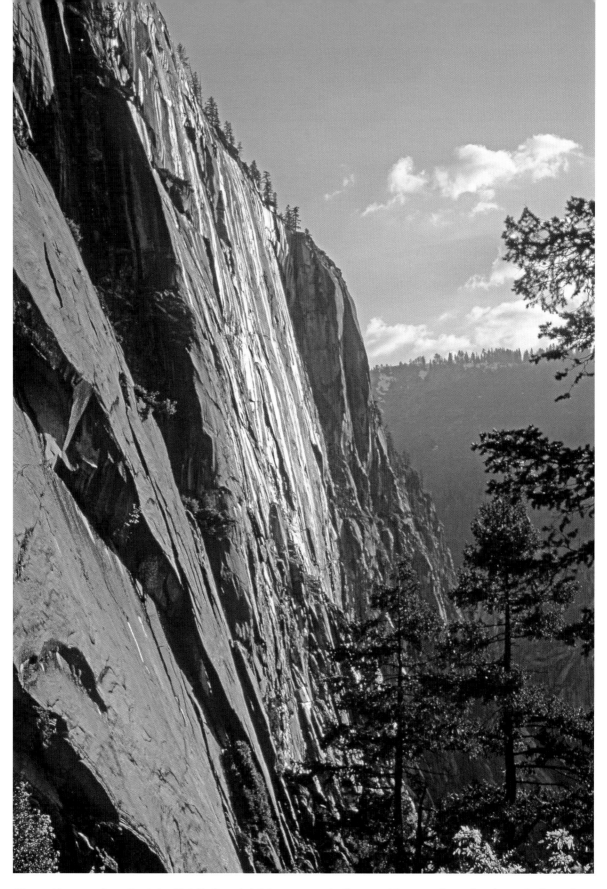

Above: Also seen from the John Muir Trail are bright water streaks (from melting snow) running down the face of Panorama Cliff.

Facing page: This view of a rainbow and Nevada Fall, 594 feet (181m), was taken from the Mist Trail below the fall.

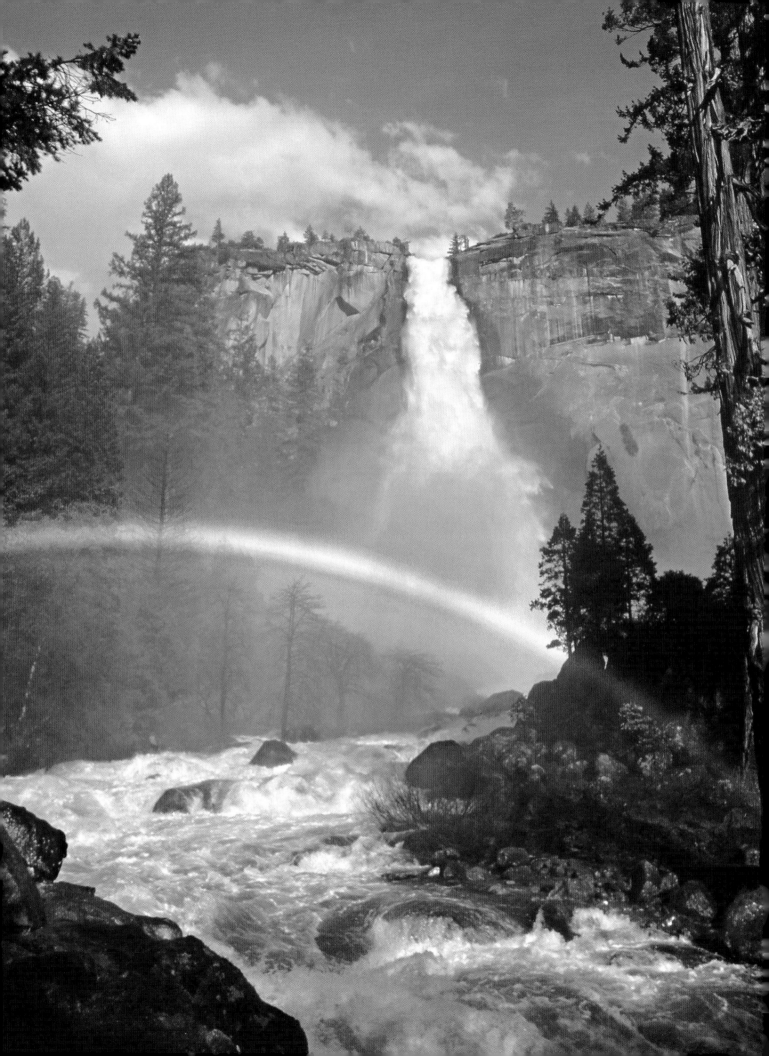

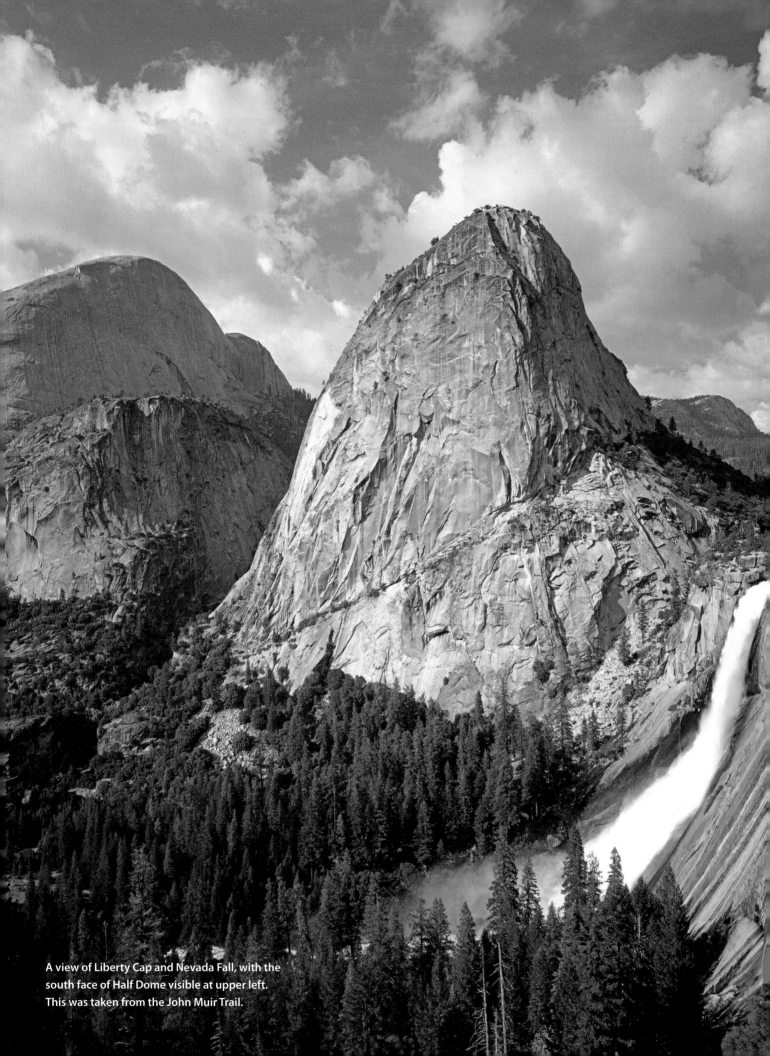

A view of Liberty Cap and Nevada Fall, with the
south face of Half Dome visible at upper left.
This was taken from the John Muir Trail.

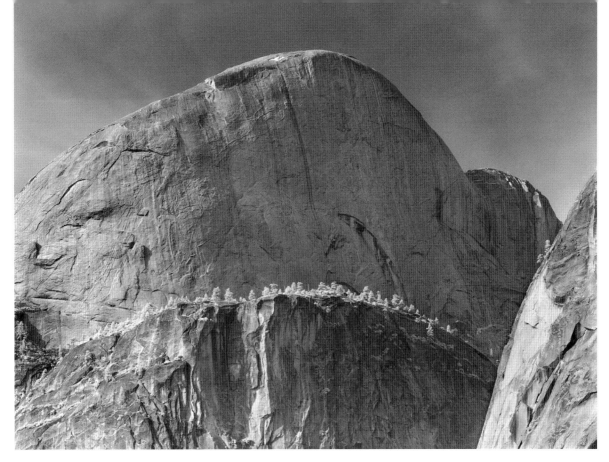

Above: Another (telephoto) view of the south face of Half Dome, 8,836 feet (2,693m), taken from near the previous site on the John Muir Trail. This has a very different look from the familiar view of the northwest face seen from the floor of Yosemite Valley; Mount Broderick forms the cliff face in front of Half Dome. This photo was taken in a 4 x 5 format using infrared film.

Below: The Mist Trail merges into the John Muir Trail above Nevada Fall. Shortly thereafter, a separate trail goes north to Half Dome. In this image two hikers contemplate the cable route up Half Dome, which is directly above them.

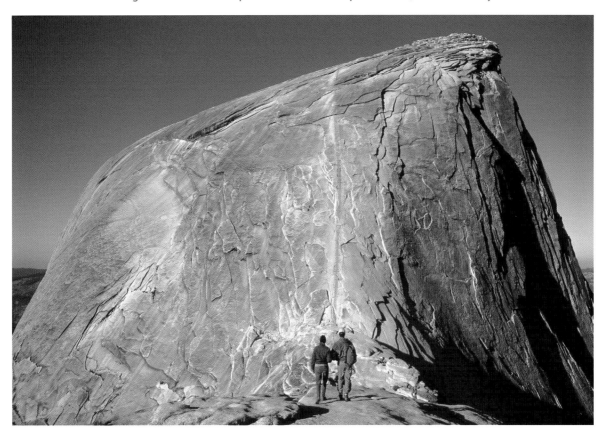

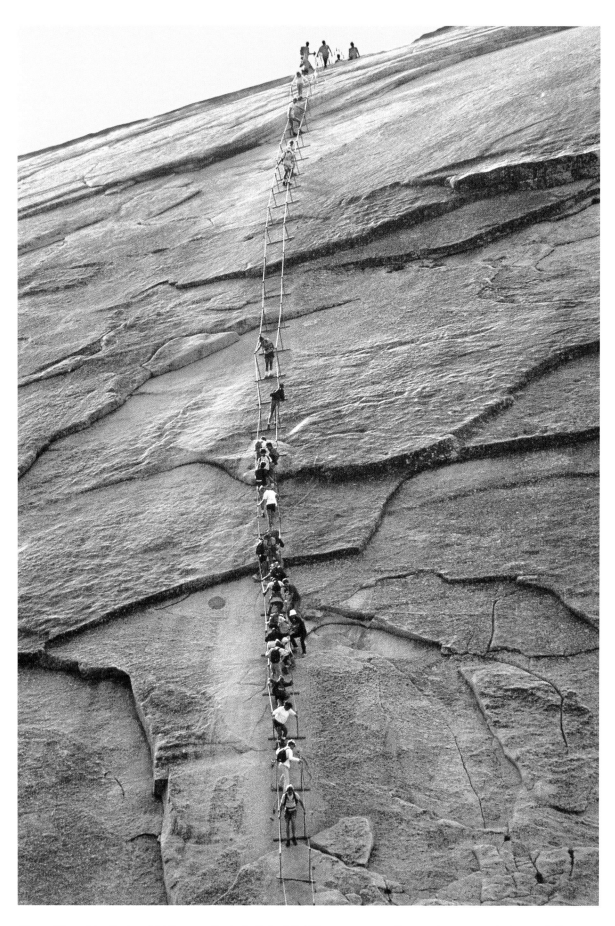

Above: The cables that assist hikers up the last pitch of Half Dome can sometimes get very crowded, especially on holiday weekends. This picture shows the route on an ordinary summer day, not a weekend. Permits issued by the National Park Service are now required to ascend the cables route on Half Dome.

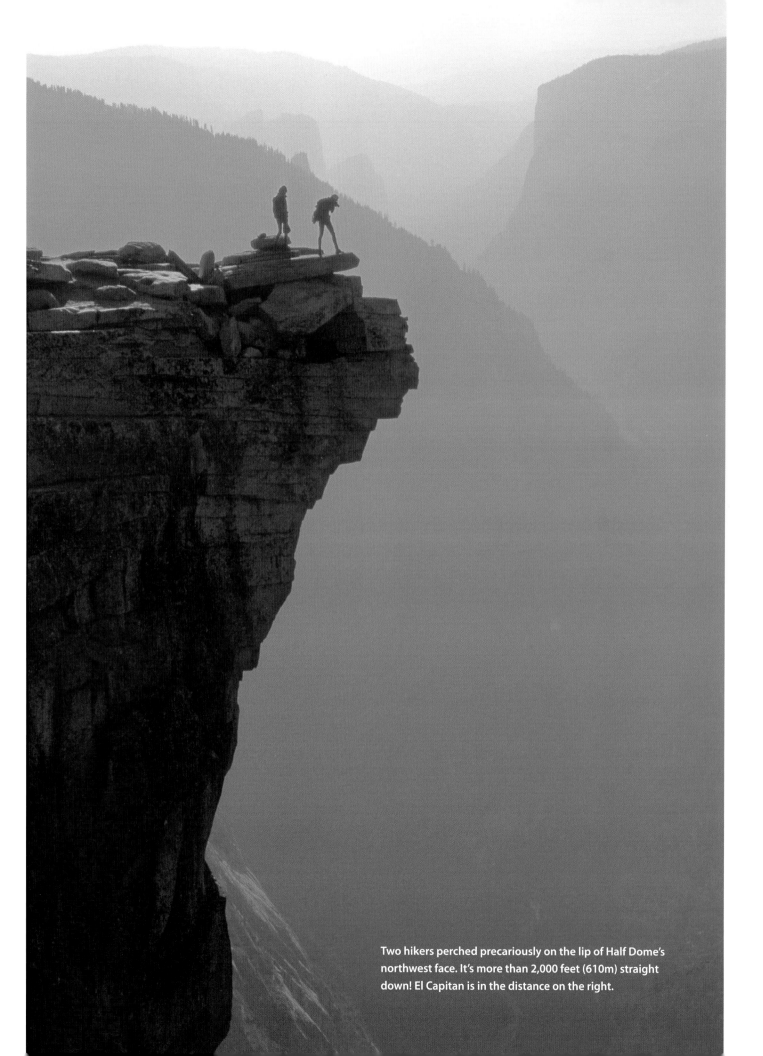

Two hikers perched precariously on the lip of Half Dome's northwest face. It's more than 2,000 feet (610m) straight down! El Capitan is in the distance on the right.

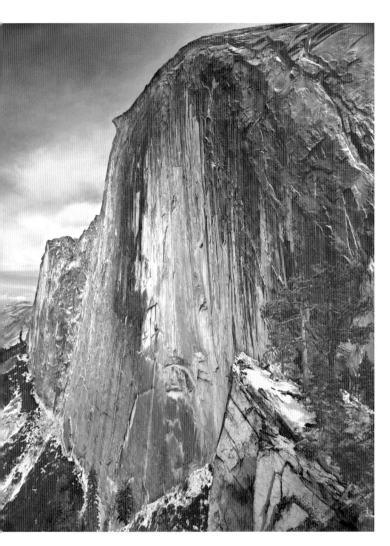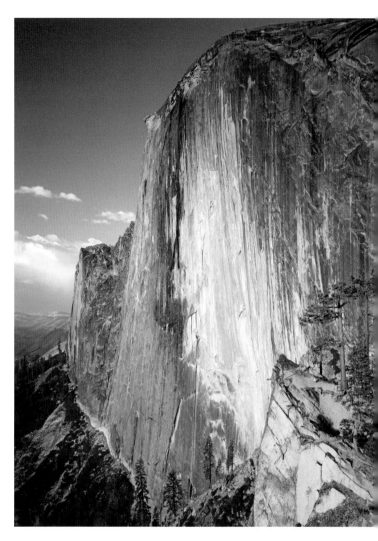

Above: These two photos of the northwest face of Half Dome were taken from the Diving Board almost 27 years apart. The first, a black and white, was taken in 1963 (thirty-six years after Ansel Adam's classic, "The Monolith," was taken in April 1927). The second, a sunset view, was taken in 1990. I have cropped the views identically; both were wide-angle views taken with a 4 x 5 camera. It is an arduous trek to reach the Diving Board, but well worth the effort. There are at least two different suggested routes. I hiked to the top of Nevada Falls, and at the appropriate point I headed for the bottom of the south face of Half Dome. I then went to the west to avoid large cliffs, finally angling to the right and up to the Diving Board. I have spent two or three nights at this fantastic location. You feel the power of rock to a degree not possible in any other location you can hike to.

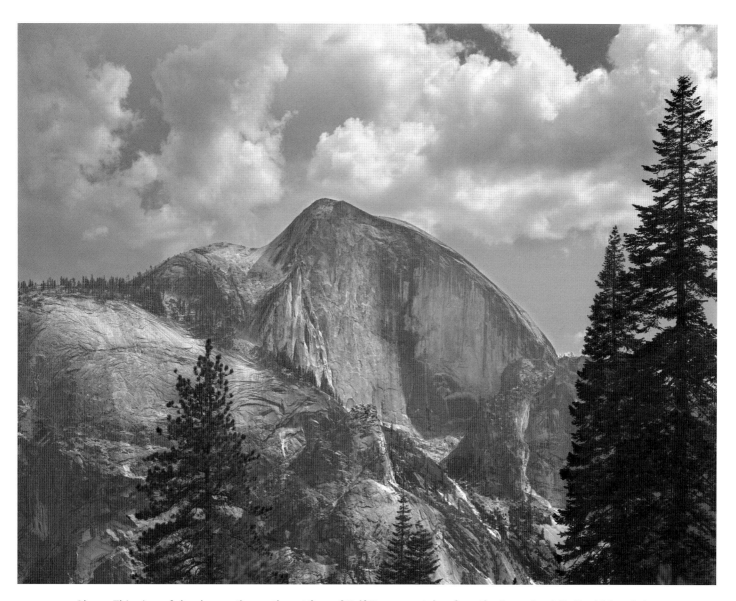

Above: This view of clouds over the northwest face of Half Dome was taken from the Snow Creek Trail, which switch-backs up the north side of Tenaya Canyon not too far beyond Mirror Lake. This short trail into Tenaya Canyon ends approximately where the switchbacks up the Snow Creek Trail start.

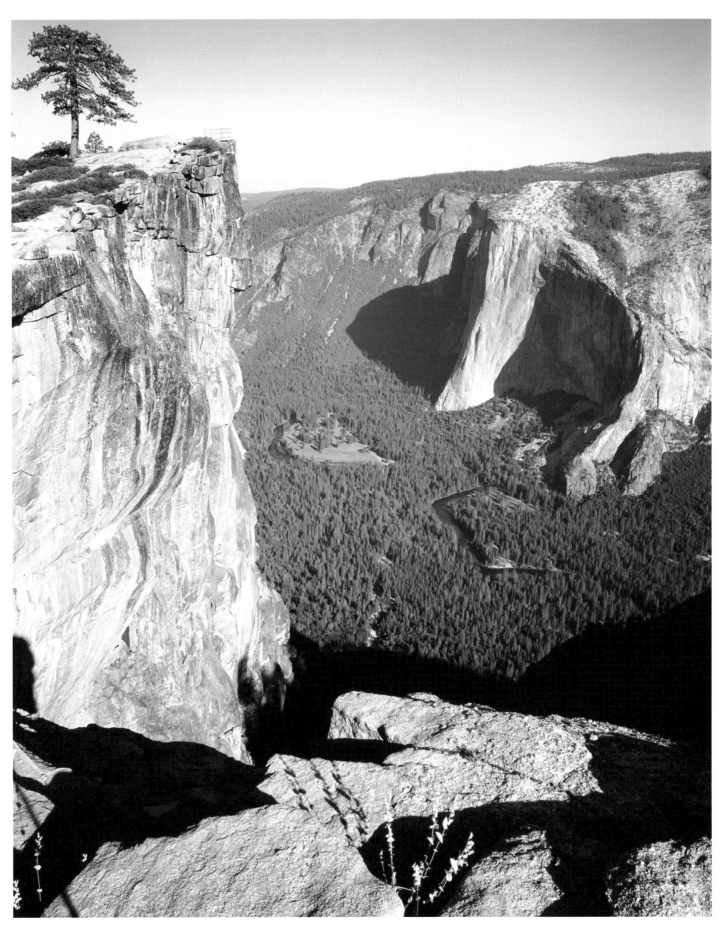

Above: This view is from the south rim of Yosemite Valley, with Taft Point on the left and El Capitan on the right. The Merced River may be seen on the valley floor. Mountain jewelflower, *Streptanthus tortuosus,* is on the rock in the foreground. Taft Point is reached by a trail leaving from Sentinel Dome trailhead along the Glacier Point Road.

THE VALLEY
FROM ABOVE

This section features a few views looking down at some of Yosemite's great landforms in the larger setting of the valley. While some of these images could easily have been placed in another chapter, given their unique perspective it was my choice to group them together here. Also included is a treasured relic from revered mountaineer John Salathé.

Below: This closer-up view of El Capitan and the floor of Yosemite Valley from Taft Point was taken a number of years after the previous photo. Both of these views were taken very early in the morning to capture the nice shadows. This image highlights the Nose and the Wall of Early Morning Light. The east buttress of El Capitan is at the lower right.

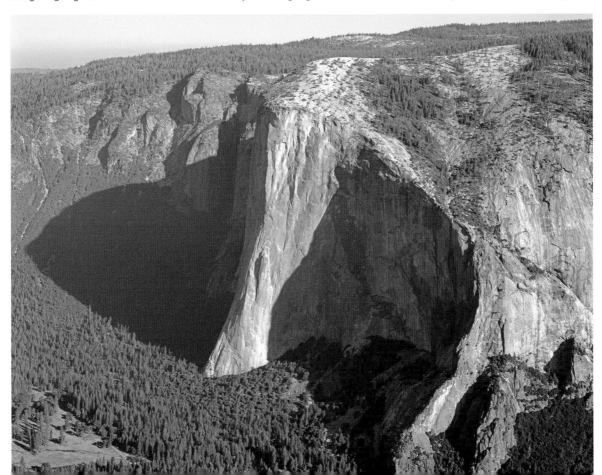

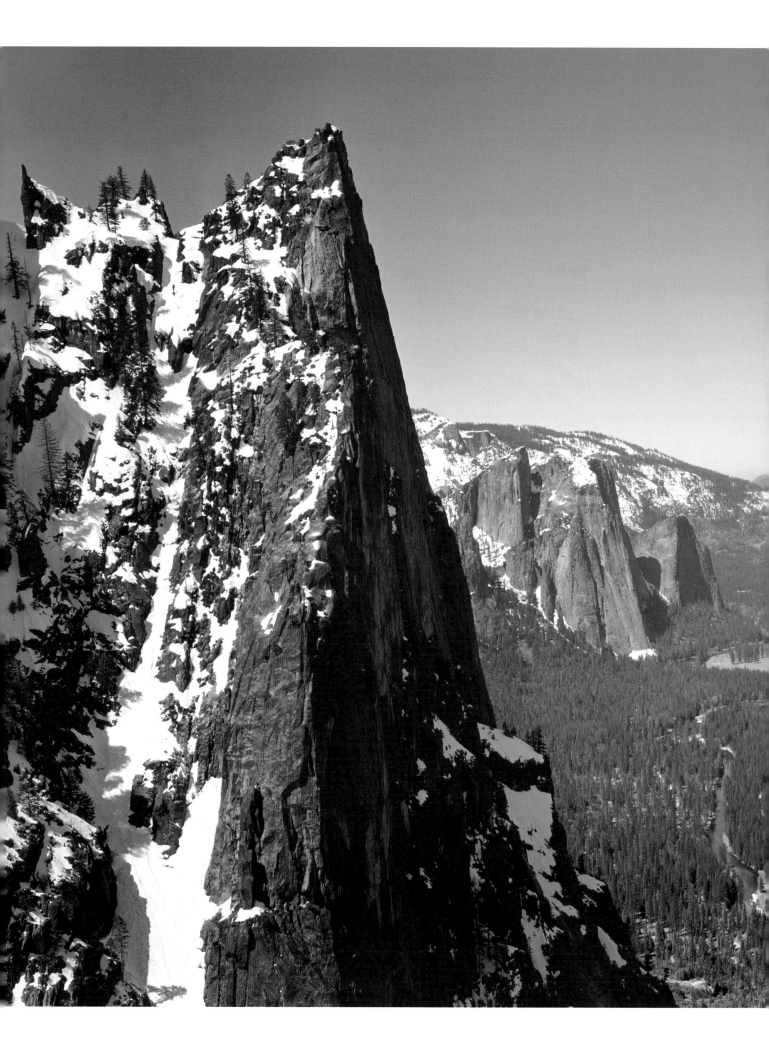

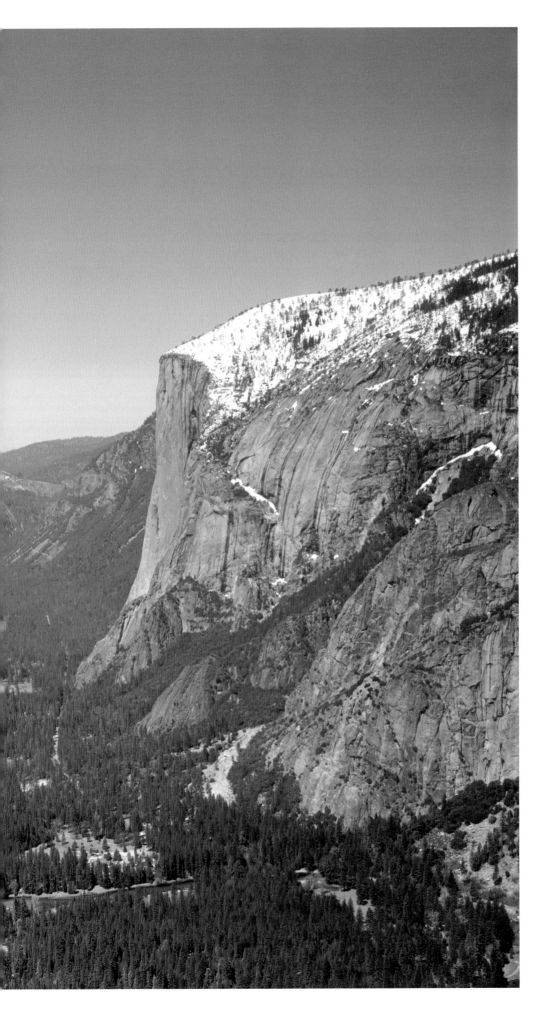

This view of Yosemite Valley was taken high up on the Four Mile Trail. When I took this picture (with a 5 x 7 view camera), the road to Glacier Point was still closed by snow and I was wading waist-deep in the white stuff. Sentinel Rock is on the left, with the Cathedral Rocks just to the right in the distance. El Capitan is on the right. The Merced River is the blue ribbon on the valley floor. The Four Mile Trail trailhead is about 1.2 miles (1.9km) west of Yosemite Village along Southside Drive. Since Southside Drive is one way going east, you have to drive west on Northside Drive until you can cross to Southside Drive at El Capitan Bridge. If you are in the vicinity of Yosemite Village, it is simpler to just walk this distance to the start of the trail.

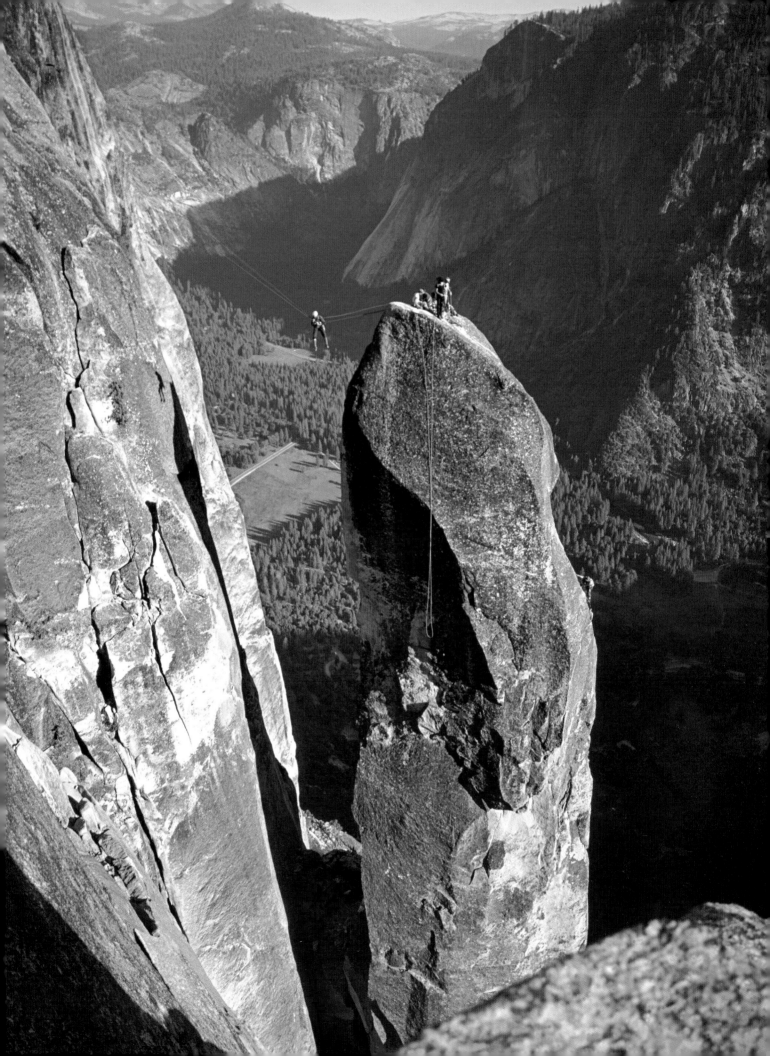

its two ledges and its notch are appropriately called First, Second, and Third errors, respectively. The route to the first ledge leads between a 70° buttress and the 85° face on small holds, highly polished and rounded by water and avalanches. Ascent in the main couloir to a point level with the First Error can be made without direct aid, and a rope traverse to the ledge is possible.

Second Error (6,450). Class 6. First ascent by Anton Nelson and John Salathé, July 4, 1947. A 400-foot, 80° chimney leads from the First Error to this ledge. Many direct-aid pitons are necessary. Time from base is about two days.

Third Error (6,750). Class 6. Reached by John Salathé in August 1946 by a descent from the rim of the valley (*SCB*, 1947, 2, 3).

Last Error (6,875). Class 6. First ascent September 2, 1946, by Jack Arnold and Anton Nelson, who prusiked up a rope thrown over the summit, and Fritz Lippmann, who came via the Tyrolean traverse which was set up (*SCB*, 1947, 1–10). First direct ascent from the base, by Anton Nelson and John Salathé, September 3, 1947. The route follows the long chimney via the first and second errors. The ascent was accomplished in five days and required much preparation (*SCB*, 1948, 103–108).

Yosemite Point Buttress (6,935)

★Class 6. First ascent July 1952 by Allen Steck and Robert Swift. The granite buttress forming the southeast wall of Yosemite Point can be divided into two parts: the pedestal and the steep face immediately above it. Climb the Yosemite Point Couloir until in line with the broken ledges and chimneys which form the right-hand side and, partly, the face of the pedestal; then aim for the large pine tree visible several hundred feet above. From the tree work upward via class 6 cracks and chimneys to the top of the pedestal, which affords an ample bivouac spot if the climb cannot be completed in one day. Above, an obvious class 6 route continues upward and to the left, then right to a sandy ledge. Several more pitches of varying difficulty lead finally to the summit. Several one-day ascents of the pedestal have been made, but the

Above: This reproduction of the actual signature of John Salathé is from my original guidebook to climbing in the Sierra Nevada, *A Climber's Guide to the High Sierra* (second printing, 1956). I met him and asked him to sign his name next to the description of the first direct ascent of the Lost Arrow, on pages 47 and 48. Although this guidebook is very battered, I consider it a priceless relic.

Facing page: Climbers on the Lost Arrow with Yosemite Valley below. The climber on the rope between the spire and the wall to the left is performing a Tyrolean traverse. This mass ascent of the Lost Arrow took place on September 9, 1967, and commemorated the twentieth anniversary of the first direct ascent of the Lost Arrow from its base, made in September 1947 by Anton Nelson and John Salathé. This view is from the north rim of the valley, reached by the 3.3-mile (5.3km) Yosemite Falls Trail, which starts a short distance west of Yosemite Village.

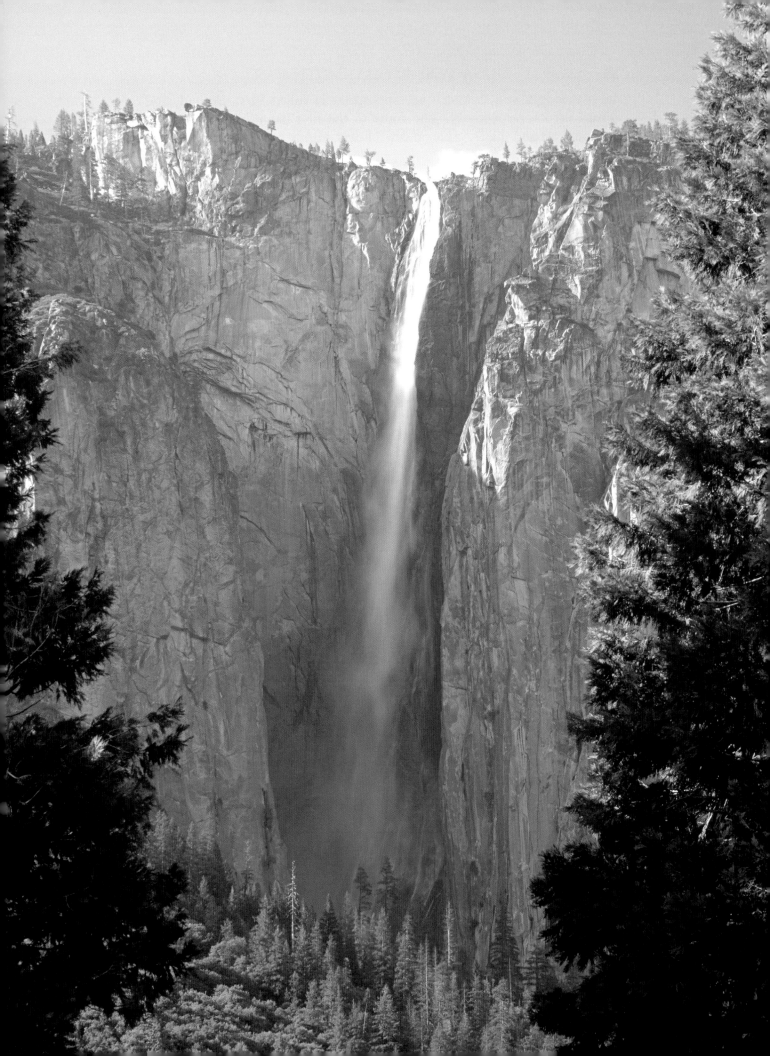

13

▲▲▲

WAWONA TUNNEL ROAD

The actual name of this route is the Wawona Road (CA 41), but I have inserted the word Tunnel to make it clear I am referring to that portion of the road above the Yosemite Valley floor near the tunnel. There are two fairly large parking lots at the west end of the Wawona Tunnel, and this area is labeled Tunnel View on the official National Park Service brochure. Because of the constant traffic, it is extremely difficult (and dangerous) to try to get a picture of Yosemite Valley as seen through the mouth of the tunnel.

This road is the main entrance to the valley for most visitors coming north from Fresno and Southern California. All tour buses stop here, and more pictures are probably taken from this point than from anywhere else in the valley. Inspiration Point is a 1.3-mile (2.1km) hike uphill from here. Tunnel View is located 1.5 miles (2.4km) west of its junction with Southside Drive.

The Wawona Tunnel area's popularity as a prime picture-taking site is justified, however, as demonstrated by images captured in this chapter. They include ephemeral Ribbon Fall and new perspectives on El Capitan, Half Dome, and other valley landforms. Different seasons, times of the day, and weather conditions all provide stunning views.

Facing page: Ribbon Fall, 1,612 feet (491m), is visible from a number of points in the several miles between the Wawona Tunnel and the point where Wawona Road joins Southside Drive. Here the fall is seen near its maximum volume in the spring. Technically it is the highest single-drop waterfall in North America, but the nod for the highest fall goes to Upper Yosemite Fall because the volume of Ribbon Fall is so low and for much of the year it is totally dry.

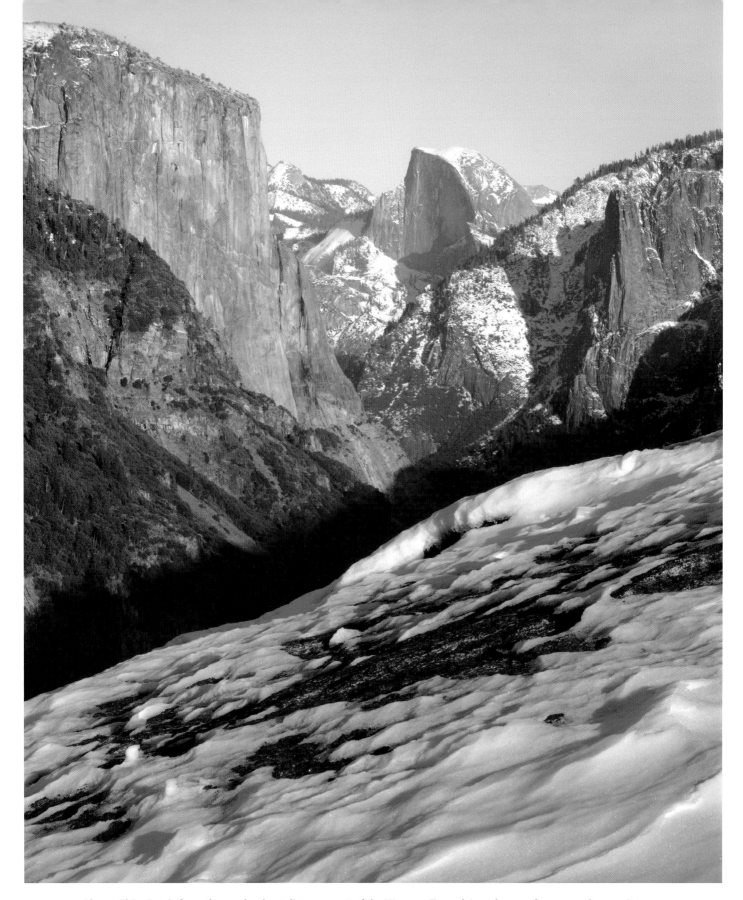

Above: This view is from the road a short distance east of the Wawona Tunnel. I made use of snow on the granite slabs just below the road to provide an interesting foreground to this view of Yosemite Valley. El Capitan is on the left, Half Dome in the center, and Sentinel Rock is on the right.

Facing page: To obtain this view of Yosemite Valley with rock penstemon in the foreground, I searched the area above Tunnel View. El Capitan is on the left, Half Dome in the distance, and Cathedral Rocks and Bridalveil Fall on the right.

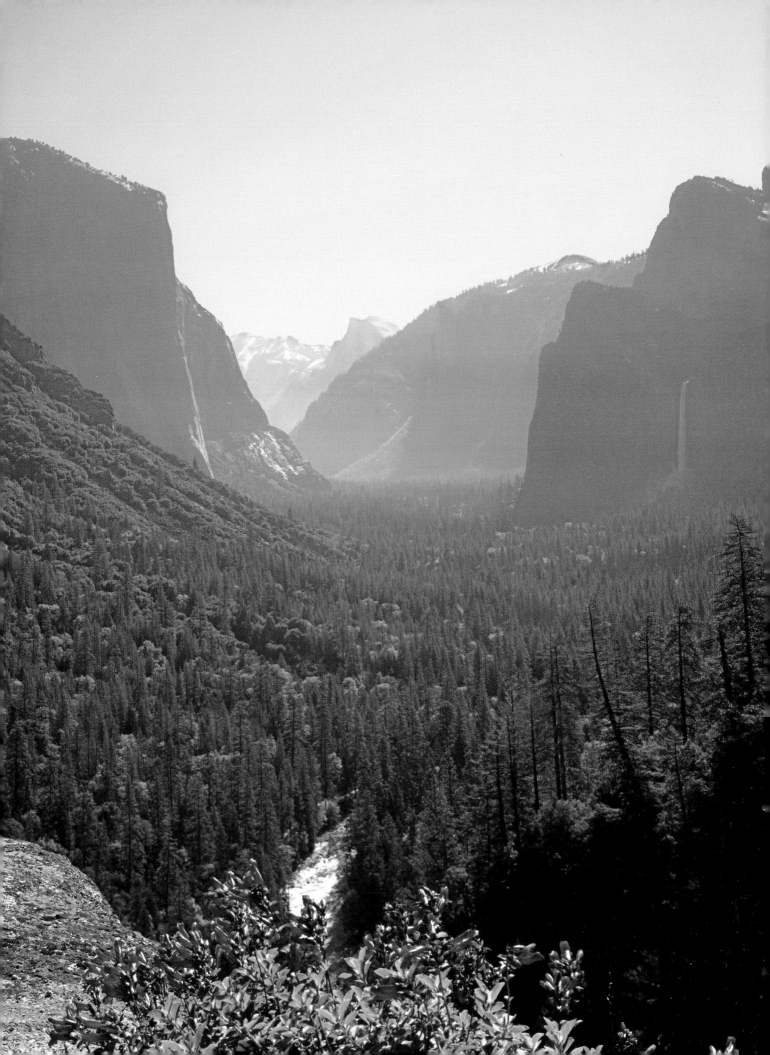

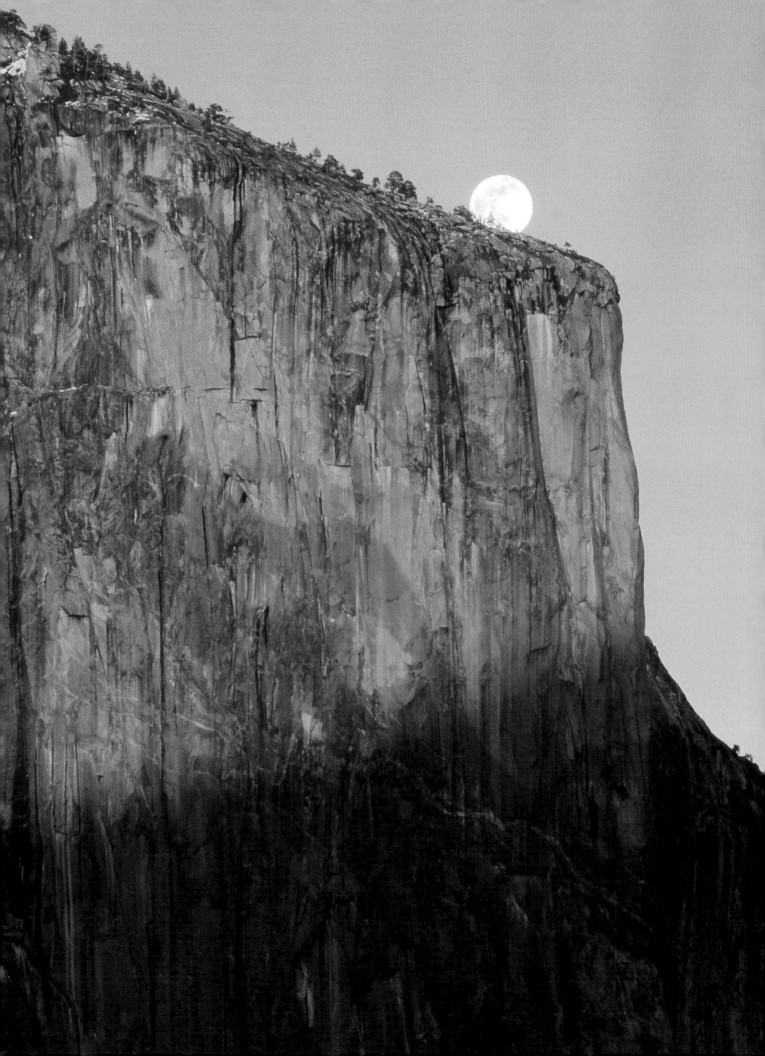

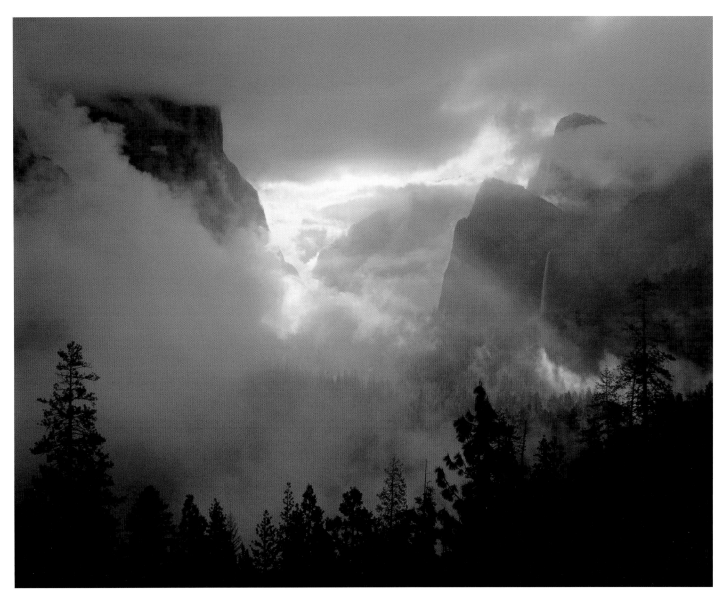

Above: So many pictures have been taken at Tunnel View that it is difficult to come up with anything different. I hurried to the popular location in order to be there at sunrise; a brief storm clearing made this image possible. I felt I was witnessing creation itself taking place. The clouds closed in right after this, and rain poured down the rest of the day. This picture is, I think, a fitting image for the end of this book.

Facing page: On one of my trips to Tunnel View near sunset, I saw the moon over El Capitan, but it was a little too high to include in the picture. I calculated when the moon would be in the perfect position the following evening. I returned at that time and, using a telephoto lens, captured this image.

ABOUT THE AUTHOR

Ed Cooper became the first "climbing bum" in the Pacific Northwest during the Golden Age of North American climbing (the 1950s and 1960s). He is the author of the acclaimed *Soul of the Heights: 50 Years Going to the Mountains* and *Soul of the Rockies: Portraits of America's Largest Mountain Range* (FalconGuides), and his photos have graced the covers of *Audubon, Arizona Highways, Backpacker, National Geographic, Sierra,* and many other magazines and books. Ed and his wife, Debby, live in Sonoma, California.